IMAGES
of America

ELKHART

INDIANA

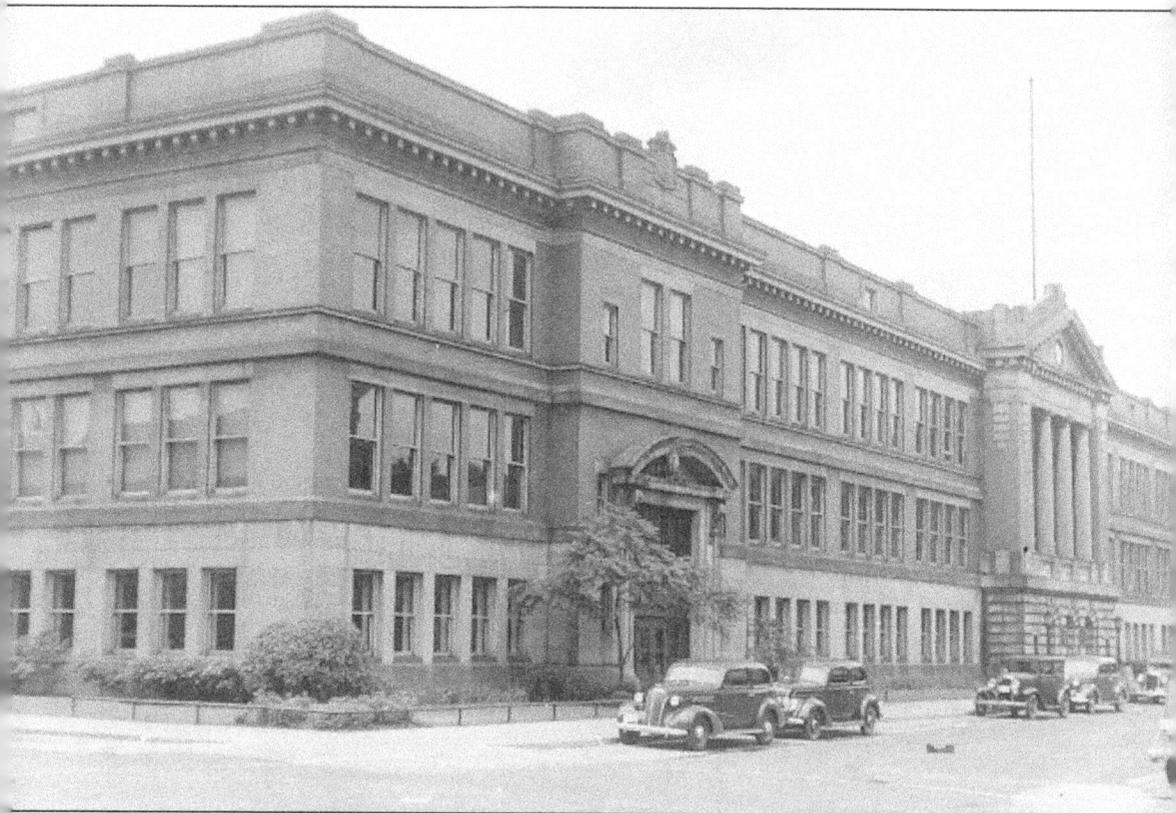

Elkhart High School, as it looked in the early 1930s. The school was built in 1911, a welcome addition to a growing and evolving school system. The sprawling campus was located on the square bordered by Second and High streets, and was a contribution of E. Hill Turnock's architectural talents. The spacious facility continued to serve as the high school for the next 60 years. The issue of overcrowding, however, had to be revisited in the mid 1960s, when the student population of Elkhart High School had climbed to nearly 2,700. By 1972, a new high school complex was built along California Road, and would be called Elkhart Memorial High School. The older school was renamed Elkhart Central High School, and both school systems are still flourishing today. (Courtesy of Time Was Museum.)

IMAGES
of America

ELKHART

INDIANA

Amy (Lant) Wenger

ARCADIA
PUBLISHING

Published by Arcadia Publishing
Charleston, South Carolina

Library of Congress Catalog Card Number: 2002103816

For all general information contact Arcadia Publishing at:
Telephone 843-853-2070
Fax 843-853-0044
E-mail sales@arcadiapublishing.com
For customer service and orders:
Toll-Free 1-888-313-2665

Visit us on the Internet at www.arcadiapublishing.com

For my husband, Larry Wenger Jr., the love of my life,
and for our daughter, Hannah Gabrielle, the love of our life.
For my parents, Robert and Karen Lant, and my sister, Sarah Gilmer.
Thank you all for your love and your faith in me.
And thanks be to God, from whom all blessings truly flow.

CONTENTS

ACKNOWLEDGMENTS

Mrs. Holly Heller, managing editor, *Bremen Enquirer*. It was because of your initial efforts that this dream was able to blossom into reality.

Mrs. Tammy Venable, whose own contribution to the *Images of America* series was the impetus for my introduction to Arcadia Publishing.

The Elkhart Public Library Local History staff, with special thanks to Mrs. Deb Ehret for her research, and to her co-workers for granting her the time to work alongside me. Also, thanks to Mr. Brent Ferguson, young adult librarian, for his tremendous computer expertise. You all went far above and beyond the call—my gratitude will never be fully expressed.

Mr. Paul Thomas, curator of the "Time Was" museum—a grand gentleman who is to be revered as much as the treasures you harbor. Thank you for your enthusiasm and your wisdom.

Mr. Robert Lant—your assistance on this endeavor allowed me to respect, admire, and love you on another dimension. Thank you for all you've done—your help was invaluable.

Mr. David Miller, Mayor of Elkhart - a man whose kind heart and spiritual words of assurance will stay with me forever.

Mr. Al Hesselbart and staff, RV/MH Foundation—what a fascinating adventure visiting with you and your remarkable facility.

Mr. Ronald Coulter—the genial, gentle soul who gave so much of his personal archives to aid me in my research—my sincerest thanks.

Mr. Steve Ervin, computer expert extraordinaire!

The Nappanee Public Library.

The Wakarusa Public Library.

The Bremen Public Library.

The *Elkhart Truth*.

The amazing staff of Arcadia Publishing—all of whom graciously accepted the challenge of working with a novice author. I am particularly indebted to Ms. Samantha Gleisten, acquisitions editor. You offered me praise, fueled my motivation, and instilled in me courage. You are a true friend.

All of the previous authors who so brilliantly took on the task of chronicling various aspects of Elkhart history—your works were of tremendous guidance and inspiration to me. Special thanks to Mr. George Riebs, Mr. Dave McLellan, Mr. Bill Warrick, and Mr. Emil Anderson.

God bless you all!

FOREWORD

John Ruskin is attributed as saying, "our duty is to preserve what the past had to say for itself, and say for ourselves what shall be true for the future."

William Shakespeare recorded, as only he could, "Whereof what's past is prologue, what to come in yours and my discharge."

The first confirmed inhabitants of what is Elkhart were Miami Indians who lived here for two centuries. Elks were abundant and the small island at the mouth of the river was shaped somewhat like a heart. They called it "Mishiwa-Teki-sipiwi;" Mishiwa for Elk, Teki for heart, and sipiwi for river.

In the early 1700s the Pottawattamie Indians came and kept the meaning but changed the name to "Mishiwa-Odaik-Sebe": Elk-Heart-River. Their villages occupied the length of the river. Reverend Isaac McCoy, a Baptist Missionary who traveled many times to this area translated the name to English and first wrote it in 1822 as Elksheart. The "s" was later dropped in a treaty and when the state incorporated the county in 1830, they changed the spelling to its current day "Elkhart."

The first white settler to come to the area was Colonel John Jackson in 1812 as a part of General Anthony Wayne's detachment of soldiers from Fort Wayne, then a mere outpost. Jackson visited the Prairie again in 1825 and told someone that when he awoke one morning he saw the sun rising above the trees on the prairie and thought it was the most beautiful sight. He resolved then to make this his future home. He settled permanently in early 1829. Jackson played a significant role in Elkhart County's early development. In 1830, after spirited debate, the county seat was selected and a name chosen. Coincidentally, the name Goshen was suggested by Commissioner David Miller (no relation I know of) who had much to do with selecting the site.

Settlers streamed in. Houses, schools, churches, streets, and mills were built. Stores and businesses followed. Two of those homesteaders were Ebenezar Browne and his brother William. They came to Elkhart from Plymouth, Massachusetts and were direct descendants of Peter Browne of Holland who sailed to America on the Mayflower. Ebenezar owned a large tract of land and became a leading citizen who, with Jackson, founded the area's first newspaper. Some Elkhart settlers moved on west to Iowa in the mid-1800s and they brought their hometown's name with them. Elkhart, IA was founded in 1853.

In 1866, fourteen year old Avery Brown moved to Elkhart, Indiana and lived here until his death in 1904. He holds the distinction of being the youngest soldier of the Civil War. He joined the service at age eight to play snare drum, which he was quite proficient at. He is buried in Gracelawn cemetery. And so began the rich heritage that is Elkhart. Suitably named.

Amy Wenger has assembled a remarkable snap-shot of Elkhart; obliging the dictum of Ruskin giving our present a clearer picture of the prologue that was Elkhart.

Few communities can boast that the spirit of the Elk resides in the heart of the city. Unlike any place on earth, Elkhart is a city with a strong heart.

Proud to be part of Elkhart's present, helping to chart Elkhart's future, we offer you a glimpse into Elkhart's past.

Dave Miller
Mayor, April 2002

INTRODUCTION

There was beauty and inspiration to be found in this land of gently rolling plains and swiftly winding waters.

It seems that once upon a very long time ago, in these same parts, elk were prevalent here as well. The Native Americans who visited the region were compelled to make their homes here, so enticed were they by the bounty that nature offered. According to popular folklore, the Indian inhabitants discovered that where two flowing waterways converged, a small patch of land nestled in between formed the silhouette of an elk's heart. So, hence the name, "Elkhart."

But there is yet another story that is often told regarding the christening of this city, a tale which perhaps has more factual merit. More than two centuries ago, the established tribes of Potawatomi and Ottawa were surprised upon the arrival of a band of Shawnee, who desired to settle here. The tribes did not hold each other in the highest of regards, and trouble ensued. One of the Shawnee leaders was Chief Mishiwa-Teki, whose own daughter was held captive during one of many skirmishes. The English translation of the Shawnee chief's name was Elk-Heart, so it lends more credence to the supposition that he may well have been the one for whom the latter-day naming is credited.

In those earliest days of organization, though, the region was not initially christened Elkhart, nor was it even located within the boundaries of the state of Indiana. In 1787, the Northwest Ordinance was drafted, which instituted the Northwest Territory to include what we now know as Ohio, Indiana, Michigan, Illinois, Wisconsin, and a small section of Minnesota. By 1803, Ohio became the first state carved out of the vast expanse of land—the remaining portion would be known as the Indiana Territory. Just two years later, the Michigan Territory was created. The southernmost boundary was declared to run horizontally across the tip of Lake Michigan extending eastbound to Lake Erie. Encompassed within the newly formed state of Michigan were the future cities of Michigan City, South Bend, and Elkhart.

More fascinating still is the discovery that over the course of one year, Elkhart and the surrounding Michigan Territory were seized as a victory for the British during the war of 1812. The United States lost the territory to Great Britain as they maintained a position in Canada, and the Michigan Territory was renamed British North America. Just one year later, the future ninth president of America, General William Henry Harrison was at the helm of an army that recaptured the territory and relinquished it to the United States.

When Indiana was granted statehood in 1816, the newly proposed north boundary extended from a line ten miles further north than the previous Michigan Territory, so a small portion of Lake Michigan now dipped into the state. This was done to allow for Indiana to someday establish a port on Lake Michigan. The change in the borders was subsequently approved by Congress, and so the Elkhart area was now officially a part of the state of Indiana.

Shortly thereafter, the appearance of white settlers in the region gave way to some of the most pivotal moments in early Elkhart history. Around 1822, a minister and his wife traveled through the vicinity on their way to a mission post near Niles, Michigan. The Reverend Isaac McCoy and his wife, Christiana, erected a campsite on the banks of the Elkhart River. The

couple was so taken with the area that the Reverend decided to honor his wife by naming a tributary of the river after her. From then on, the area where the McCoys made their temporary home would be known as Christiana Creek.

Just one year prior, in 1821, a treaty was signed granting a section of land in Concord Township to a man named Pierre Moran. Moran carried an interesting pedigree—his father was French and his mother, a Kickapoo Indian squaw. The signing of this particular treaty was of special interest to the Native American homesteaders—it was attended by some 3,000 representatives of Potatawatomi, Ottawa, and Chippewa heritage.

A few years later, in 1827, Pierre Moran met with a fellow named Richard Godfroy, who at the time was an Indian agent. The meeting ended with an offer from Godfroy to purchase the land owned by Moran. For a price of $300, Godfroy said, he would buy up the 640 acres. Moran consented, but soon learned that Godfroy did not quite have the ready cash on hand. So Moran settled for payment of a horse and a wagon, with Godfroy promising to come up with the cash at a later time.

There were some complications that arose, however, which eventually rendered the deal invalid. Whenever a transaction of land involved an Indian selling to a white man, the deed had to bear the signature of the presiding President. Whether that step was taken was called into question, although one record indicated that President John Quincy Adams did sign such a deed. Godfroy's woes did not end there, however. John Tipton, another local agent representing the Indians, claimed that Godfroy's paltry offer of $300 was nowhere near the required sum of at least one-fourth of the land value. To make matters worse, nowhere was it recorded that Godfroy had ever attempted to settle his earlier cash balance with Moran. So Godfroy was no longer in possession of the tract of land, and ownership reverted back to Pierre Moran.

Another gentleman arrived at the valley in 1828 and quickly settled along Christiana Creek. His name was George Crawford. Crawford teamed up with fellow newcomers Lewis Davis and Chester Sage to build a grist mill at the mouth of the creek. The men named the tiny village Pulaski, in reverence to a general who served and died in the Revolutionary War. A post office was established a year later, in 1829, but was later transferred south to the other small village that was rising just across the St. Joseph River—it would become absorbed into Elkhart's boundaries in 1839.

That new village would become Elkhart, and once again, Pierre Moran was a tremendous player. In 1830, Dr. Havilah Beardsley came to Pulaski and settled with George Crawford. Dr. Beardsley approached Moran with a more enticing offer for purchase of his land—$800. John Tipton, the agent whose research nullified the earlier arrangement with Moran and Godfroy, came back with a counteroffer on Moran's behalf—$1500. Dr. Beardsley never flinched, and in 1831, the deed was inked. President Andrew Jackson granted his consent as well, which made Dr. Beardsley the exclusive owner to the acreage that would serve as the foundation for Elkhart. In 1832, George Crawford was hired by Dr. Beardsley to plot what would amount to 51 lots. In the two decades that followed, the townsfolk went to work building upon their hometown—a school was built, churches erected, and the Main Street business thoroughfare established.

And on September 7, 1858, the nearly 1,500 residents that had grown to cherish this promising land as their home were able to witness the incorporation of Elkhart as a new town.

Nearly 150 years later, the sprawling city of Elkhart has most certainly carved out a respectable and magnificent legacy across the timeline of Indiana history. Most people recognize and celebrate the numerous achievements that can be directly traced to Elkhart—the strides in the pharmaceutical field, the vast array of musical instrument manufacturers, the dawn of the recreational vehicle industry, to name a mere few. In more recent years, the Elkhart area has been bestowed with more than a fair share of acclaim. Among such accolades include the declaration that the city is among the most desirable in the nation in regards to affordable housing and job opportunities. Elkhart is a city that is also rightfully proud of its devotion to heritage and to culture, and there are many events and festivals held throughout the year which give rise to these occasions of laud.

One might wonder if those founding fathers from nearly two centuries ago could have possibly imagined how their contributions would come to pass. They, quite literally, paved the way for those who now carry the torch of greatness to grace future generations, and for those who await their chance to share in the incredible legacy that will forever be part of "the city with a heart."

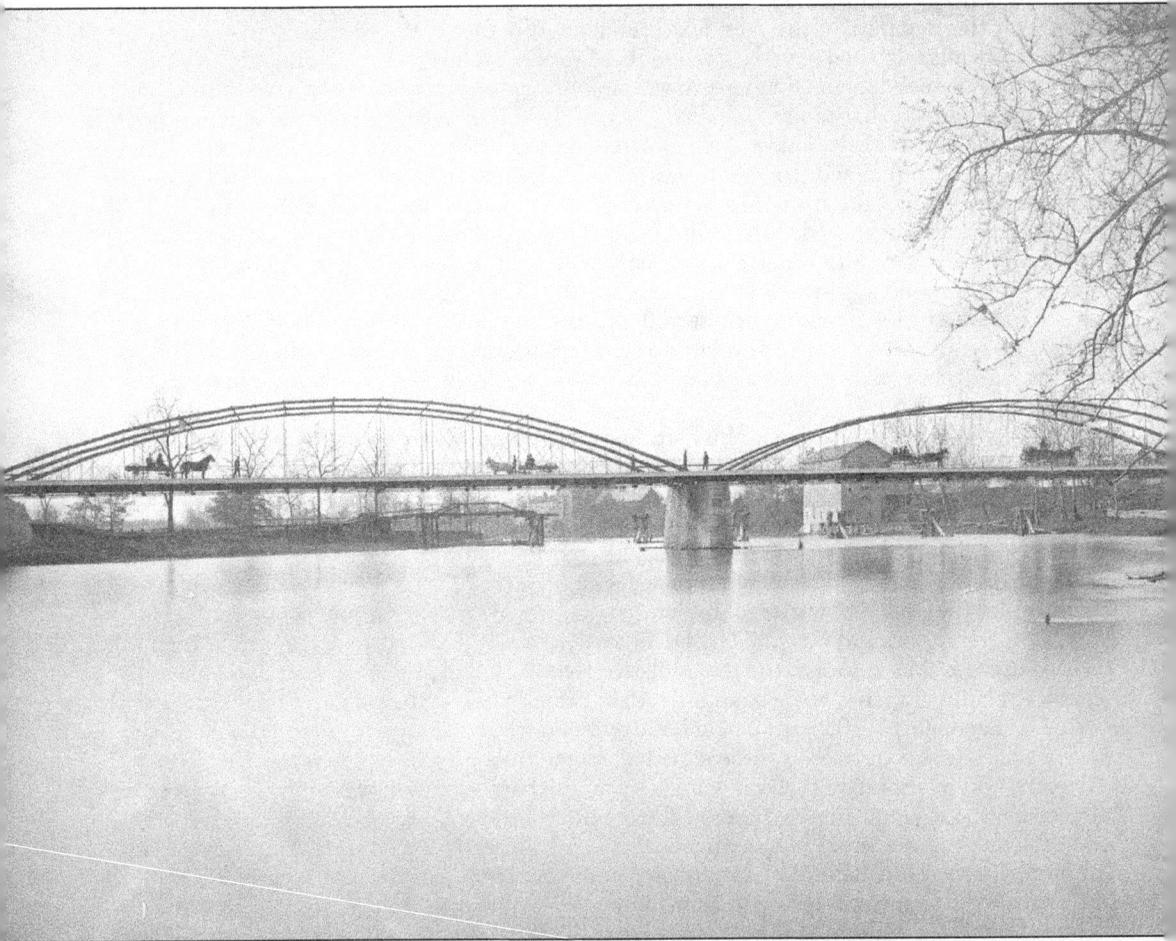

The first arched iron bridge spanning the St. Joseph River, shortly after its construction in 1871. Its purpose was to connect the settlers on the north side of the river to the business district on the south side. When the bridge was dismantled in 1891, one of the two spans was used to construct a new bridge to Island Park. (Courtesy of Elkhart Public Library.)

One

THE 19TH CENTURY

"THE CORNERSTONE YEARS"

With the evolution of Elkhart from a tiny riverfront village to a prospering small town, the years to come would be replete with milestones and "firsts." In the 30 year span of time from 1860 to 1890, the population of Elkhart soared from roughly 1,500 to well over 11,000. This surge in residency was attributed primarily to one factor—the railroads.

During the time that America was embroiled in the Civil War, the location of Elkhart was seen as beneficial to the railway, because it was situated in a prime crossroads. Elkhart was the place where the Old Road through Michigan, and the Air Line through Indiana and Ohio, intersected. So in 1864, a brick engine roundhouse was built, which featured six stalls and a wealth of adjacent land, in the event an expansion should ever be needed. Just three years later, a dozen stalls were added to the original engine house, and railroad repair shops became part of the complex as well.

With all of these advancements to the railroad system, Elkhart was perceived as a place where railroad jobs were all but guaranteed. So the influx of new citizens grew rapidly over the course of the mid-to late-1800s. An annual report of the Lake Shore and Michigan Southern rail system, released in 1870, describes the completion of a new machine shop, a blacksmith shop, along with a newly created foundry and more repair shops. Even the local newspapers hailed these accomplishments as a boon for the city, both socially and economically.

Other local historical accounts list a number of fledgling railroad companies which provided still more means of employment. There was the Michigan Southern and Northern Indiana, Northern Indiana, Lake Shore and Michigan Southern, Michigan Southern, Buffalo and Mississippi, Western Airline and Old Road, New York Central, CW & M Big Four, and the Elkhart Line.

In 1875, a vote was passed by a slender margin to transform Elkhart from a town into a city. With this change of status, it became necessary to implement several branches of local government. Henry C. Wright served as Elkhart's very first mayor, elected on May 11, 1875 in a contest that defeated John McNaughton. A city council was also needed, as was a city clerk, a treasurer, and a judge. Not long after the election was held, a new city hall was dedicated, a three-story structure built to house not only the civic leaders, but also the fire and police departments, a council chamber, and the city jail. The third floor was usually kept vacant, but for public meetings and social events. However, the ringing of the fire bell on the rooftop caused the building to tremble in such a way that the third floor eventually was unsafe to use, as there were fears that the entire building might collapse. The municipal building, which was located on the northeast corner of Second and High streets, was used for nearly a quarter of a century, until 1895.

One of the very first amenities that was deemed a necessity to Elkhart, even before it was ever incorporated into a town, was a public school system. A gentleman by the name of Nehemiah Broderick is credited as having been the first schoolteacher, with his students

attending classes in a small log cabin. The cabin originated in 1836, along East Washington Street, located near the south bank of the Elkhart River. Interestingly, Broderick and his wife, Margaret, were also the parents of the first child born to settlers of Elkhart—they had a baby boy named John, born in 1835.

After the log cabin was rendered too small to accommodate its purpose, a new school was built in 1838 on the east side of Second Street, between Jackson and Washington. But its life was a short one—the building burned down in 1844. For a time, students had to take their lessons at "Tammany Hall," a famed landmark at the southwest corner of Main and Jefferson streets. Another school was soon to be built, a four story frame structure at the southwest corner of High and Second streets. When that building was also lost to a fire in 1867, it was almost a bit of a mixed blessing, as the town officials had just been grappling with the decision to create a more modern school complex, where all 12 grades could be taught.

The answer to that quandary came in the form of Central School, a stately four-story brick building which was opened just in time for the fall term of 1868, at a cost of $45,000. There were a few naysayers that felt the somewhat grandiose school was too elegant and sprawling, and that there would never be enough students to adequately fill the building. But by 1884, there were a number of elementary schools that had to be built to remedy the overcrowding, quashing the notion that the lone schoolhouse was too large. There was the Fourth Ward, the Fifth Ward, East Elkhart, Weston, Beardsley, and Middlebury. Also, the Central School grounds had swelled to beyond capacity, so a small building known as the "Annex" was added to the original Central School. The little structure featured eight rooms, which were specifically earmarked for high school students. The first graduates of Elkhart High School fulfilled their scholastic requirements on this campus—commencement exercises were held in 1873, with five young ladies receiving their diplomas.

By 1892, an entirely new location was chosen as the grounds for a new Elkhart High School, on a lot donated by Samuel Strong. The structure, still standing at the corner of Lexington Avenue and Vistula Street, was a three story building with ample space and features for the growing student population. It would serve as the high school for the next 20 years, and after the completion of a new Elkhart High School in 1912, the former site became the Samuel S. Strong Elementary School.

Other notable events from the 19th century included the construction of the first dam to be built over the St. Joseph River. Built in 1868, it allowed for more of the town's mills and factories to utilize hydraulic power. C.G. Conn unveiled his first band instrument manufacturing plant in 1877, and over time, scores of additional instrument facilities sprung up, which allowed for Elkhart to be dubbed the "Band Instrument Capital of the World." The Bucklen Opera House was opened in 1884, and the Hotel Bucklen came into being in 1889. the *Elkhart Truth*, the city's only daily publication to survive for more than 100 years, debuted in 1889, and by 1891, a pioneer in pharmaceuticals was about to launch a most formidable institution for the city and the reputation of Elkhart. His name was Dr. Franklin L. Miles, and more on his fantastic contributions to both Elkhart and to modern day medicine will be chronicled in the second chapter.

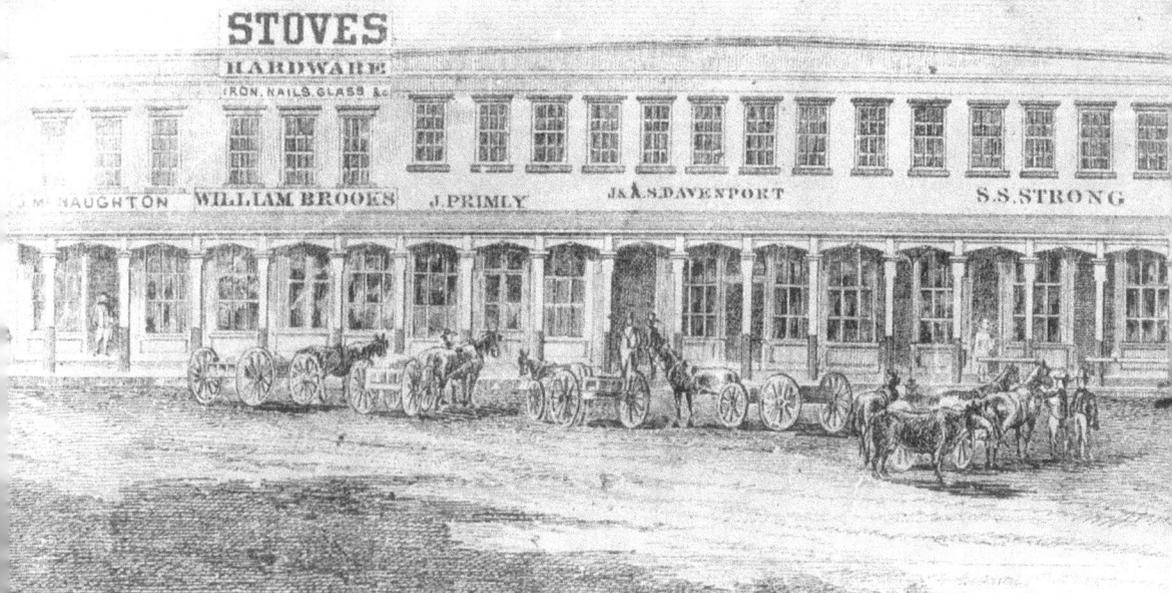

This is an artist's rendering of the west side of Main Street, as it appeared around 1860. This was an extensive commercial block, and at the time, was regarded to be the heart of the business district. The storefronts extended just south of Jackson Boulevard to the first alley south on Main Street. Proprietors of the era were John McNaughton, William Brooks, J. Primly, J. Davenport, and Samuel Strong. (Courtesy of Elkhart Public Library.)

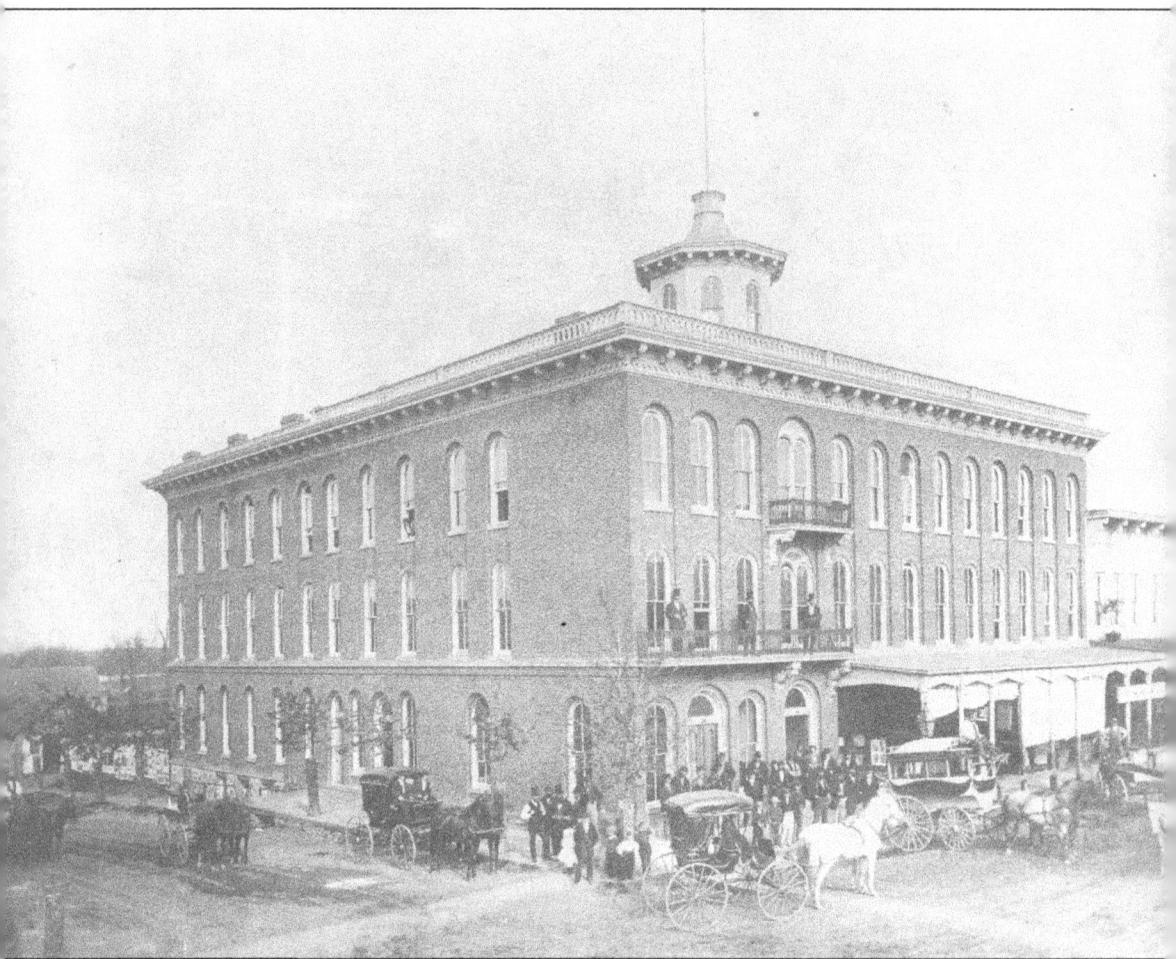

The original Clifton House, as it looked not long after its creation in 1863. It was situated on the southeast corner of Main Street and Jackson Boulevard, and was a project led by esteemed Elkhart businessmen J.R. Beardsley, B.L. Davenport, and Silas Baldwin. Clifton House would later be purchased by Herbert E. Bucklen, and would rise to even greater prominence as the Hotel Bucklen. (Courtesy of Elkhart Public Library.)

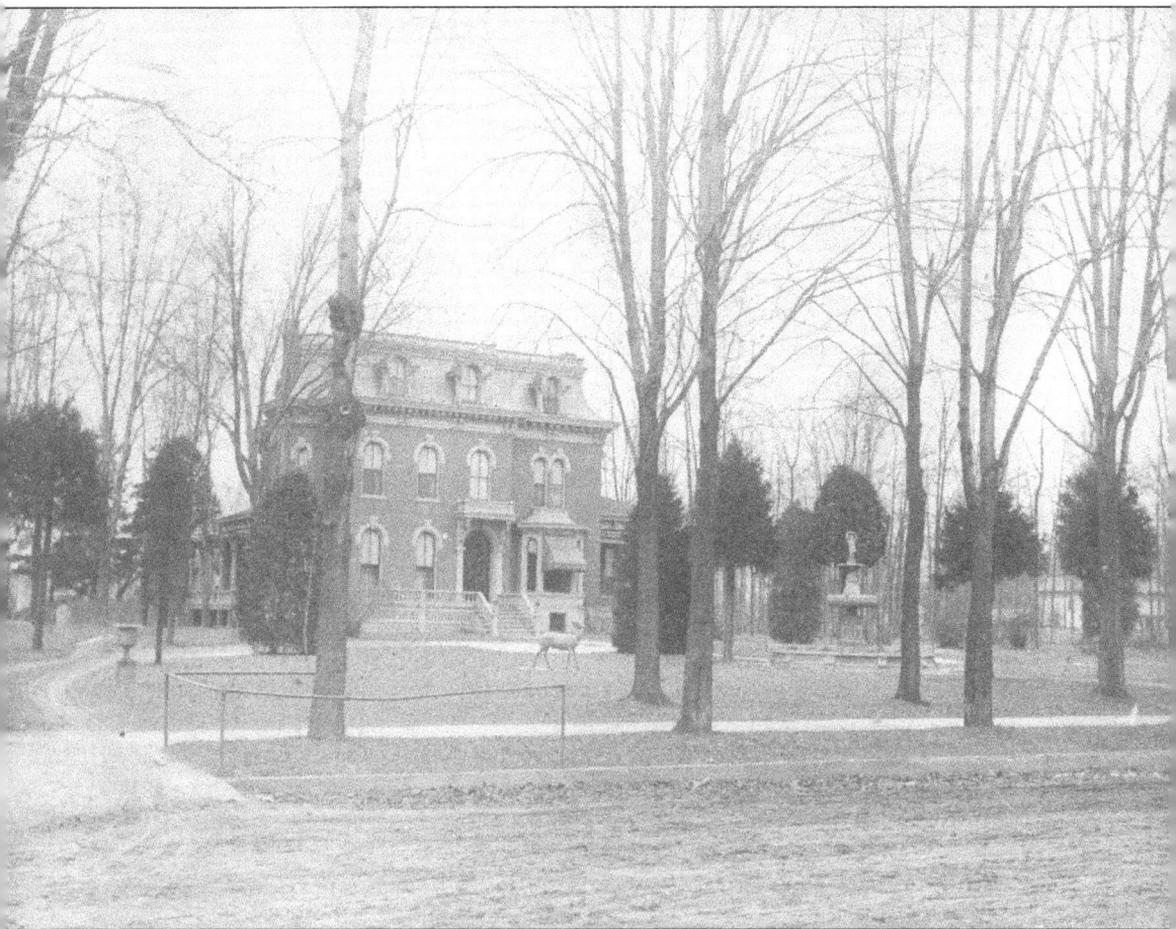

The home of Benjamin L. and Sarah Davenport, the daughter of Havilah Beardsley, the man lauded for the creation of Elkhart as a village in 1832. The home was built in 1850, and was established at the intersection of Main Street and Beardsley Avenue. It was torn down in 1941. (Courtesy of Elkhart Public Library.)

This photo was taken in 1883, at a home called the "Every" house on the corner of Main and Pratt streets. Presumably, the name was intended to refer to a typical Elkhart home. Just barely distinguishable are the shadowy figures of a man and woman seated beneath the shade of a front yard tree. This house later became the site for the Templin Music Store. (Courtesy of Elkhart Public Library.)

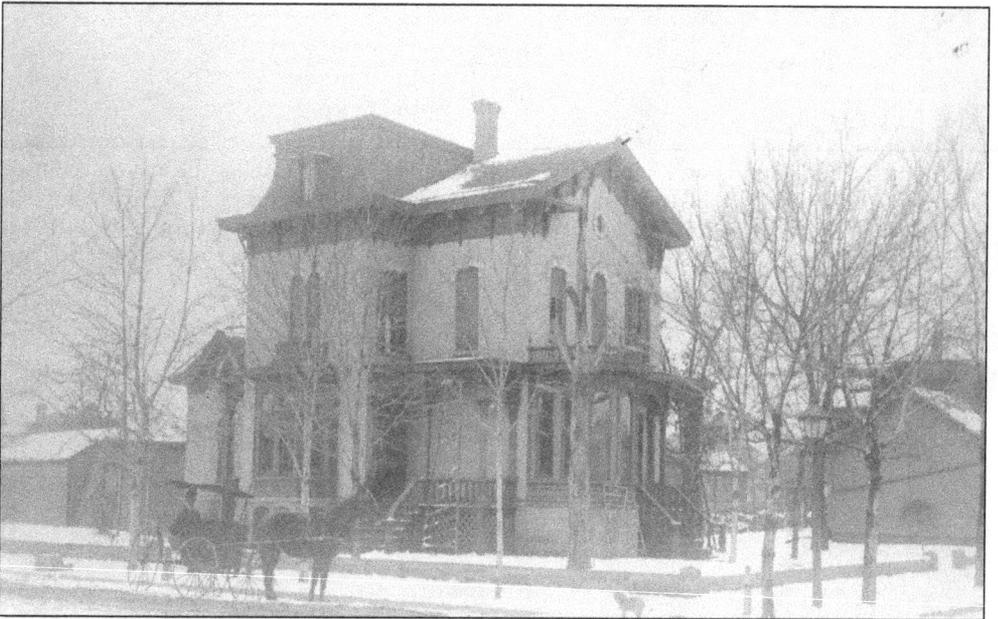

The home of W.B. Vanderlip was built in 1866. It was raised on a site at the northwest corner of Second and Harrison streets. Though the photo bears no date, it might be safe to assume that it was taken prior to 1900—note the carraige at left. In 1904, the home was relocated to 212 West Harrison Street, but in 1957, it was to be no more—the land was needed to make way for a new underpass. (Courtesy of Elkhart Public Library.)

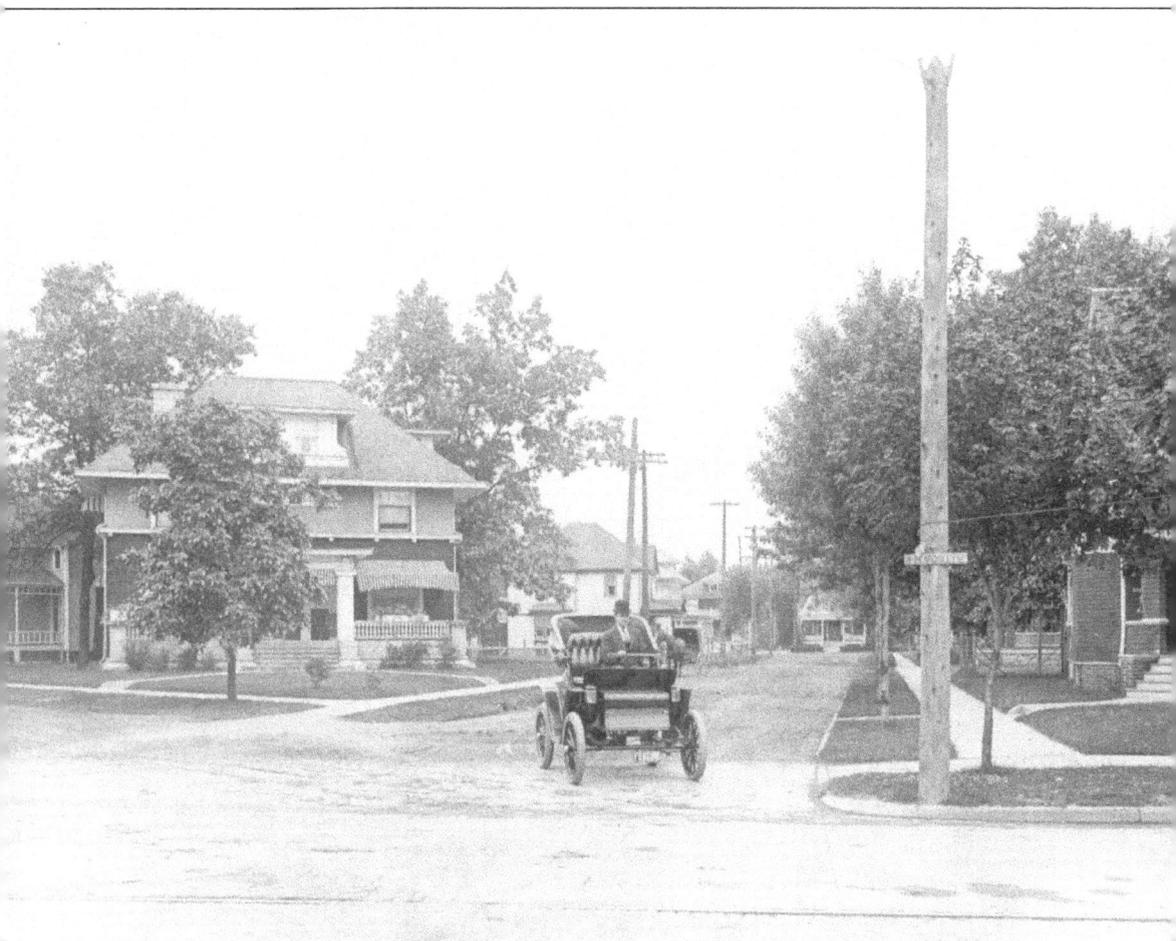

The Percy Cochran residence located at 301 Christiana Court. This picture does not carry a specific date, but it appears to have been taken around the turn of the 20th century. Note the gentleman riding a horseless carriage, seemingly about to execute a turn onto Beardsley Avenue. Just visible in the foreground are the brick streets, etched with streetcar tracks. (Courtesy of Elkhart Public Library.)

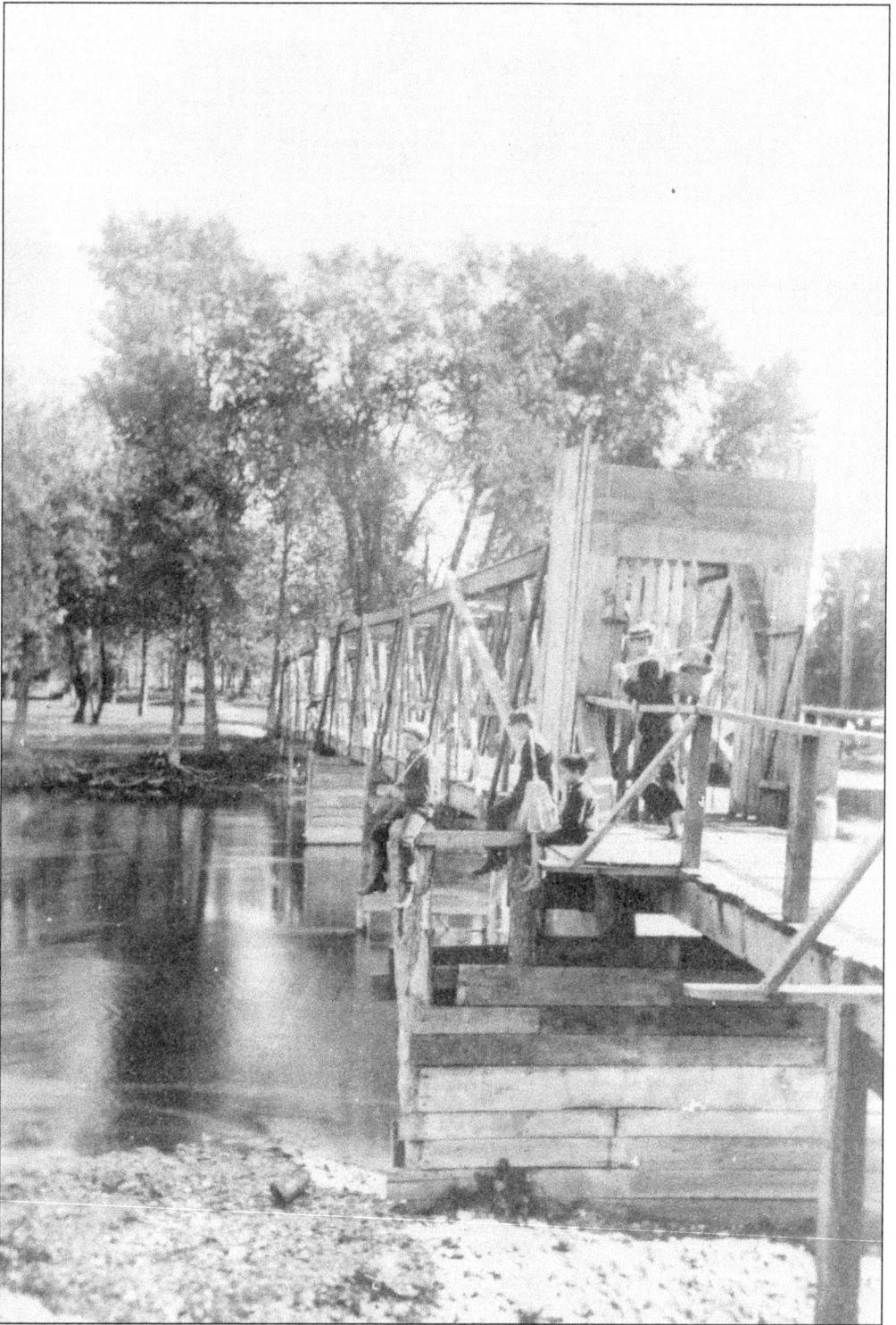

The original Island Park Bridge, *c.* 1885 was a peaceful spot for some local anglers. (Courtesy of Elkhart Public Library.)

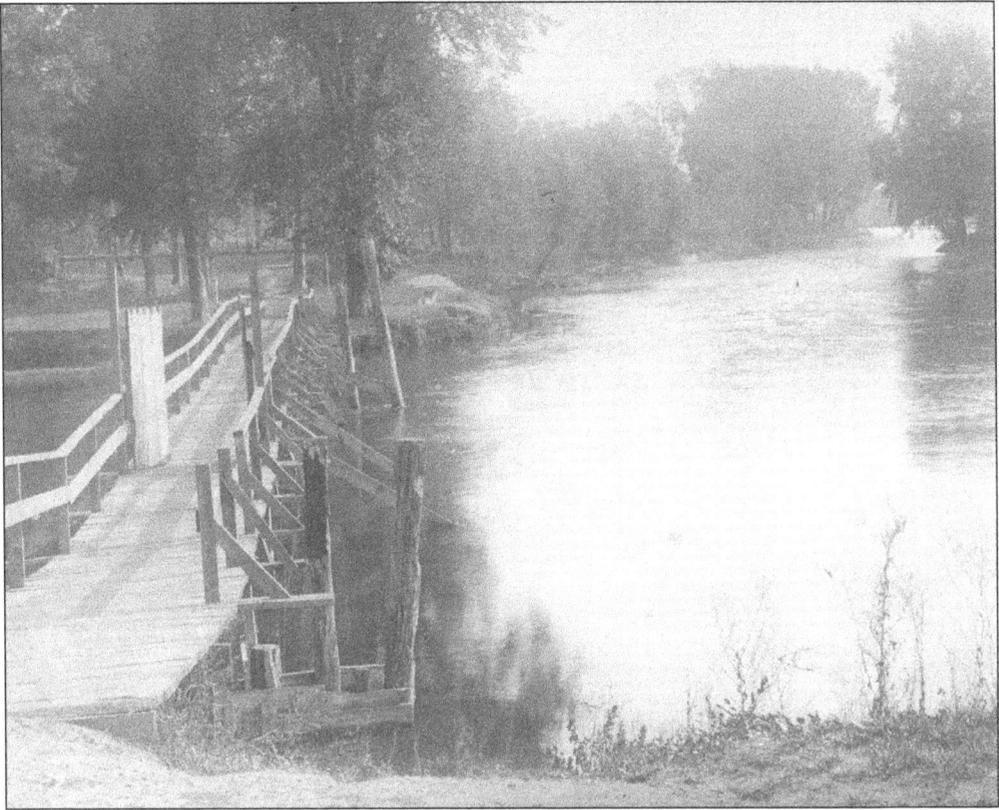

Here we have another view of the first Island Park Bridge, in a photo taken around 1890. (Courtesy of Elkhart Public Library.)

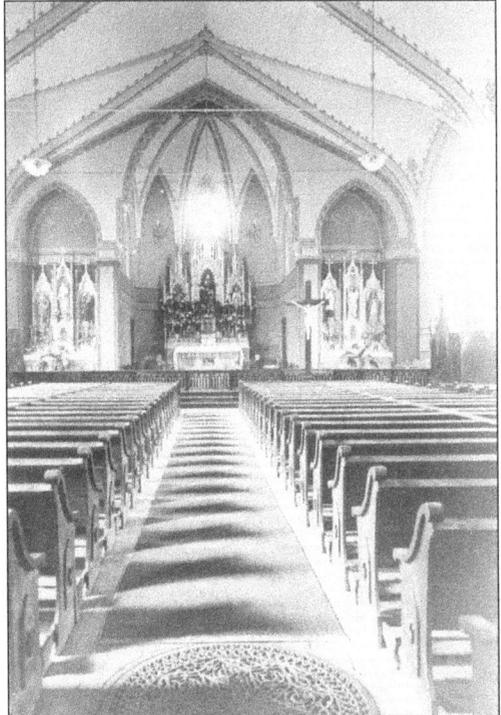

This is the interior of St. Vincent's Church, one of the more ornately designed and beautiful places of worship in the community. This church was located at the crossroads of South Main and Prairie streets. The photo was taken not long after the church was built in 1887. (Courtesy of Elkhart Public Library.)

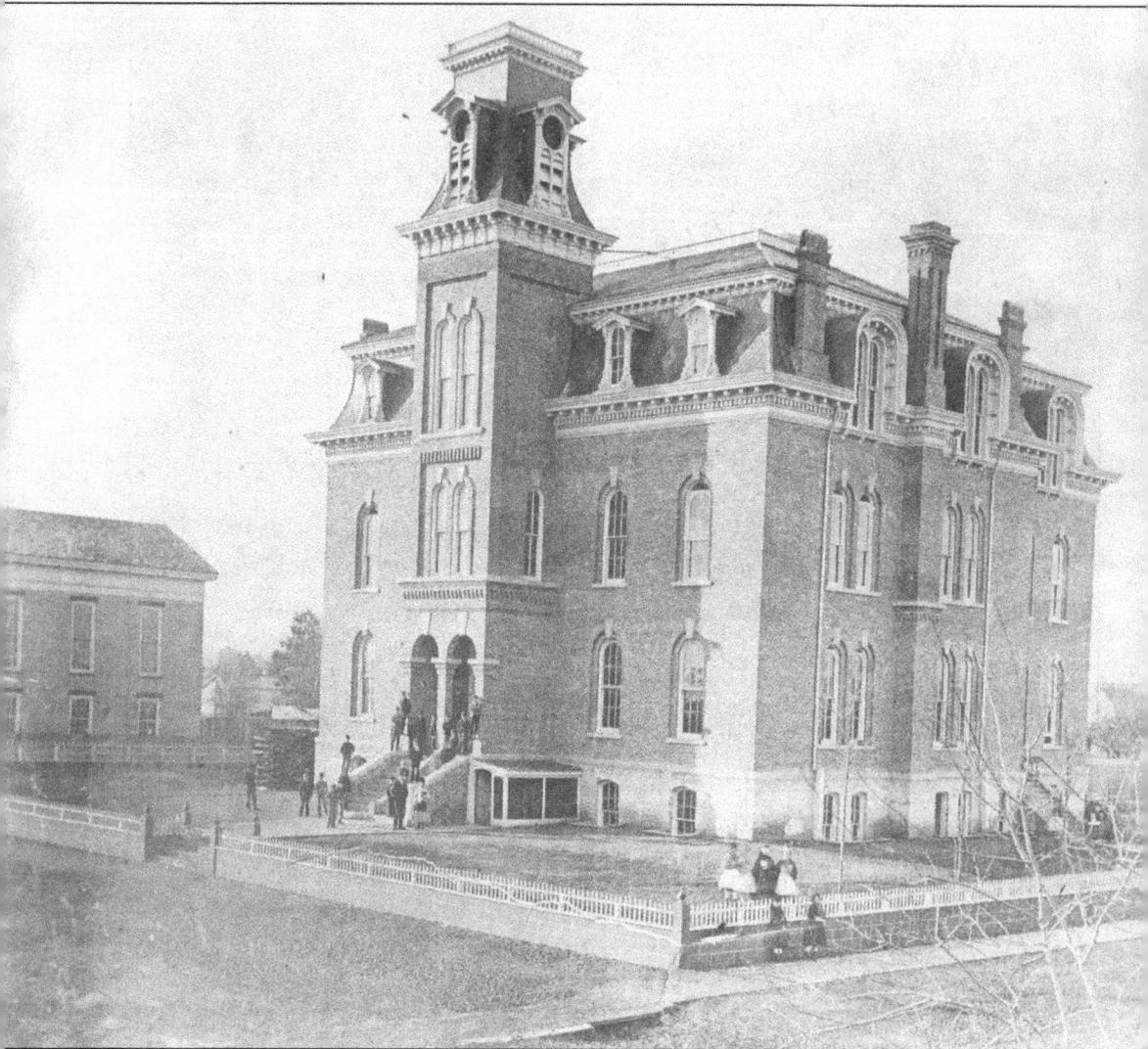

The "old" Central School is pictured here sometime prior to 1884. This building was raised in 1868, at the southwest corner of Second and High streets, for a cost of $45,000. It was the first school created for the purpose of housing all students in all grades. The first commencement exercises for Elkhart High School were held here in 1873—the graduating class was comprised of just five girls. With overcrowding issues becoming a primary concern by the 1880s, it became necessary to add an annex to the building in 1884. (Courtesy of Elkhart Public Library.)

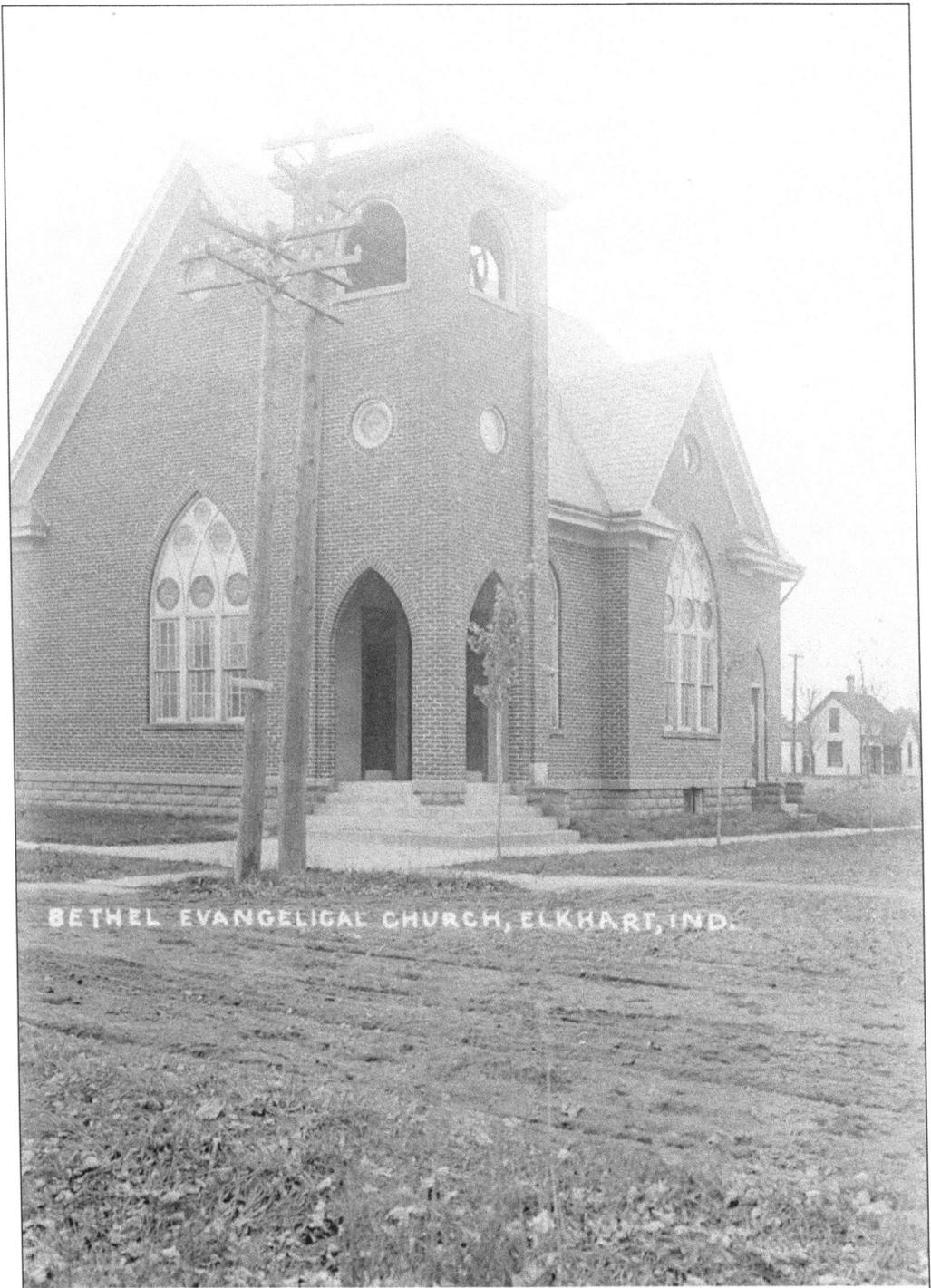

The Bethel Evangelical Church, located at the corner of Simonton and Michigan streets. The best approximation as to when this photo was taken is from the late 1800s to perhaps the early 1900s. It would seem that the church had just been built, as the lawn looks new, and there are freshly planted trees nearby. (Courtesy of Elkhart Public Library.)

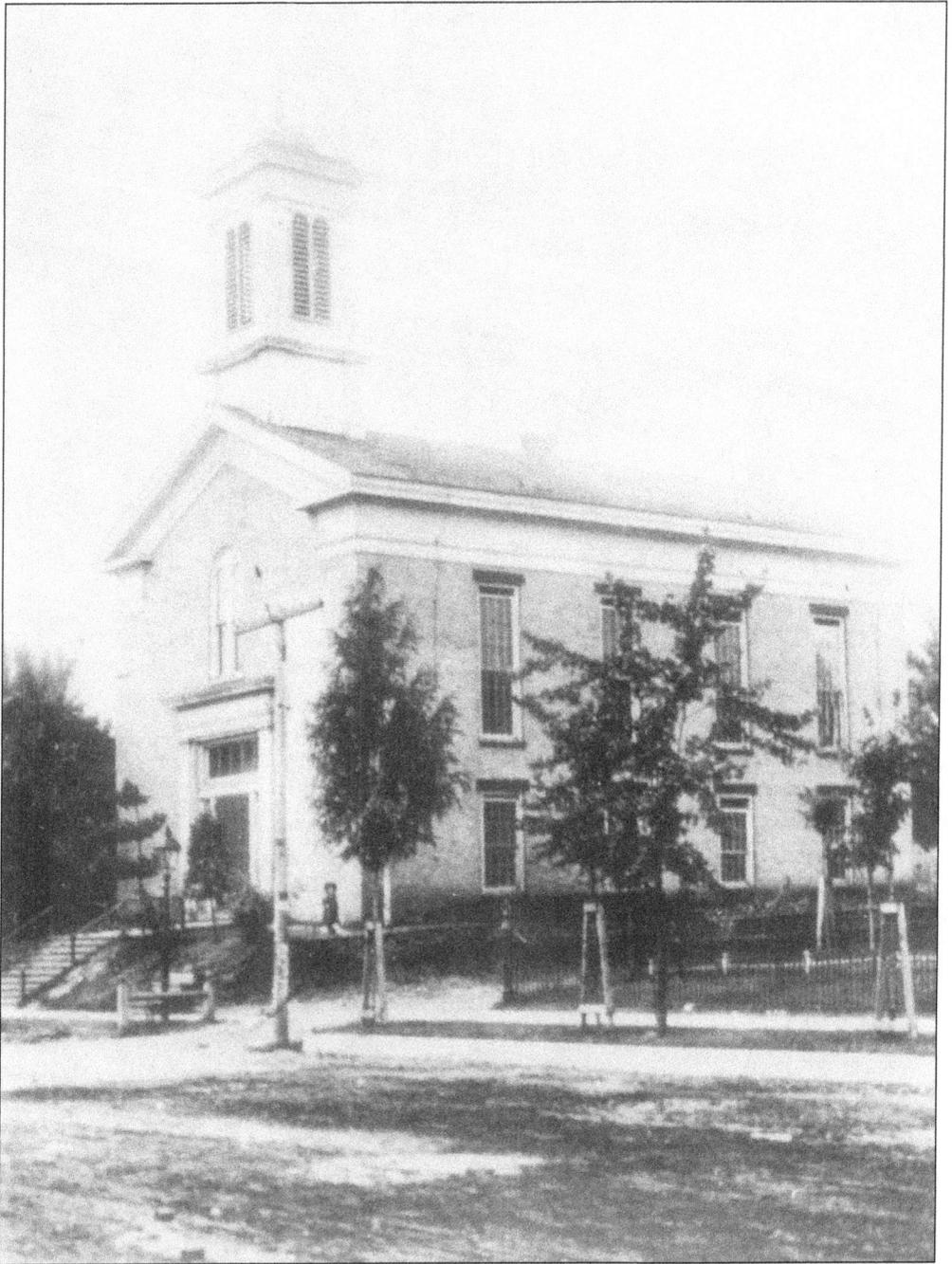

One of the city's earliest churches, this is the first Trinity United Methodist Church, which was located at 317 South Second Street. Construction of the church actually began in 1855, but it would be seven years before the project would reach completion, as storms and other obstacles caused building delays. By the late 1880s, the church could no longer accommodate a rapidly growing congregation. In 1888, several worshipers chose to form their own church, which would be called Willowdale Methodist. This church was torn down in 1889 to make way for a larger church. (Courtesy of Elkhart Public Library.)

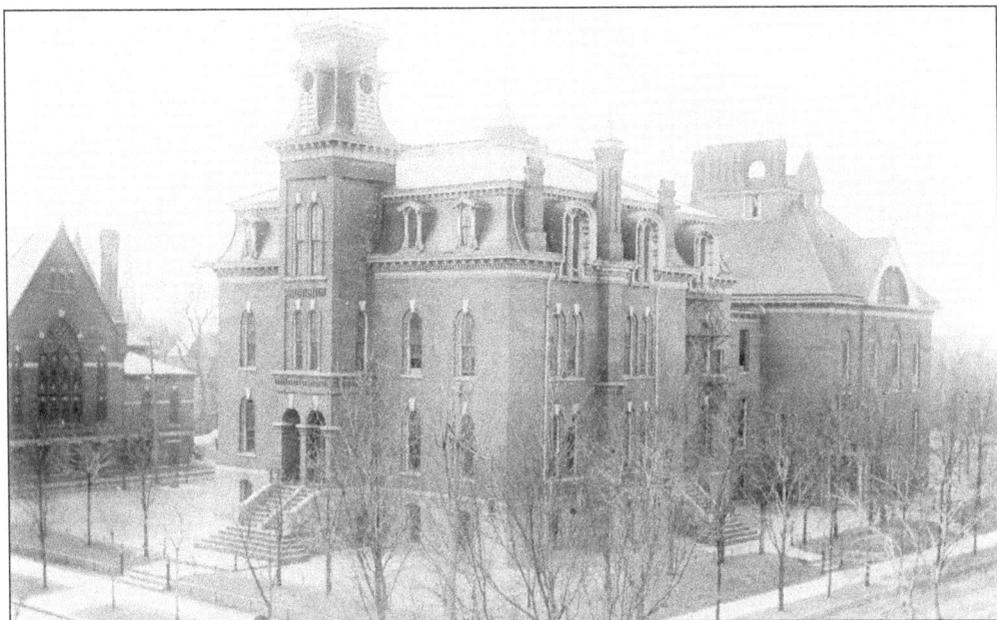

The first Central School building is shown here in a picture taken between 1890 and 1907. It was located at the southwest corner of Second and High streets. The original Central School, located in the foreground, was built in 1868, and once held students of all ages. But overcrowding became an issue in the mid-1880s, so the decision was made to build an annex to the rear of the structure. The annex provided space for eight additional classrooms, with a library, museum, and superintendent's office in the connecting link. (John Inbody photo, courtesy of Elkhart Public Library.)

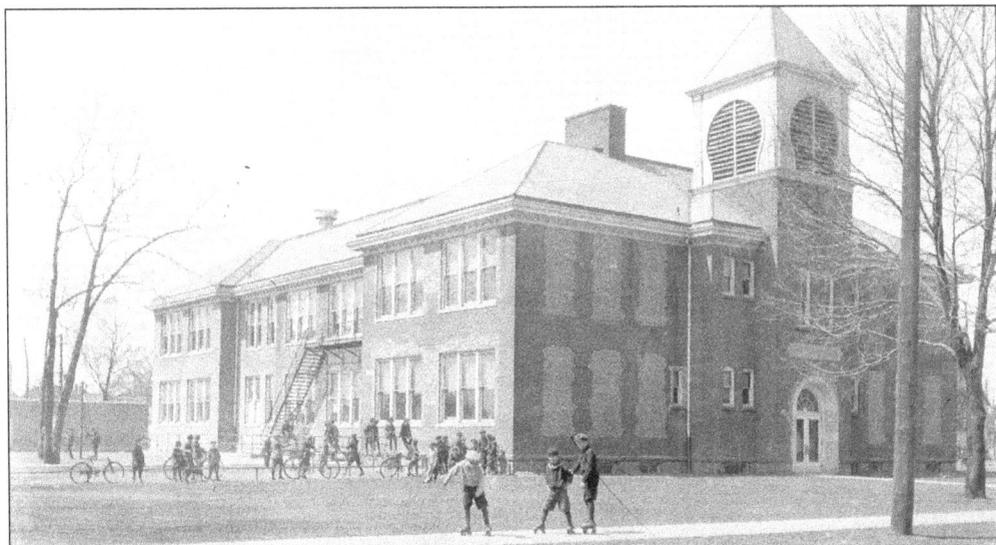

This is one of the city's first schools exclusively built for primary students, the Weston Elementary School, built in 1878. This was one of five elementary schools which were added to the Central School system by 1884. The other schools were Fourth Ward, Fifth Ward (later replaced by Roosevelt.), East Elkhart (later replaced by Rice.), and Beardsley. (Courtesy of Elkhart Public Library.)

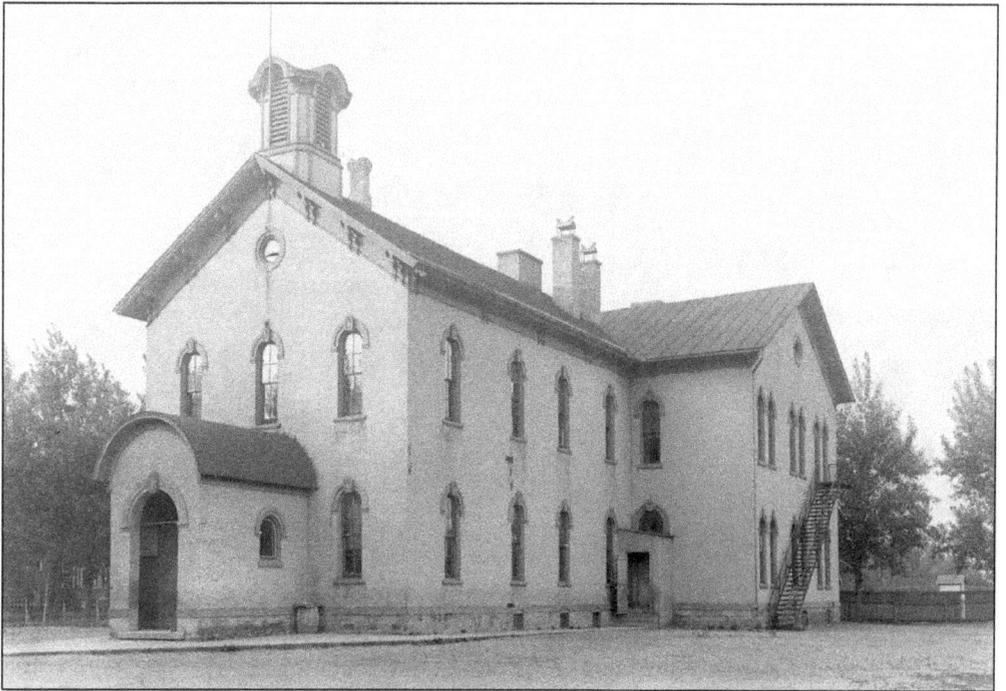

The Beardsley Elementary School, built in 1879 at the corner of Baldwin and Johnson streets. (Inbody photo, courtesy of Elkhart Public Library.)

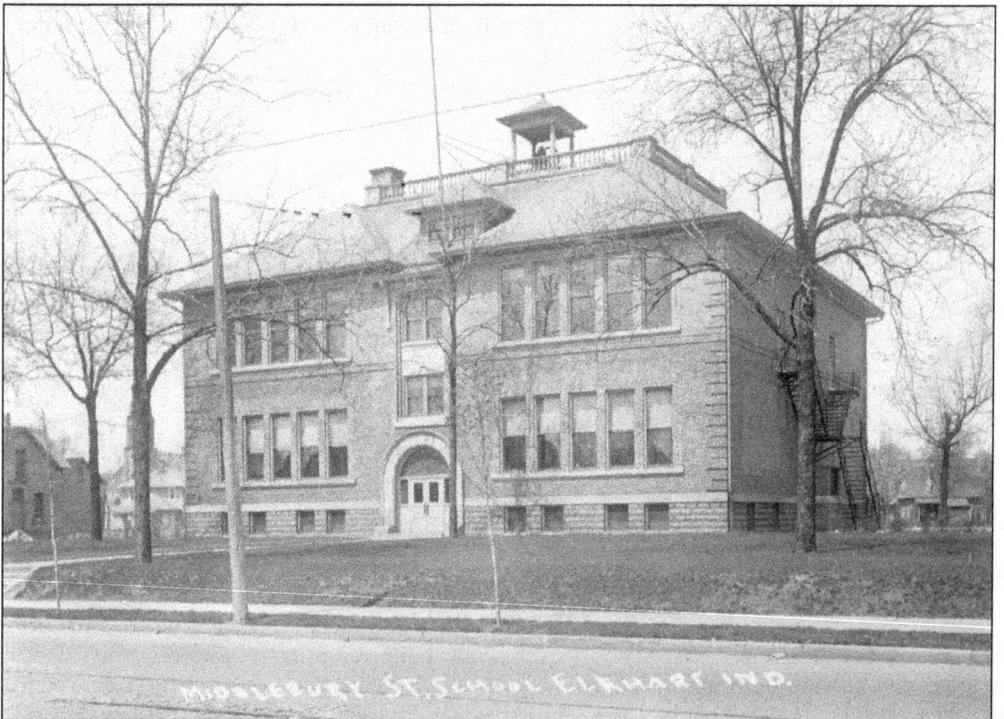

The Middlebury Elementary School, which was located at Middlebury and Prairie streets and was built in 1883. (Courtesy of Elkhart Public Library.)

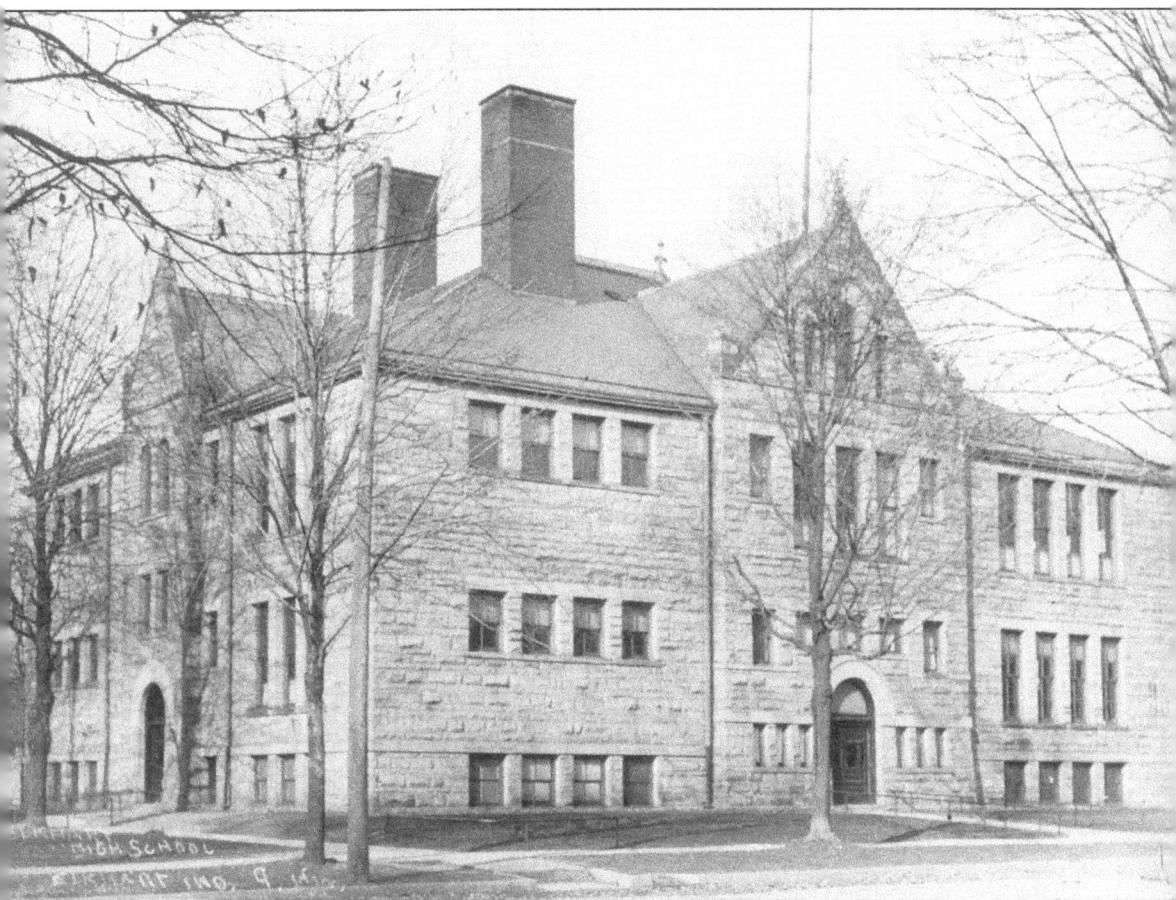

The first Elkhart High School, pictured c. 1892, was built at the intersection of Vistula Street and what was then called Pigeon Street, now Lexington Avenue. The school was situated on a unique triangular lot that once served as the site of Samuel Strong's home. The lot had been donated to the city for the purpose of erecting the new high school, a project which carried a price tag of $35,000. The stately structure was fashioned of Indiana limestone, and aside from the obligatory classrooms, there were four recitation rooms, a laboratory, biological and physical science rooms, a library, a superintendent's office, and an assembly room to seat 200. By the early 1910s, the need was already arising for another high school to be raised, so this first high school would become Samuel Strong Elementary. (Courtesy of Elkhart Public Library.)

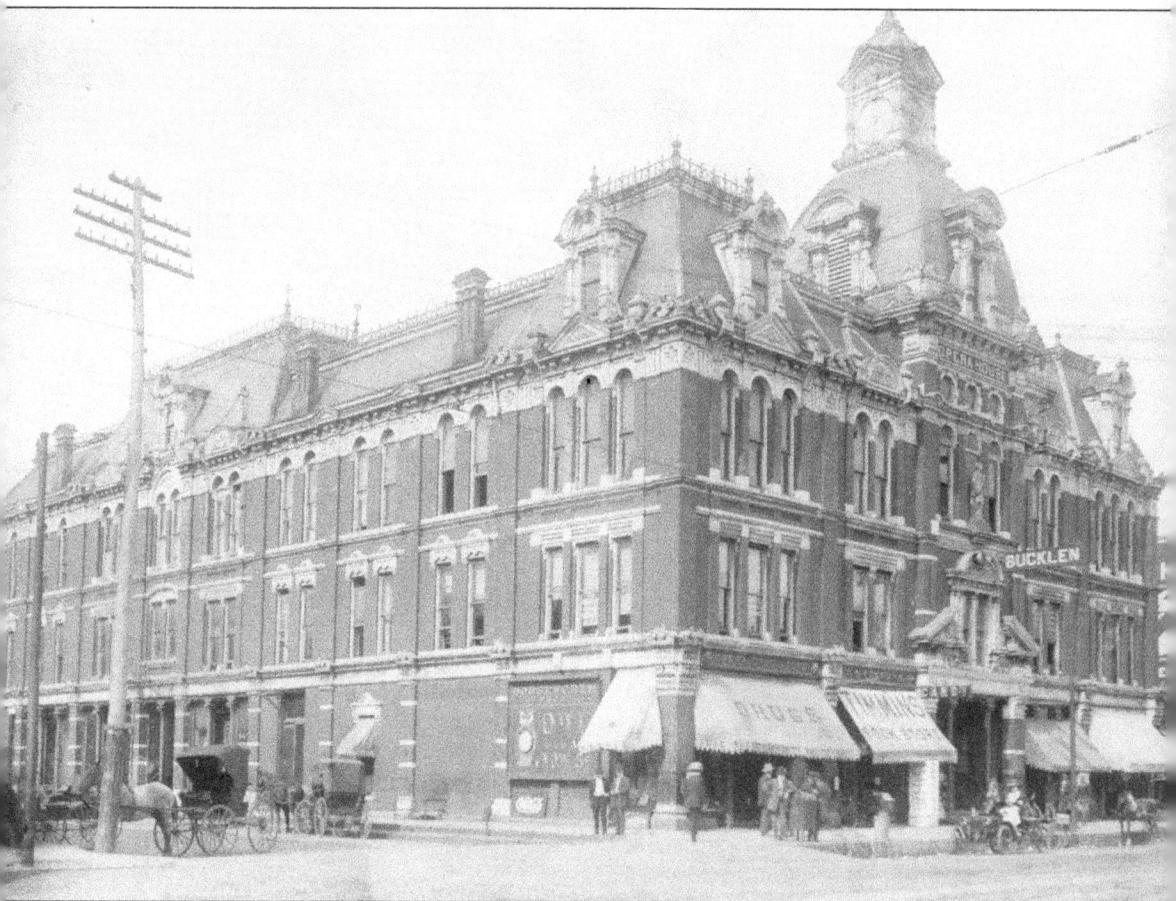

A magnificent building with an equally impressive legacy, this was the Bucklen Opera House, an opulent architectural marvel which was located at the northwest corner of Main and Harrison streets. It was built in 1884 and named for its owner, Herbert E. Bucklen. The Opera House had a seating capacity of 1,200 and in its heyday, welcomed such luminaries as Harry Houdini, Jenny Lind, and the orchestra of John Philip Sousa. The first motion picture to ever be shown in Elkhart was held here—admission was ten cents for a main floor seat and five cents to be seated in the balcony. By the 1940s, the Opera House was converted into a theatre, and later on, the Academy of Ballet Arts and the Warren School of Ballet conducted classes on the second floor. The third floor space was used by the Elkhart Symphony Orchestra as well. For a time, the main seating area of the first level was given over to retail space, but by 1986, there were increasing worries over the stability of the structure, due to years of neglect and disuse. It would be torn down that same year. (Courtesy of Elkhart Public Library.)

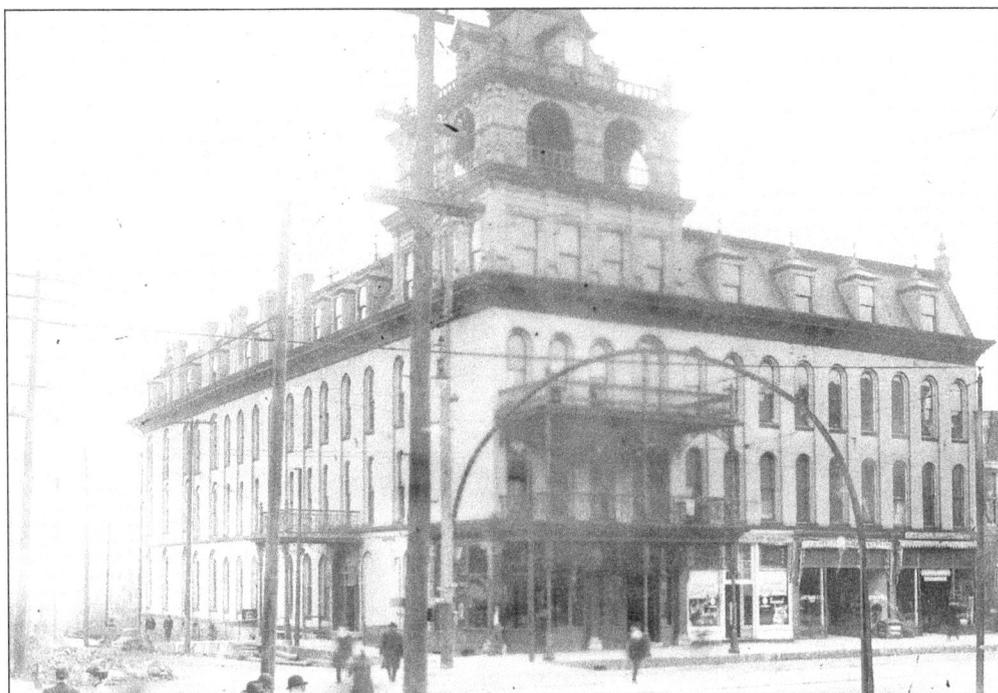

The Hotel Bucklen, pictured at the dawn of the 1900s. This is the same facility which was built in 1863 at the southeast corner of Main Street and Jackson Boulevard and originally called the Clifton House. When Herbert Bucklen purchased the property, he proceeded with a number of renovations, and unveiled the establishment in 1889 as the Hotel Bucklen. The newly refurbished hotel offered such extravagances as private baths, elevators, and a fine dining area. Another series of renovations took place in 1958, after a fire badly damaged the structure, and the hotel was christened with the name of its olden days—Clifton House. Another fire devastated the property in 1969, and this time, the building was too extensively crippled to serve any further purpose. It was leveled for good in 1973. (Courtesy of Elkhart Public Library.)

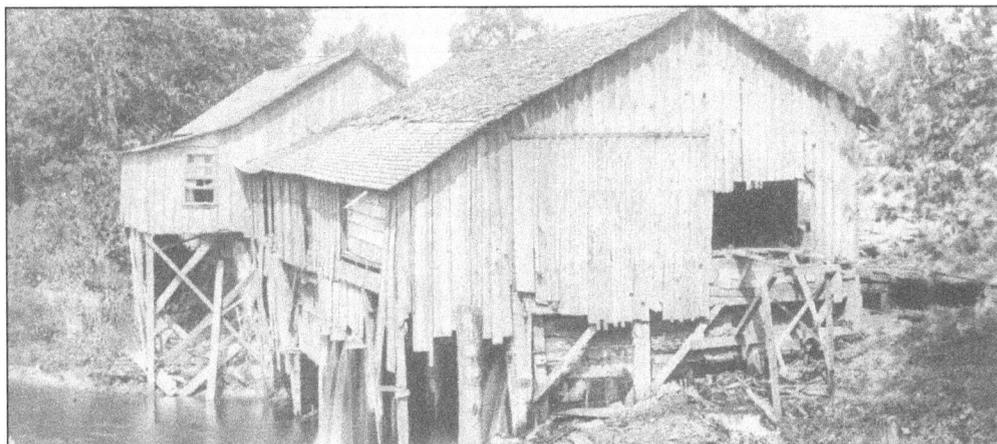

The old Arisman Saw Mill is seen here as it looked in 1885. The structure was built in 1868 to replace the original saw mill which had been built by Havilah Beardsley in 1831. It was located at the mouth of the Christiana Creek on the north bank of the St. Joseph River. (Courtesy of Elkhart Public Library.)

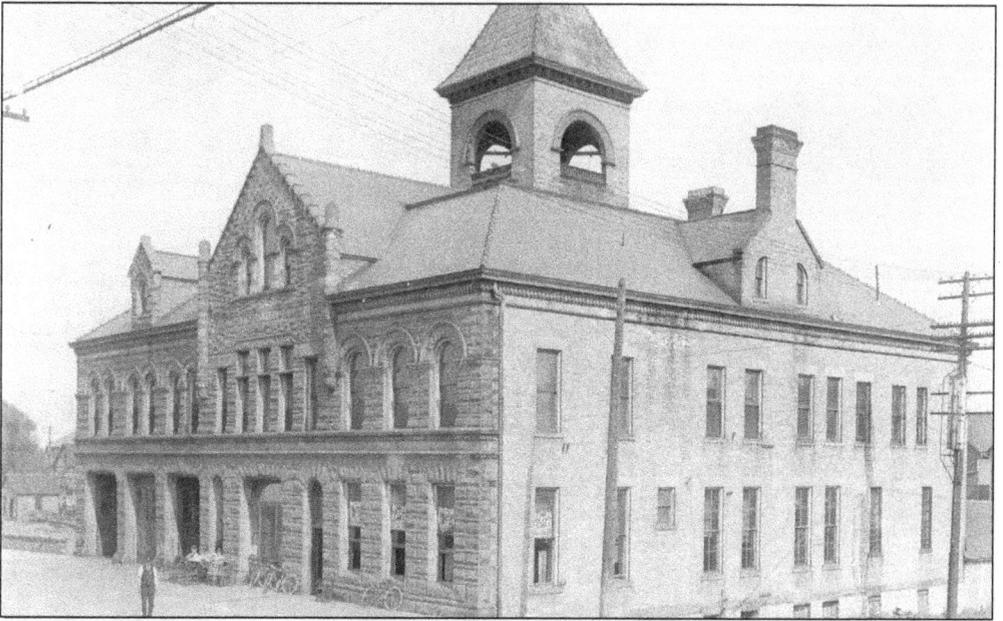

This building, once located on East Franklin Street, served as Elkhart's City Hall from 1895 until 1916. It was originally used to house the fire and police departments, but arrangements had been made to develop temporary quarters for the municipal government, including the city clerk, treasurer, judge, and council chambers. That "temporary" setup lasted for 21 years, until a new municipal building was unveiled in 1916. (Courtesy of Elkhart Public Library.)

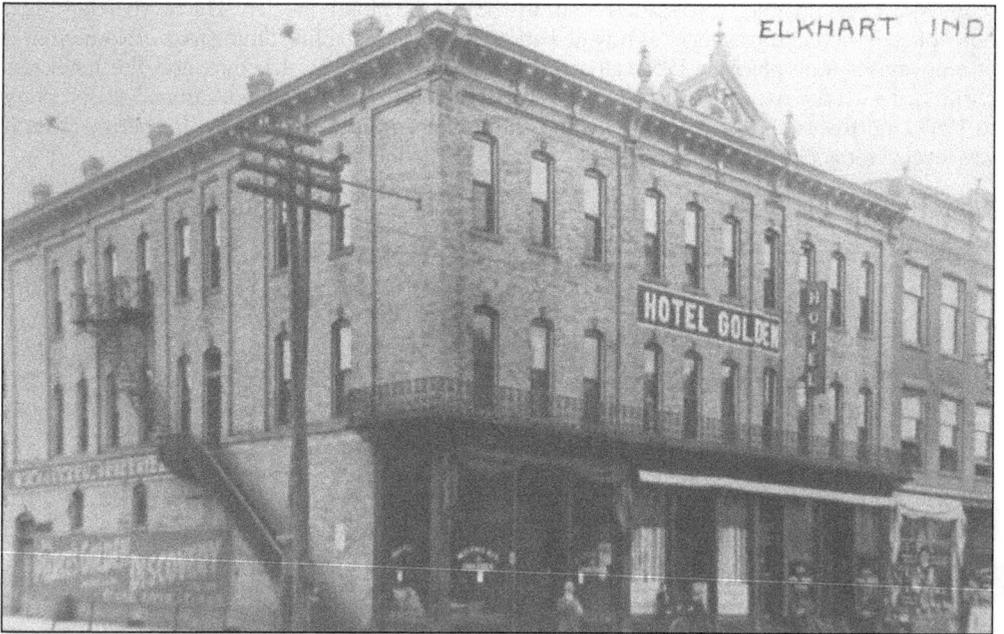

This was the Central Block Building, which was erected in 1888 and was first the site of the Hotel Golden. It was located at the southeast corner of Main and Division streets. Rooms could be rented for the extravagant price of a dollar a day, or four dollars for a week's lodging. (Courtesy of Time Was Museum.)

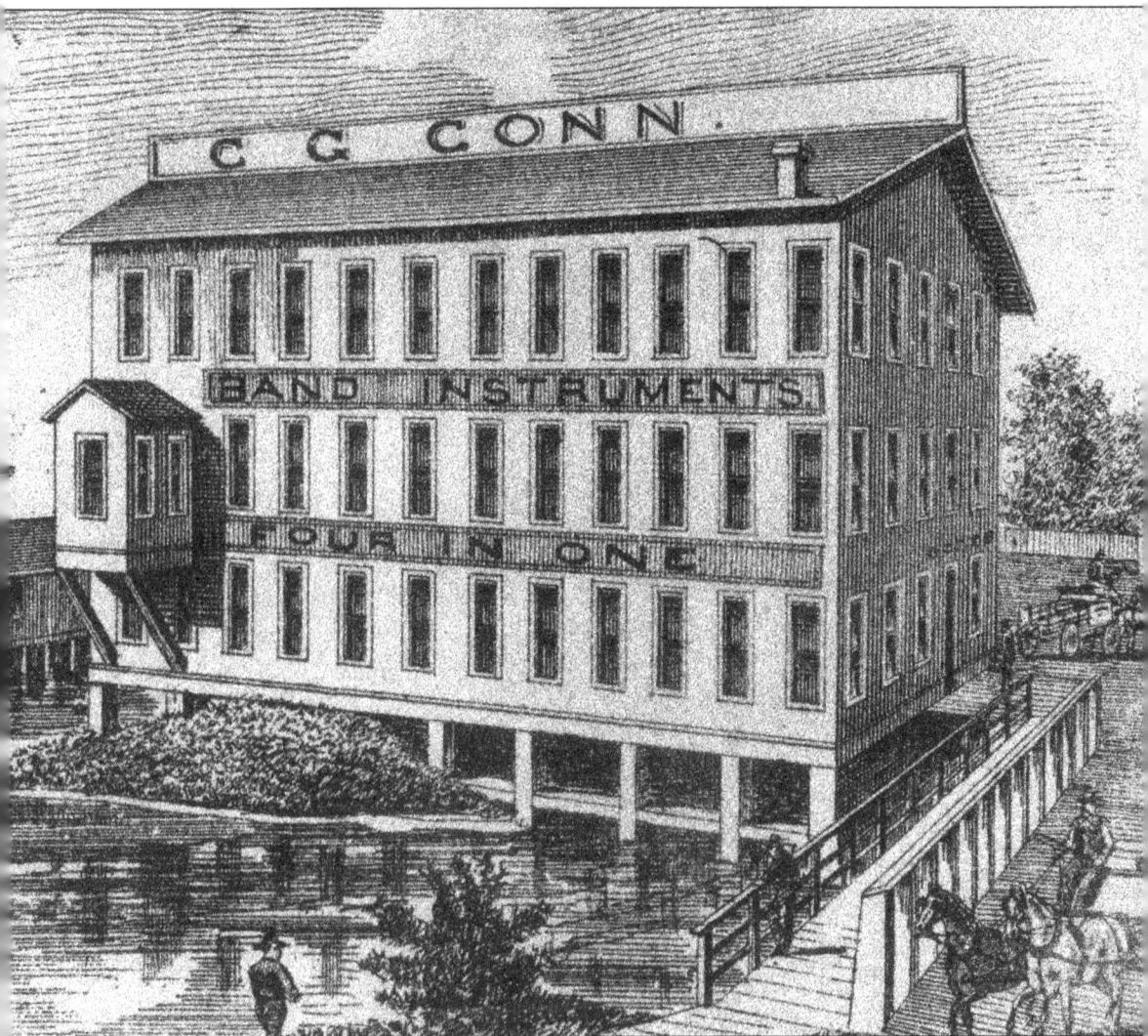

This is a sketch of the first C.G. Conn Band Instrument factory, which was situated at the corner of Jackson Boulevard and Elkhart Avenue. Charles Gerard Conn began his enterprise in 1873 by fashioning rubber cushioned mouthpieces for musical instruments. Conn discovered his inspiration through a most unusual means. He had been involved in an altercation, from which he emerged with a severely lacerated lip. When the wound had healed, the resulting scar rendered Conn unable to resume playing his cherished cornet. So he simply chose to invent his own unique specialty mouthpiece, and a legendary Elkhart business was created. He began his new enterprise in 1873 by fashioning his rubber cushioned mouthpieces for use in other types of musical instruments. By 1875, he broadened his field of expertise by manufacturing other instruments as well. His factory was responsible for the production of the nation's first cornet and also the Sousaphone. This factory was built in 1877 to accommodate the rapidly growing business but the building was lost to a fire in 1883. (Courtesy of Elkhart Public Library.)

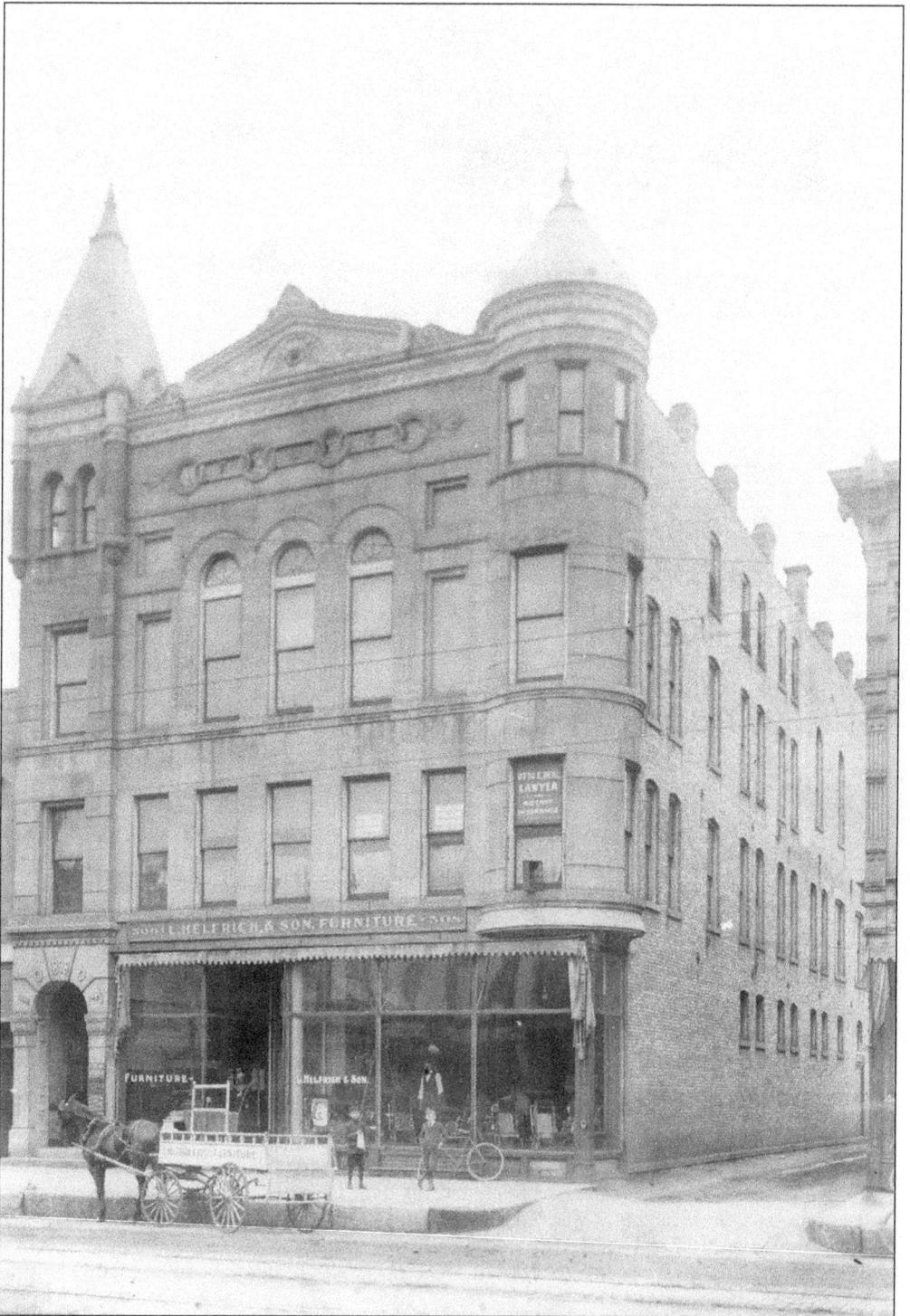

L. Helfrich & Son Furniture, which was located at 506–508 South Main Street. This is how the store appeared in the early 1910s. The business shared space in the same building as the International Order of the Odd Fellows, or IOOF. (Courtesy of Elkhart Public Library.)

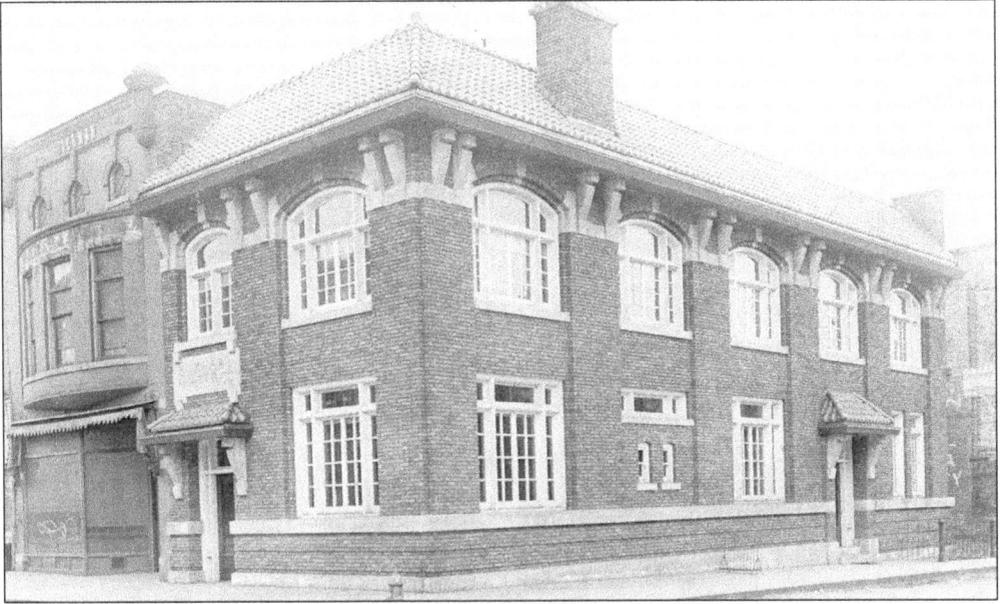

The City Water Works, in this undated photo, showing its façade along the South Main Street corridor. Another one of E. Hill Turnock's creations, the "Elkhart Water Co." etching is clearly visible on the building yet today. (Courtesy of Elkhart Public Library.)

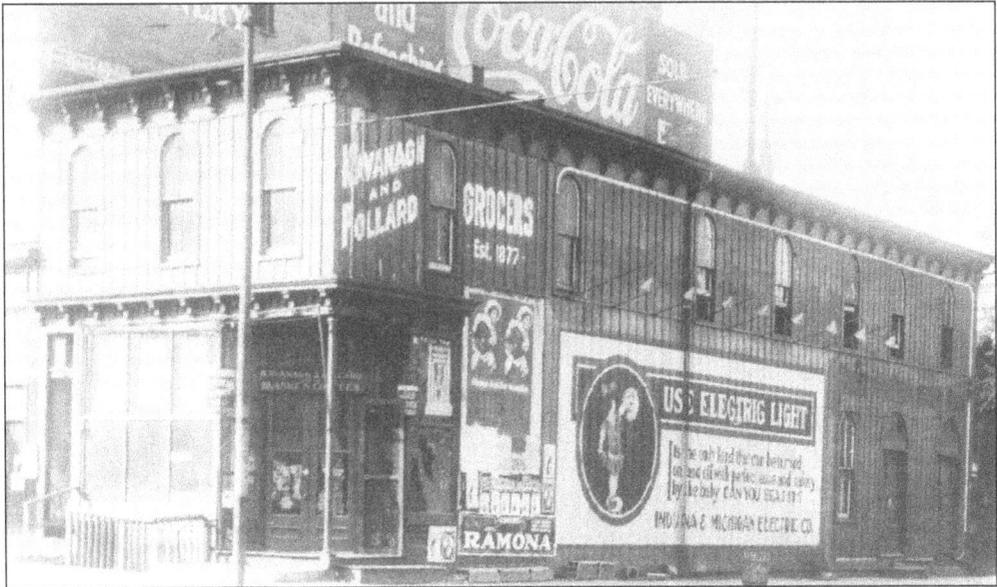

Kavanagh & Pollard's Elkhart Palace Grocery Store, at the southwest corner of Main and High streets. Built in the early 1860s under the ownership of Hiram Goodspeed, the building was first used as a wagon shop. Hiram's son, Americus, teamed up with James Kavanagh to reinvent the business as a grocery store. Goodspeed later sold his share to John B. Pollard, hence the business name and partnership of Kavanagh & Pollard. When both men died in the mid 1910s, the store was sold to C.G. Conn, then to Herbert Bucklen. The First National Bank purchased the property from the Bucklen estate in 1917, tore down the building, and built a new facility to be used as their new bank home. (Courtesy of Elkhart Public Library.)

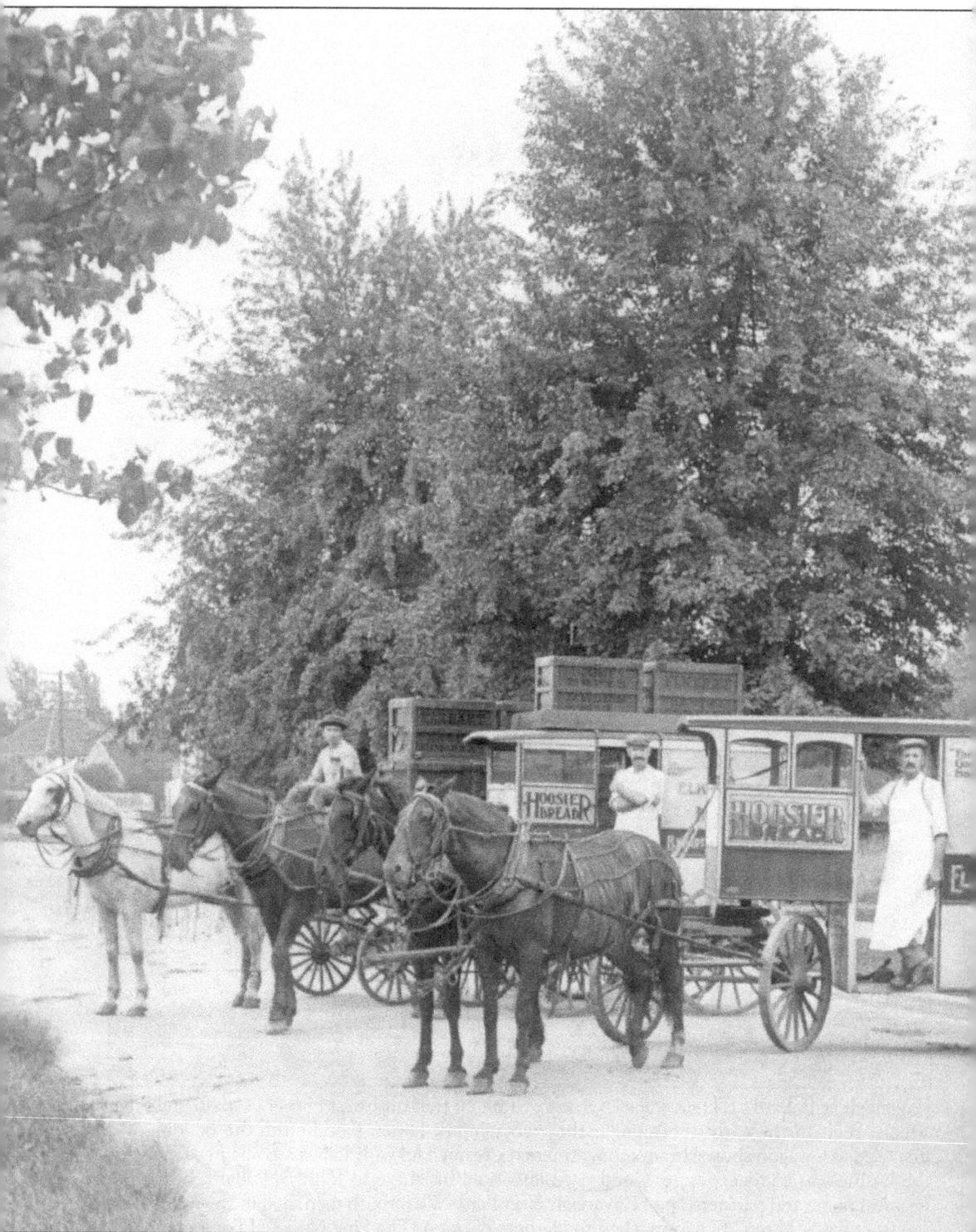

This early 20th-century tableau shows a number of horse drawn delivery wagons awaiting baked wares from the Elkhart Baking Company. The business was located at 1315 Princeton.

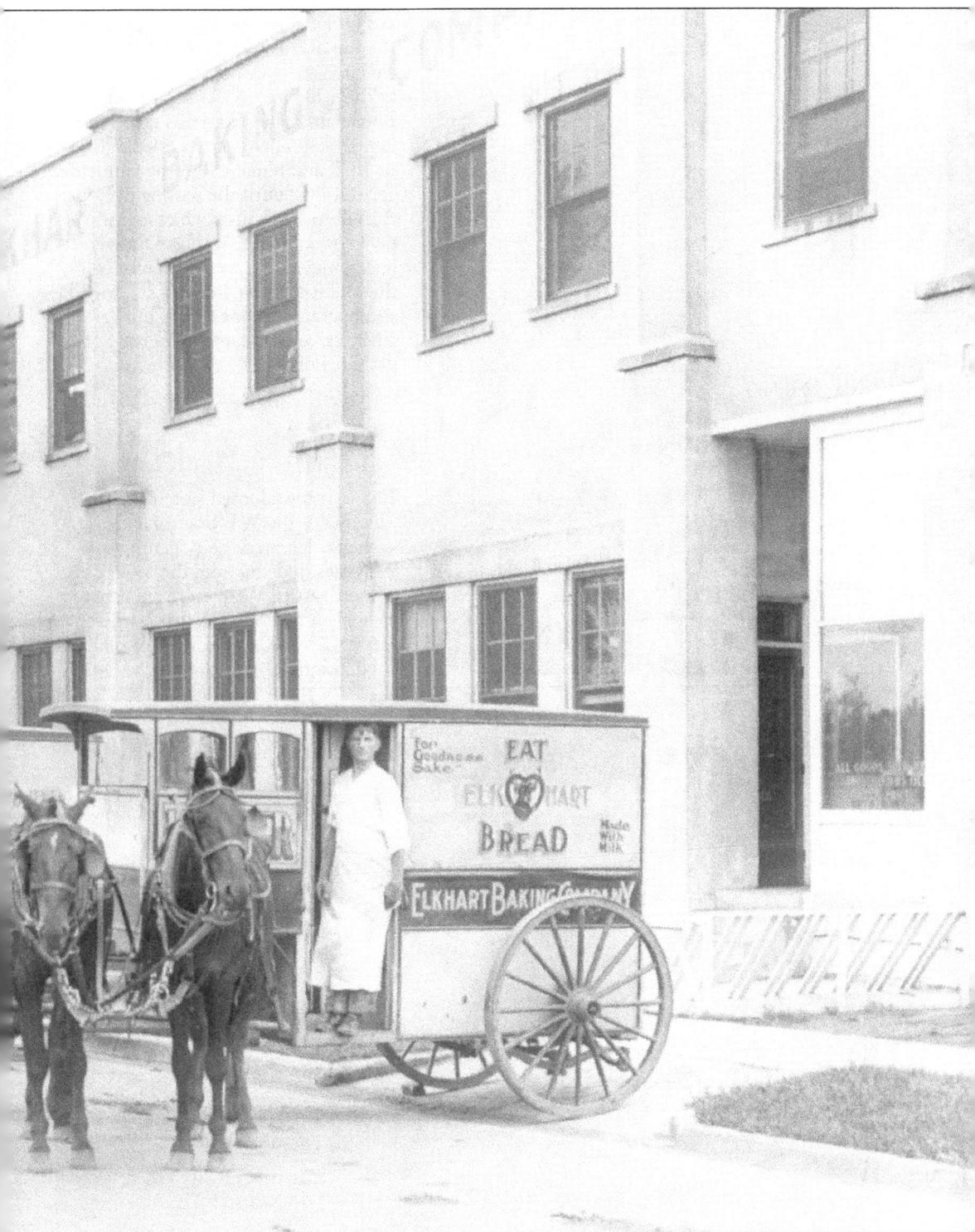

The elegantly scripted signage on the side of the wagons urges all would-be customers to "Eat Elkhart Bread." (Courtesy of Elkhart Public Library.)

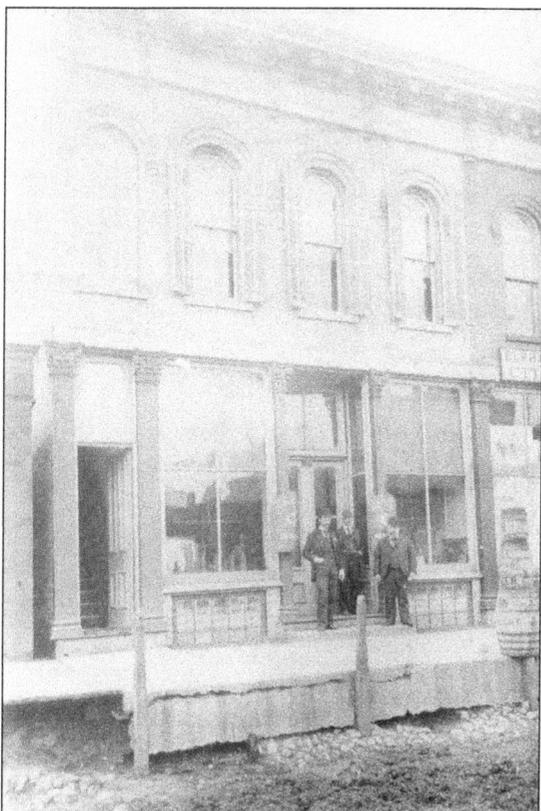

An undated photo showing a day in the life of Russell's Tavern, a favorite camaraderie spot on the south side of the 100 block of West Jackson Boulevard. The photo was taken in the late 1800s. The tavern was established in 1872 and remained in the family for generations, until the passing of Robert Russell in 1985, after which point the tavern would close its doors forever. It had achieved the recognition of being the oldest tavern continuously owned and operated by one family in the entire state of Indiana. (Courtesy of Elkhart Public Library.)

The stylishly adorned storefront windows of the W.F. Stanton Co., as they celebrated their opening day festivities. Judging from the look of the women's attire, the picture appears to have been taken in the very earliest part of the 1900s. (Courtesy of Elkhart Public Library.)

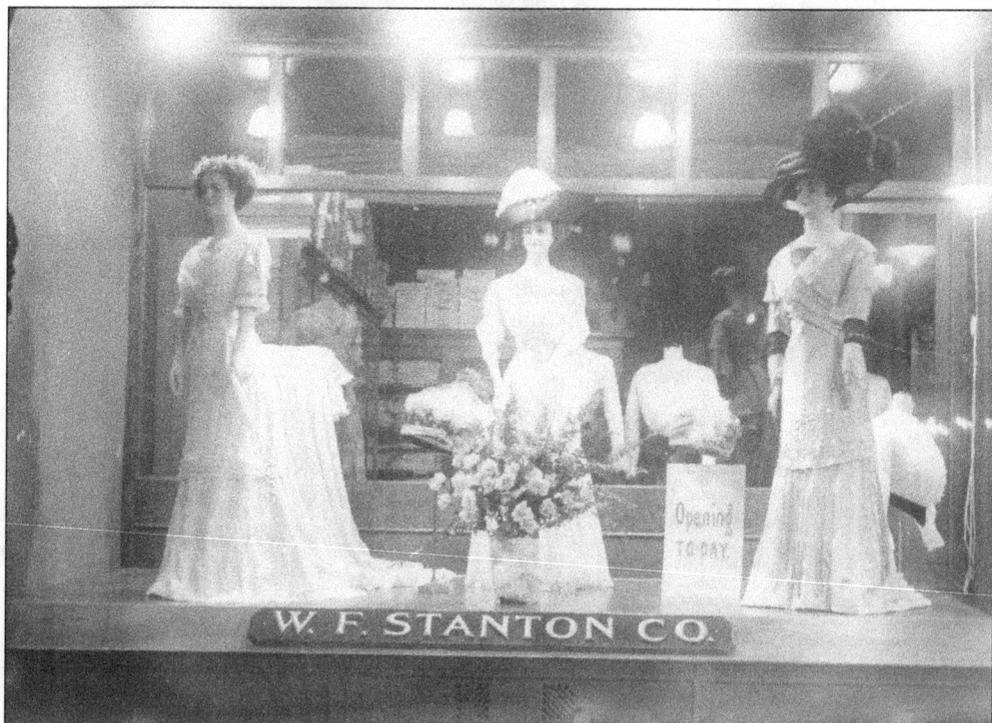

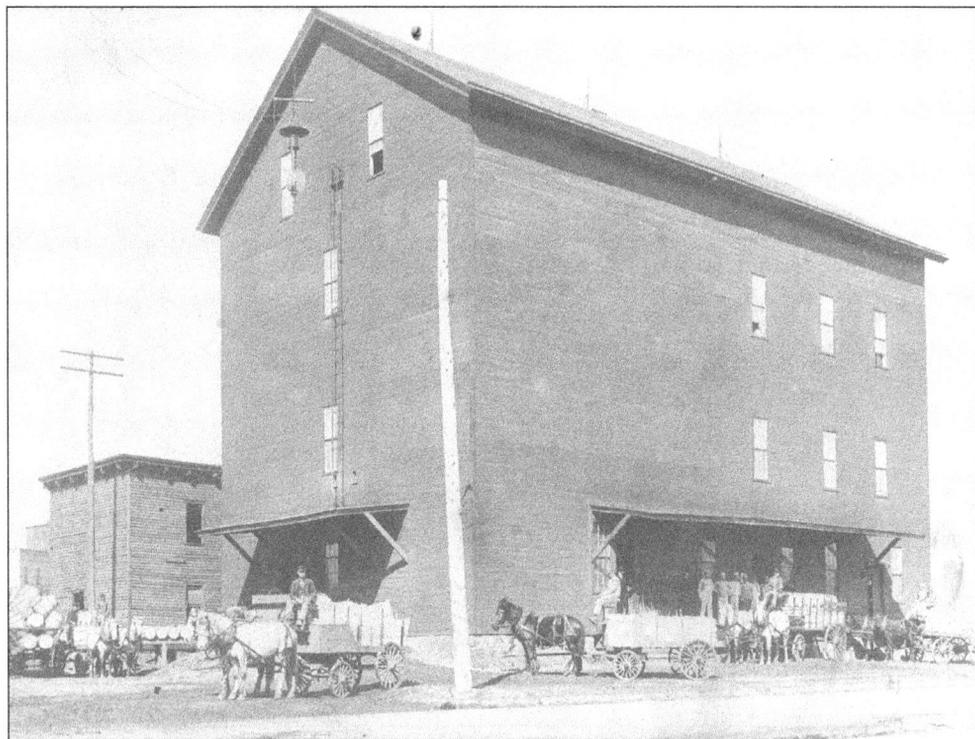

The old Sage Grist Mill, built in the early to mid 1800s, during the time of Elkhart's earliest settlers. It was later renamed the Harvest Queen Flour Mill, and it was located at the northeast corner of Elkhart Avenue and East Jackson Boulevard. It was owned by the Sage Brothers—a fire would destroy the facility in 1909. (Courtesy of Elkhart Public Library.)

A "bird's eye view" of Jackson Boulevard, taken in the fall of 1890. The Burrell Morgan Flour and Feed Mill can be seen in the distance. (Courtesy of Elkhart Public Library.)

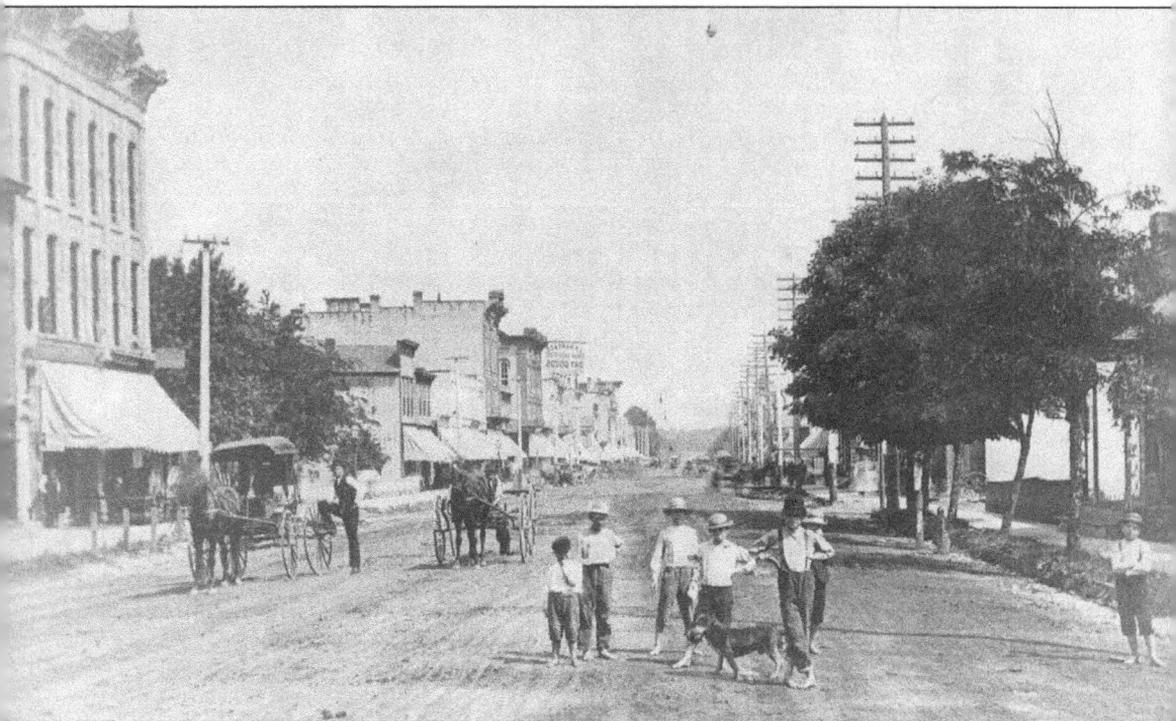

Looking north on Main Street, south of the corner of Franklin Street, in 1884. Not yet paved, it would be another two years before streetcar tracks would be laid—in following years the main roads were first paved with cedar blocks, then bricks. In those days, no one paid much mind to a group of young boys playing in the middle of the street. This is believed to be one of the very earliest photographs taken of downtown Elkhart. (Courtesy of Elkhart Public Library.)

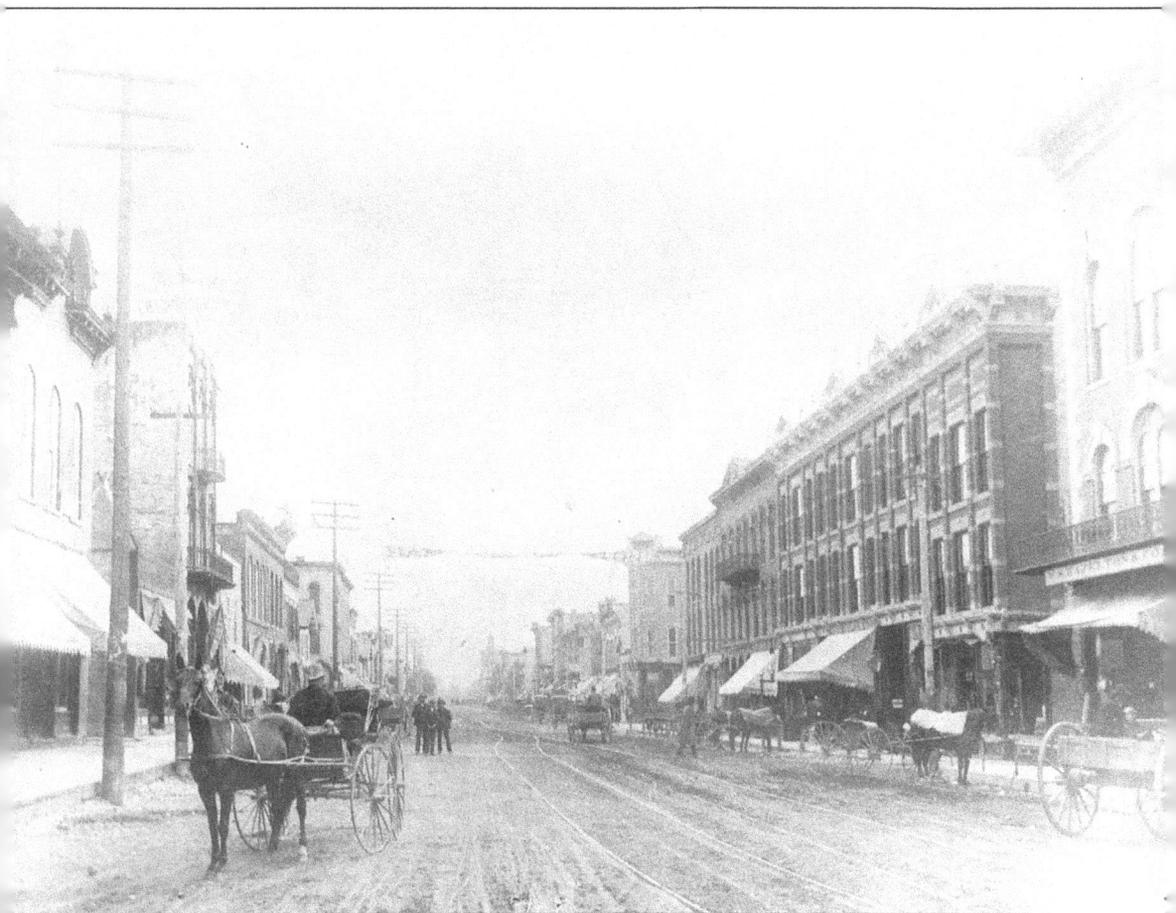

A view of Main Street, looking south from Jackson Boulevard, in 1888. (Courtesy of Elkhart Public Library.)

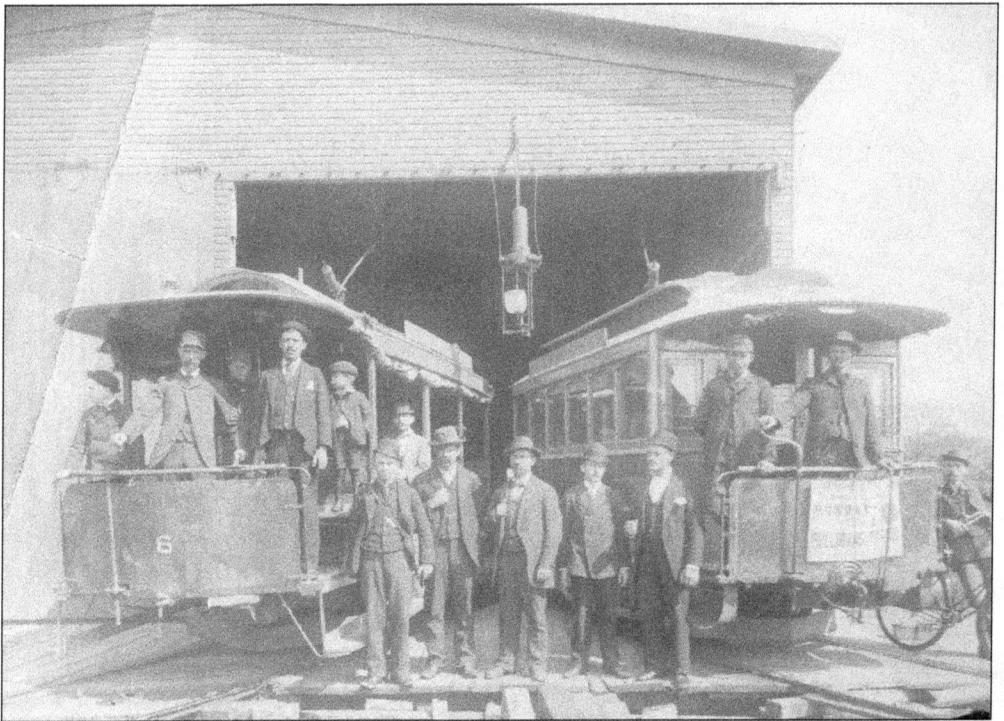

The city's first electric streetcars, shown at the original car barn on East Jackson Boulevard in 1889. (Courtesy of Elkhart Public Library.)

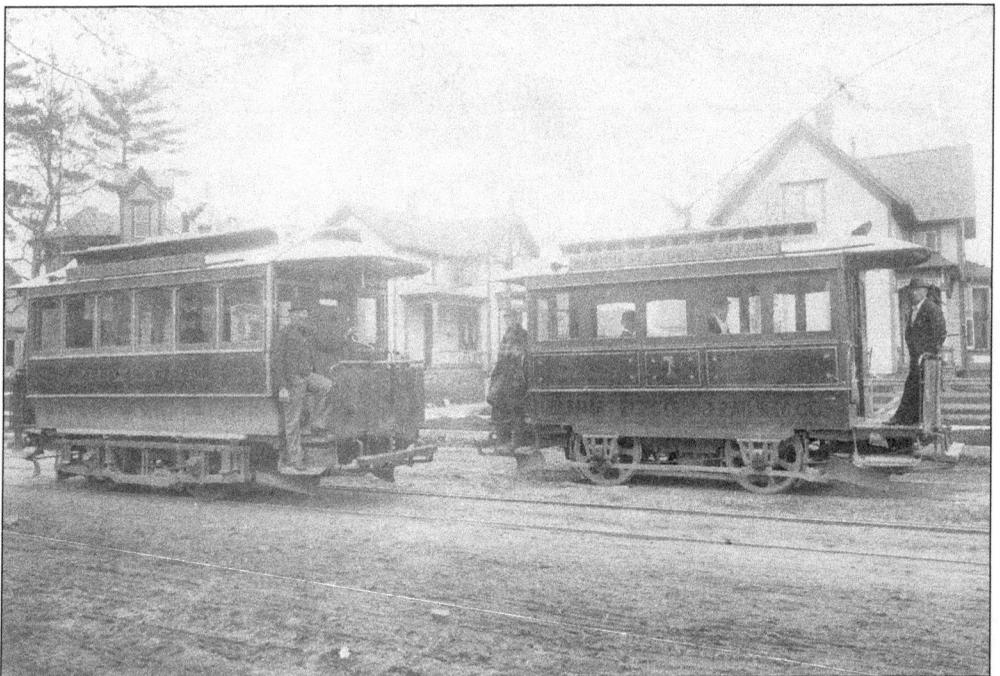

A pair of old interurban streetcars mosey along one of Elkhart's streets, in this undated photo. (Courtesy of Elkhart Public Library.)

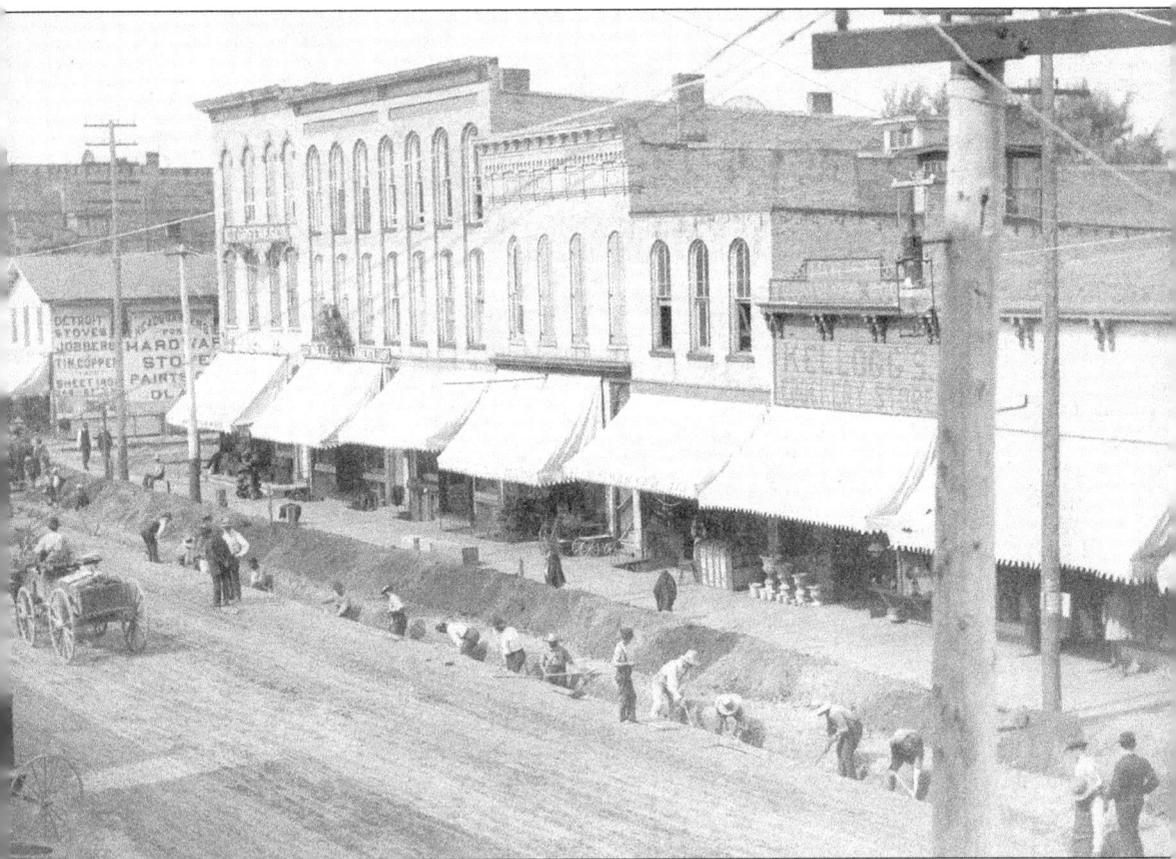

Workers feverishly dig to help install a new section of water main along Main Street. This vantage point is from the corner of Lexington Avenue and Main Street, looking north. The era is the late 1800s. (Courtesy of Elkhart Public Library.)

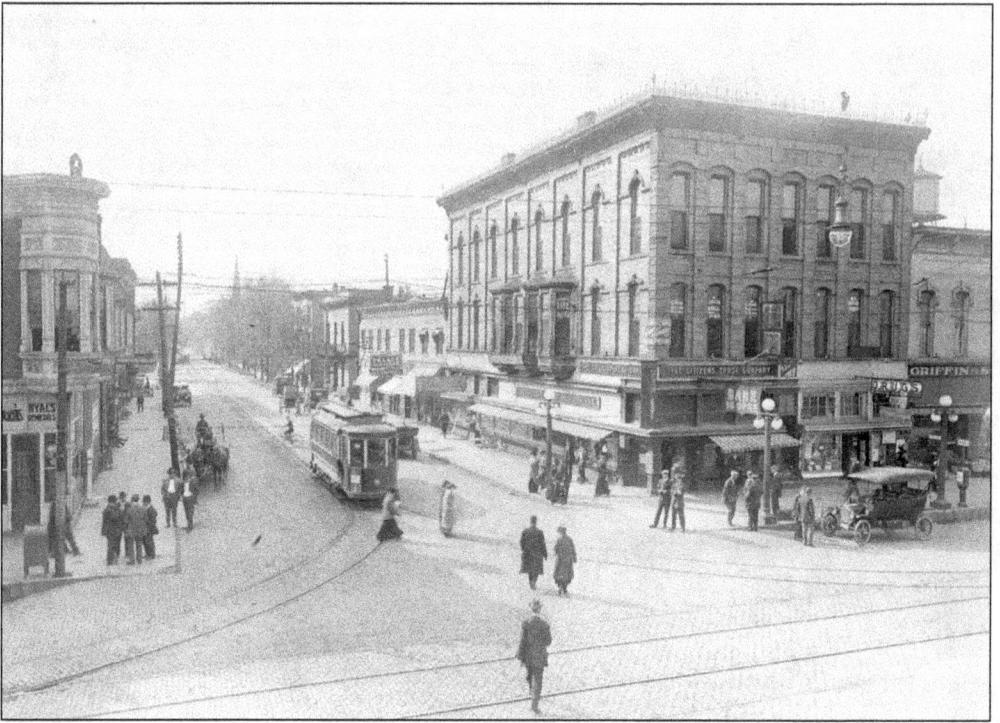

The intersection of Main and Marion streets, pictured at about the turn of the 20th century. The view is looking west from Main Street—this crossroads was referred to as the "Transfer Corner." (Courtesy of Elkhart Public Library.)

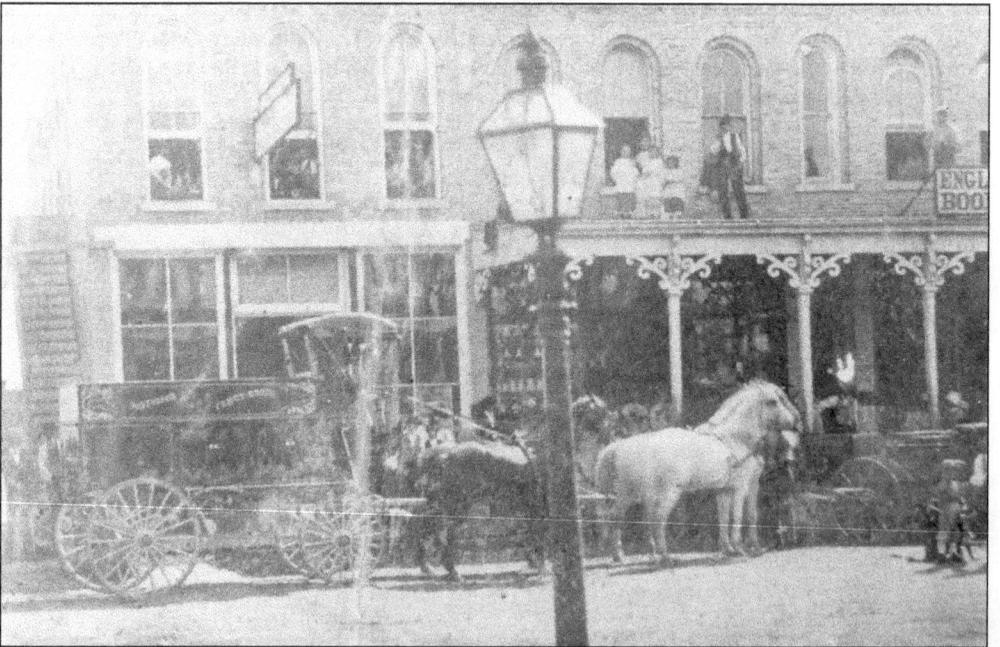

This image demonstrates a typically busy day in downtown Elkhart, as it appeared prior to 1900. (Courtesy of Elkhart Public Library.)

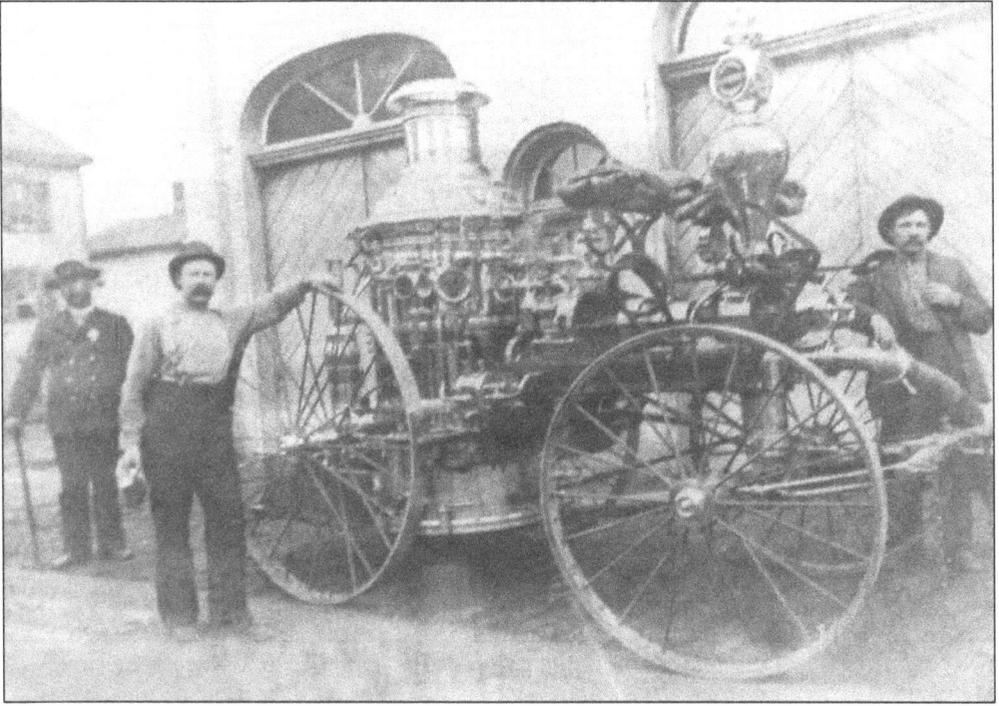

This is one of the very first images known to be captured of an early fire engine for the city of Elkhart. According to an inscription at the bottom of the photo, this engine was used during the Spanish-American War, which dates the picture to approximately the late 1800s. (Courtesy of Time Was Museum.)

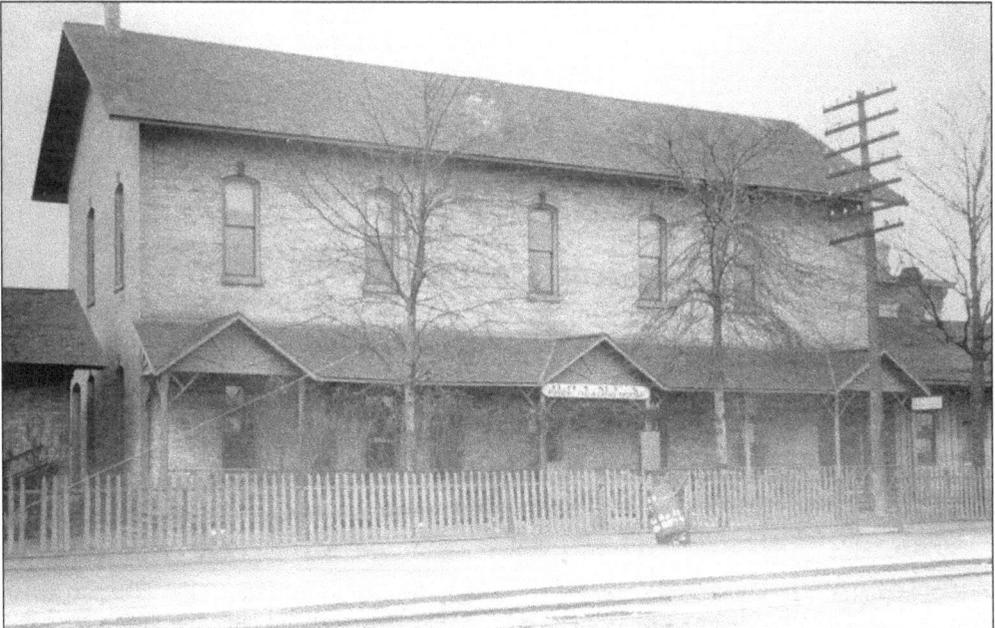

The first railroad YMCA building, just east of the Lake Shore and Michigan Southern depot, on the south side of Tyler Avenue was built in 1884. (Courtesy of Elkhart Public Library.)

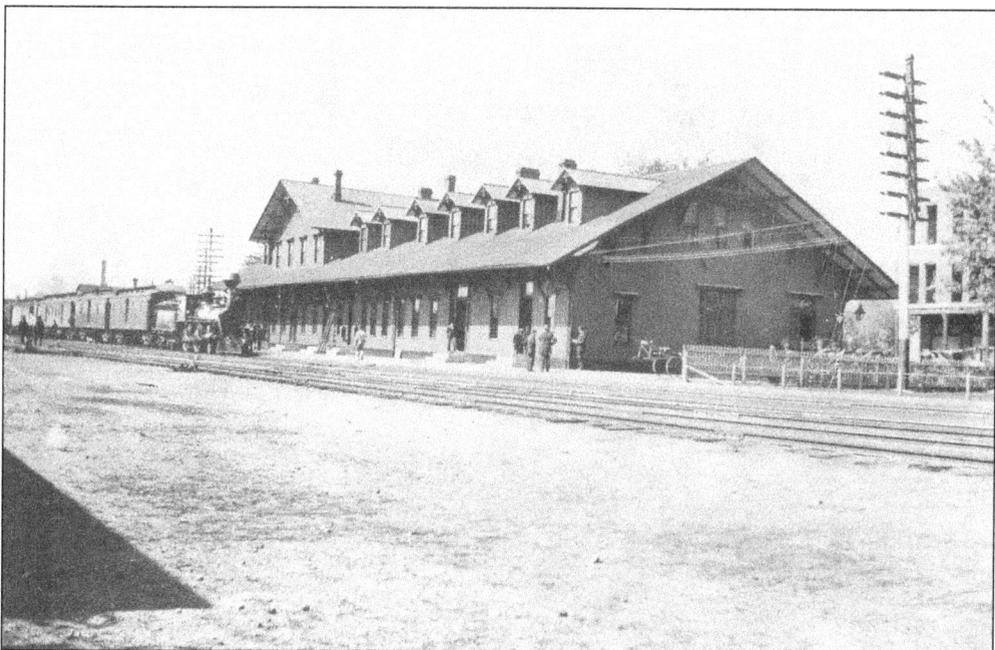

A locomotive makes a stop in Elkhart, in a photo dated simply: 1886. (Courtesy of Time Was Museum.)

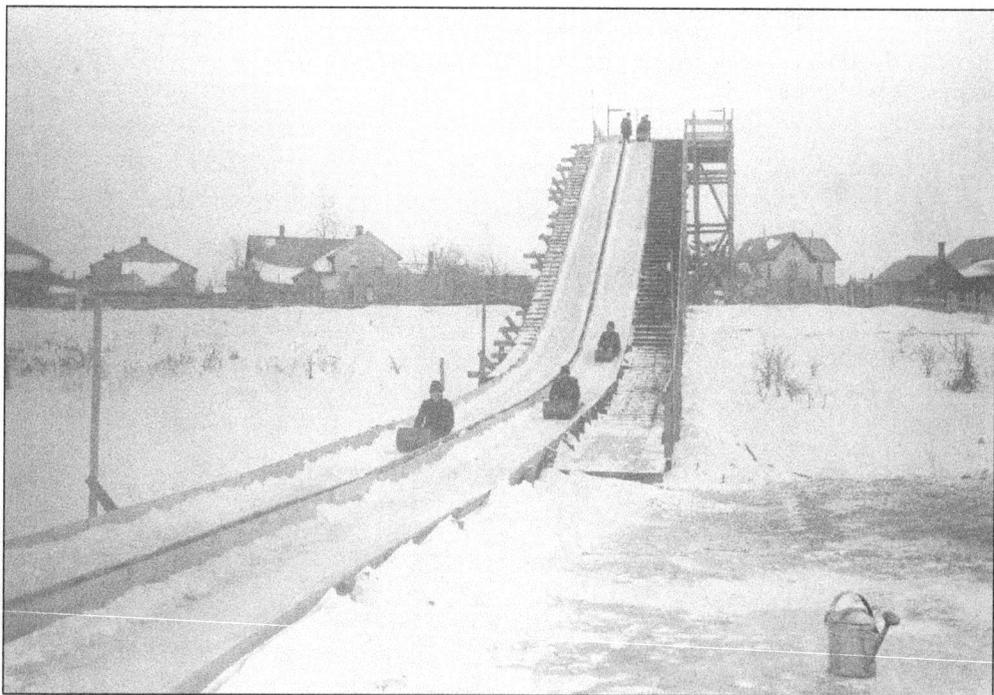

One of Elkhart's first toboggan slides, a fad that swept the area in the late 1800s. This particular slide was built in 1887, near Vistula Street. The ride's creators would charge a nickel per ride. But once the craze ended, so did the interest in the slides—most disappeared shortly thereafter. (Courtesy of Elkhart Public Library.)

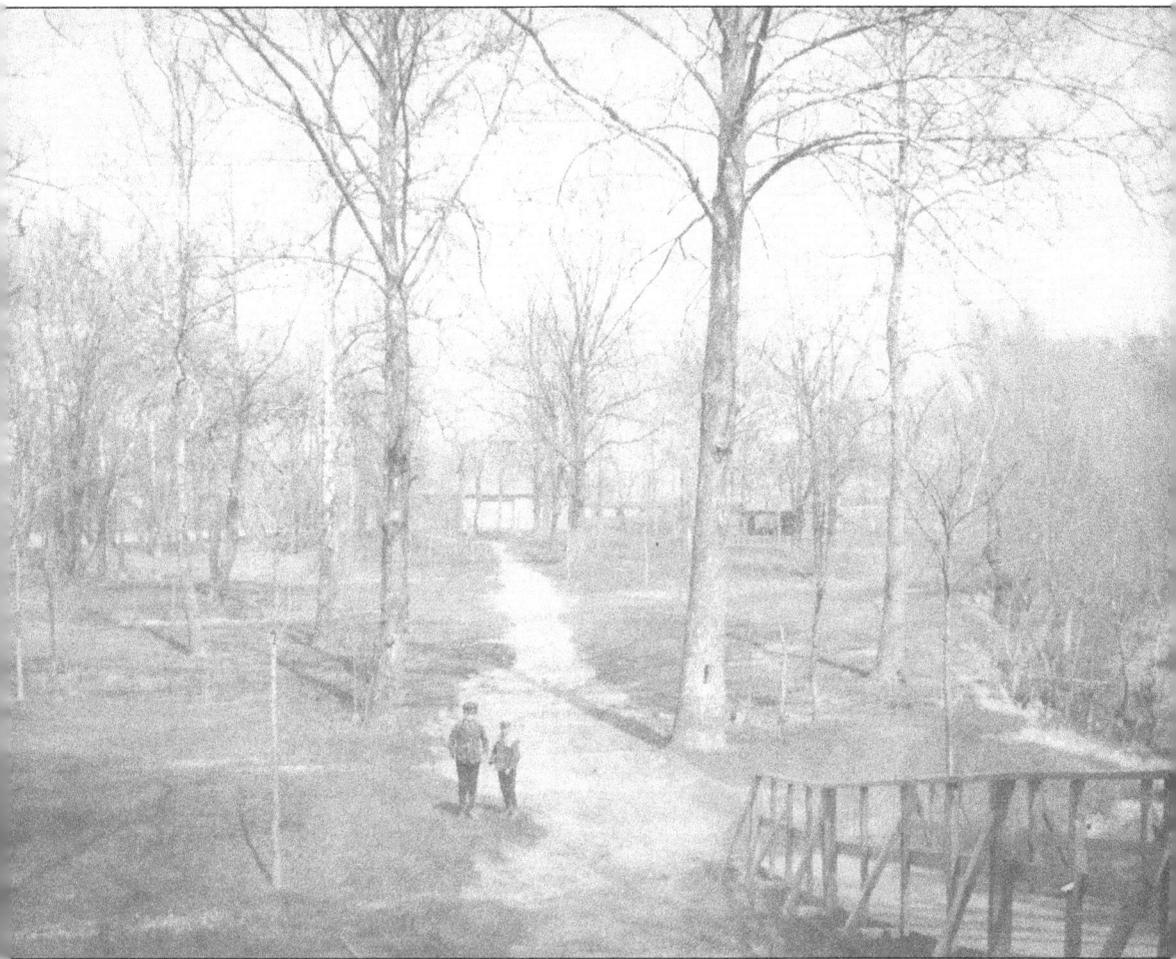

Island Park is seen here, sometime in the late 1800s, judging by the young boys' attire and the style in which the original picture was mounted. (Courtesy of Elkhart Public Library.)

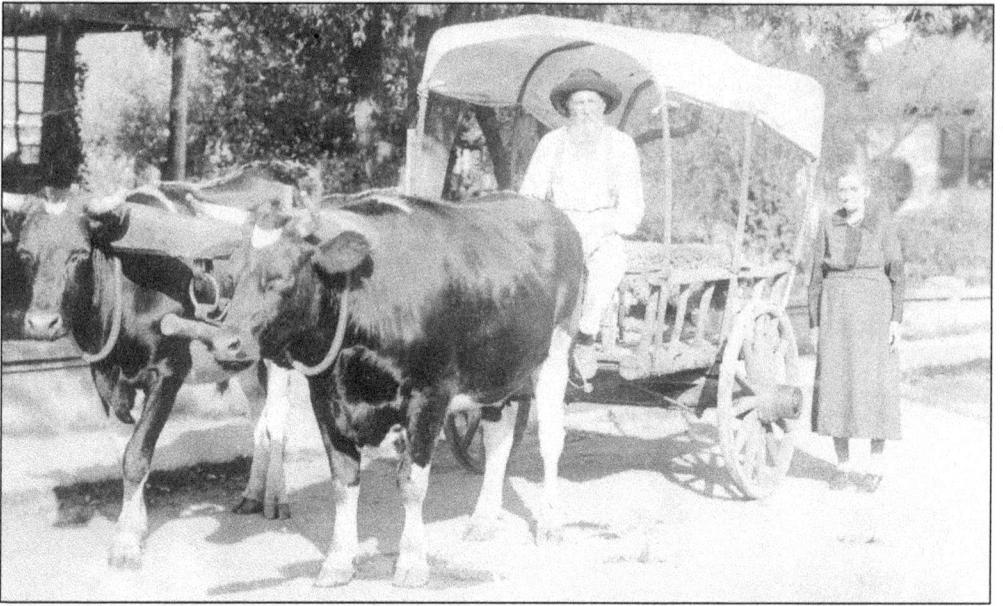

An old pioneer couple stops for a photo, as they demonstrate how they've used conventional means to navigate the "wilderness roads." The date of the picture is not known. (Courtesy of Elkhart Public Library.)

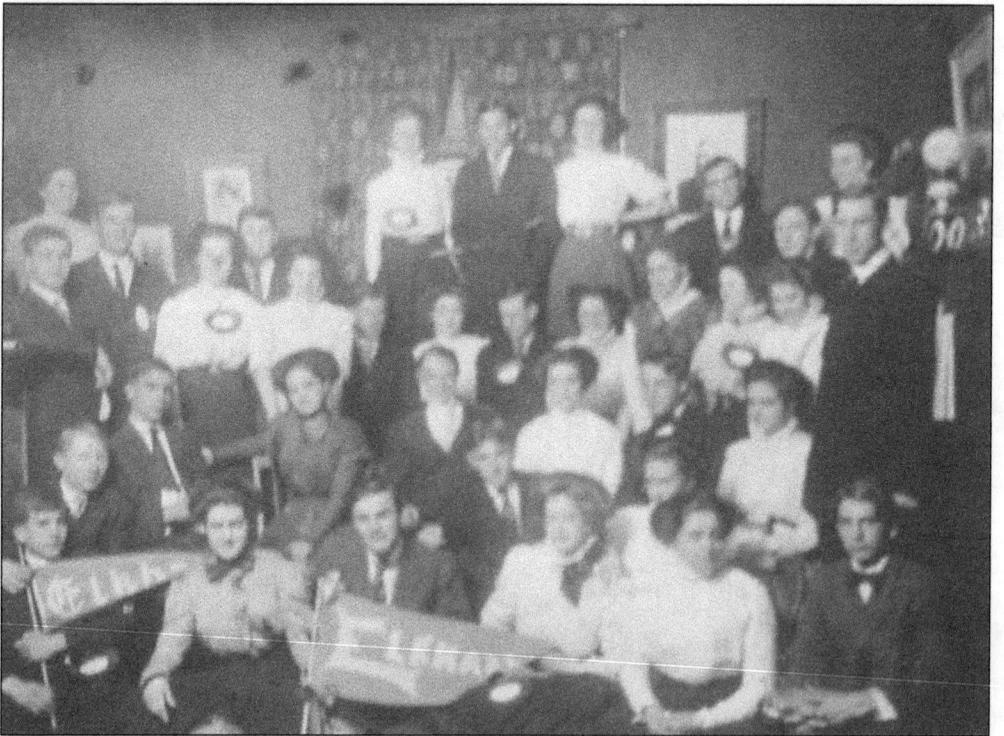

Presumably, this group is comprised of students in their senior year at Elkhart High School, as they pose with a pair of the school banners. Although the picture does not have a date, it looks to be from around the turn of the 20th century. (Courtesy of Time Was Museum.)

Two

A NEW ERA
"HOW FIRM A FOUNDATION"
1900–1930

It often seems that whenever chancing upon recollections of the turn of the 20th century, there is a sense of opulence, refinement, and elegance. Certainly that sentiment was not lost upon the people of Elkhart—just a glimpse of the lifestyles at that time illustrate this assertion rather clearly. Impeccably dressed gentlemen, and graceful, delicately attired women can be seen in almost every image, whether the moment captures a day in the general life, or a time and place amidst the business landscape.

As the 1900s arrived, one of Elkhart's most famed and celebrated residents was enjoying a successful run in the medical realm. Dr. Franklin L. Miles was one of the city's earliest residents, arriving as a young child in 1860. By the late 1870s, Dr. Miles was practicing medicine in a tiny office along the Morehous Block, on the northeast corner of Main Street and Jackson Boulevard. During this period, Dr. Miles and his wife Ellen, also a doctor, shared the family practice. They both were stricken with a disease called "typhomalaria," and while Dr. Miles was able to recover, sadly, his wife perished, leaving her husband with three small children.

Not long after the passing of Ellen, Dr. Miles created one of his first medical remedies, known as "Nervine." He maintained the notion that if the nervous system was functioning poorly, the entire body would be thrown off of its natural rhythms. During an era when most folks were wont to try virtually any potion, tonic, or powder that came to pass, Dr. Miles espoused the wisdom that a healthy lifestyle could ward off disease better than any homespun remedy.

By 1885, Dr. Miles had established a new business of producing medicine, and he was joined by key players in the community—George Compton, a local dry goods merchant; A.R. Burns, area druggist; and Albert Beardsley, company manager. The latter was the nephew of Havilah Beardsley. In 1891, the fledgling company erected a new building along the south side of Franklin Street, between Main and Second streets, and became known as the Miles Medical Company. The facility was responsible for nearly every aspect of production, from printing the labels to packaging the medicines. All the while, Dr. Miles continued to service his patients, in the confines of a large dispensary at the corner of Main and Pratt (today called Marion) streets.

Dr. Miles chose to relocate his primary practice to Chicago in 1893, taking his three children, now teenagers, with him. While living there, he met and married his assistant, Elizabeth State, who was also a native of Elkhart. During his stay in the Windy City, Dr. Miles continued to serve as president of the Miles Medical Company, though he relied heavily on the mail to keep in contact with the events back home.

When Dr. Miles returned to Elkhart in 1900, he strived to re-establish his doctoring skills in the Bucklen Opera House building, but he was eventually felled by bouts of illness and granted ownership of the dispensary to his son, Charles. Dr. and Mrs. Miles then departed for Florida,

where he remained a player in the workings of Miles Medical Company until his death in 1929. Albert Beardsley's nephew, Andrew Hubble "Hub" Beardsley, took over as chairman of the board and company president when the elder Beardsley died in 1924.

As the Miles Medical Company was ascending to its rightful place in Elkhart history, there were other significant happenings at the turn of the century as well. The population of the city had climbed once again, to 17,000, and so the need arose for more improvements in such venues as health care and schools. The Elkhart General Hospital was built over the course of 1912–1913, with a tremendous swell of public and professional support. In 1908, a committee had been formed to take care of organizational matters, with the General Hospital Association being formed in 1909. The following year, Dr. Franklin Miles pledged $10,000 to the cause of building a new hospital, with the caveat that $30,000 additional dollars must be channeled from other sources. By 1911, the fund raising campaign had succeeded in garnering $47,000 in funds.

What would be regarded as the "new" Central School opened its doors in 1908, a 24-room building situated at the southeast corner of Third and High streets. While the new High School was being built, just around the corner on High Street, a network of corridors connecting the two schools was fashioned, allowing the students to come and go between the two facilities. The new Elkhart High School was completed in 1912, and would remain the city's only high school for the next 60 years.

Other occurrences of particular interest transpired in the early 1900s. In 1903, the Electric Power Company was instituted to create a power plant. That same year, the city's first public library, the Carnegie Library, was built at the corner of Second and High streets, where the current library is located as well. By 1905, the city welcomed the completion of a brand new post office, and by 1911, a new dam spanned the St. Joseph River, along with a new powerhouse. A new municipal building was opened to city government in 1916—the building is still used for that purpose today. And in 1920, the Elkhart Chamber of Commerce was organized.

Some interesting tales were found regarding the first automobile club, which was formed in 1905. At that time, the vehicles were known as "horseless carriages," and usually boasted a top speed of about 25 miles per hour—early membership stood at about 40. Merchants generally stocked their shelves with such things as "gauntlet gloves" and veils for the ladies to wear, so that their hair would not be mussed while riding in the new fangled contraptions with no windshields.

While observing the upsurge of new buildings in Elkhart's downtown sector, it would be completely remiss not to pay tribute to one of the city's greatest architectural visionaries. E. Hill Turnock offered his styling to a number of Elkhart landmarks, many of which are still in existence. Turnock came to Elkhart in 1872, arriving with his family who were of British descent. He worked for a time as a pattern maker for the Lake Shore and Michigan Southern Railroad before accepting an apprenticeship in Chicago, working with architect William Le Baron Jenney. Turnock also took courses at the Chicago Art Institute and by 1907, was well attuned to his craft and returned to Elkhart with a number of commissions to design a host of local structures. His work was said to be patterned after Beaux Art classicism and Arts and Crafts themes, and he was a firm believer in making optimum use of the natural surroundings to enhance his work.

Among Turnock's most recognizable creations are the Ruthmere Museum, the Elkhart High School of 1912-1972, the current Municipal Building, the Elkhart Water Works, and Elkhart General Hospital, to name but a few. Turnock worked closely with many aspects of local architecture until his death in 1926.

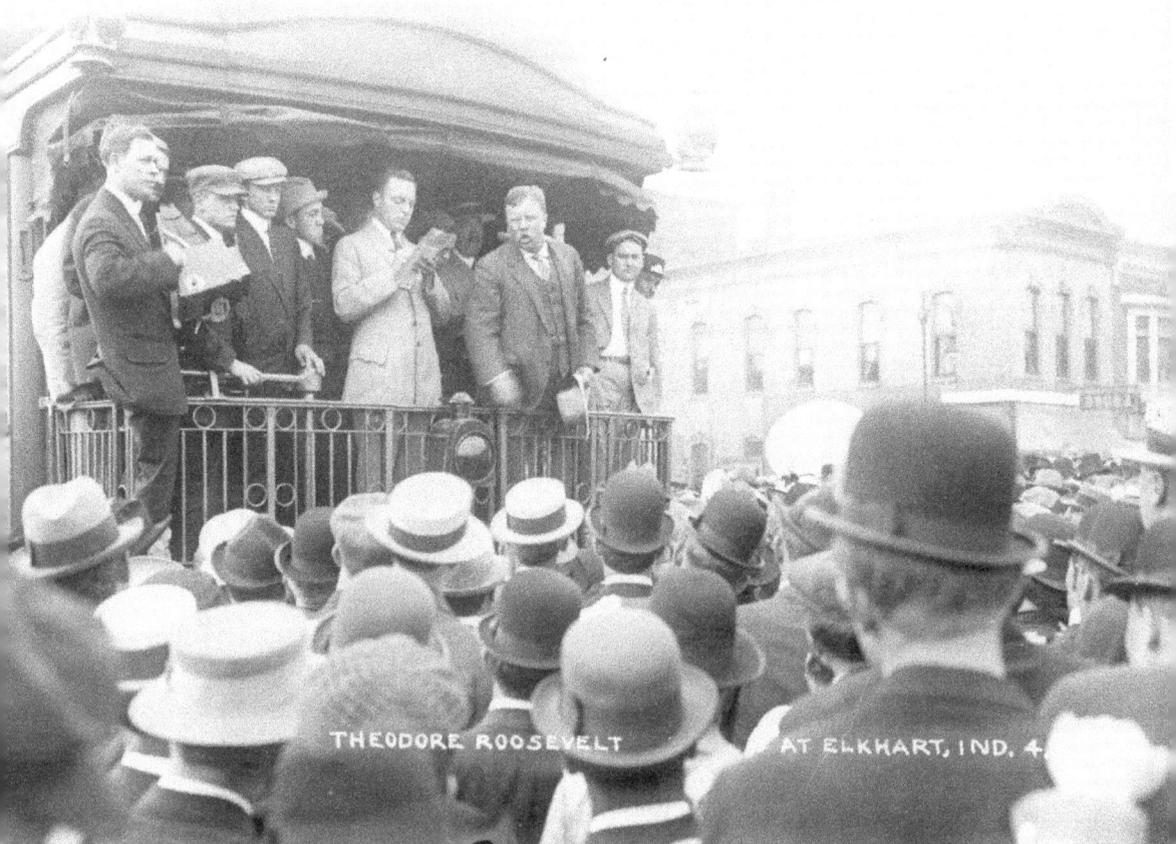

THEODORE ROOSEVELT AT ELKHART, IND. 4.

Former President Theodore "Teddy" Roosevelt appeared at the Main Street railroad crossing during a "whistle-stop" campaign. Roosevelt's time in office preceded this photo, which was taken in 1912. His two-term presidential reign lasted from 1901 until 1909. (John Inbody photo, courtesy of Elkhart Public Library.)

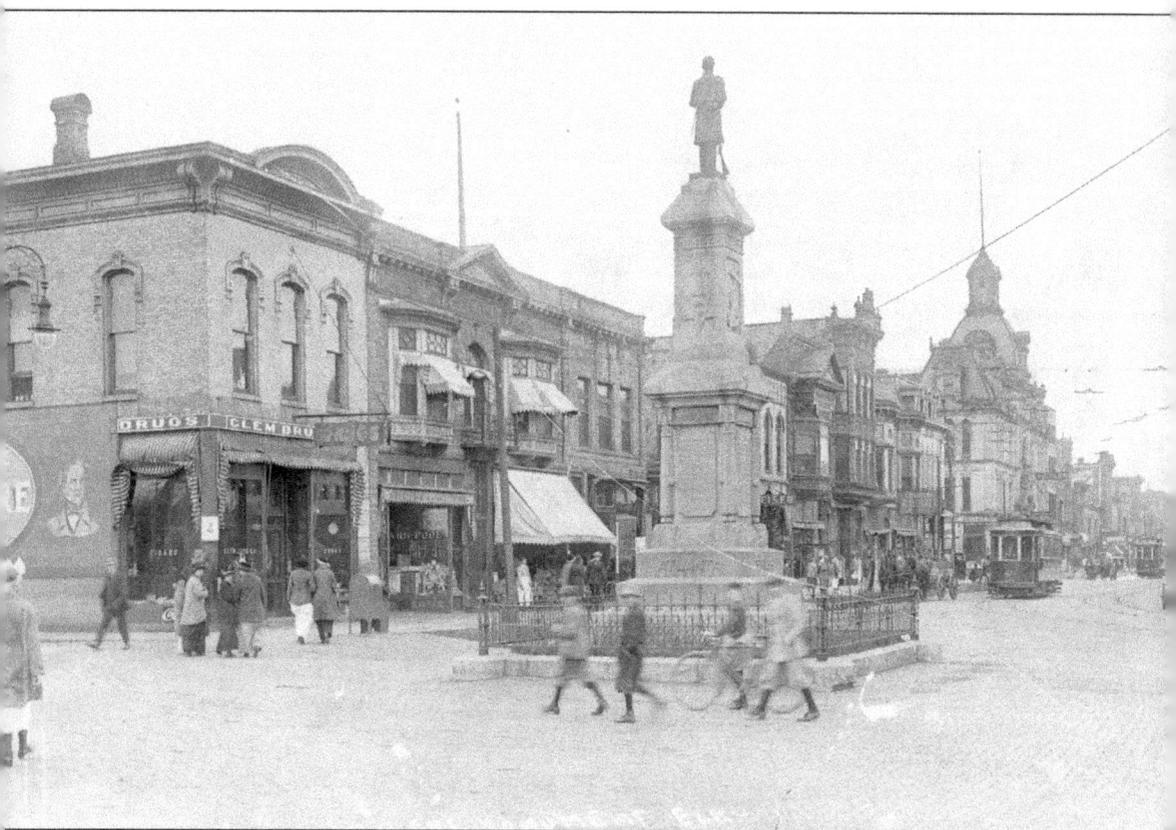

The Soldiers' Monument, in a photo taken *c.* 1905. The picture is looking north from Main and Tyler streets. This monument was unveiled on August 23, 1889, and was paid for by Silas Baldwin in honor of all the Civil War veterans who sacrificed their lives for the sake of the nation. One of those fallen soldiers was Baldwin's son, Lt. Frank Baldwin, who was killed in the Battle of Stone River on December 31, 1862. The young lieutenant was just 18 years old. Years later, this monument would find a new, proper home at Rice Cemetery. (Courtesy of Elkhart Public Library.)

Opposite: A monument honoring Havilah Beardsley was built at the juncture of Riverside Drive and Beardsley Avenue. E. Hill Turnock helped to design the statue—the photo is dated 1913. (Courtesy of Elkhart Public Library.)

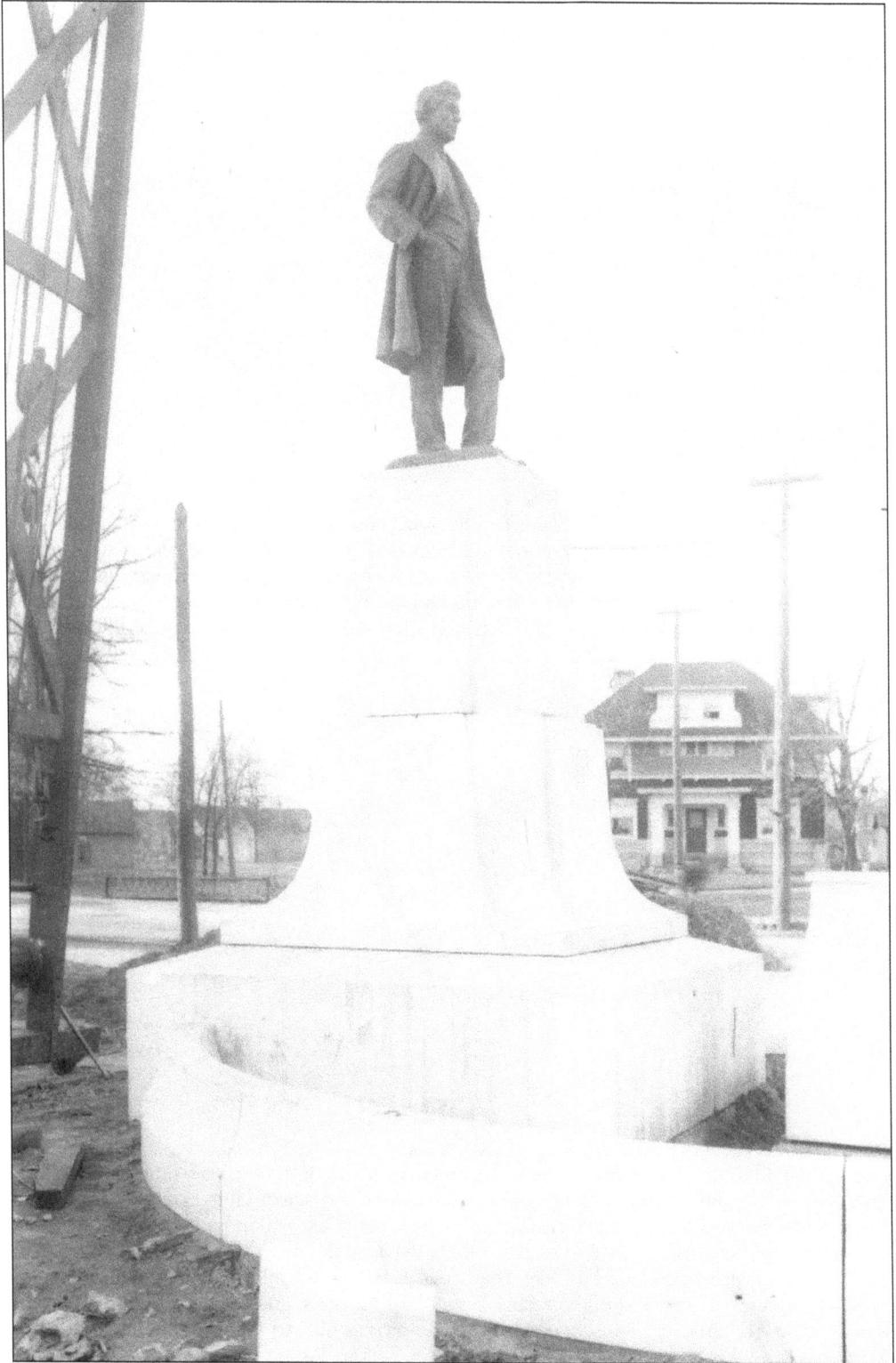

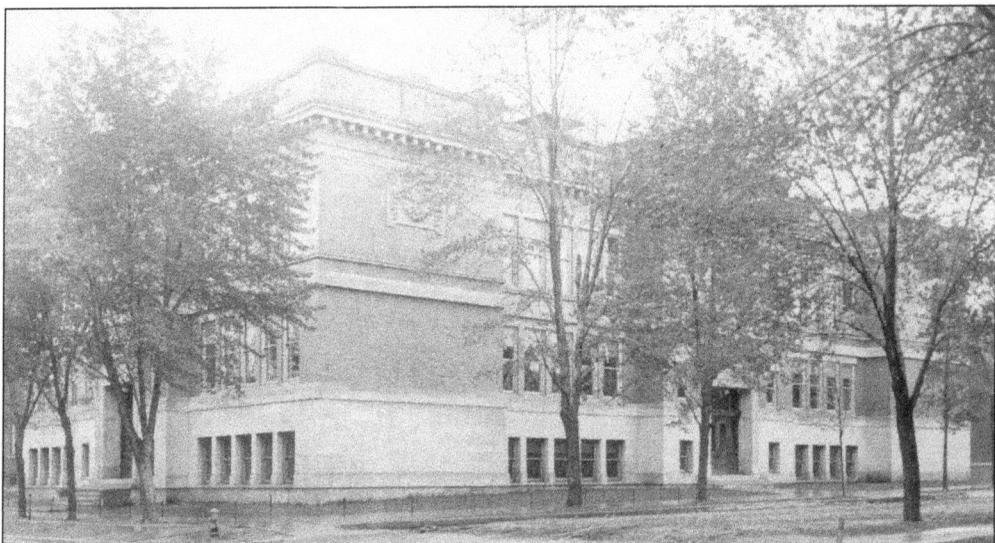

The second incarnation of Central School, located at Third and High streets, as it looked between 1908 and 1910. The 24 room facility was equipped to serve students in grades one through eight. When the new high school was built on High Street in 1910, the "new" Central School was joined with the high school by a network of passageways connecting all three floors. By 1919, several new elementary schools had sprung up throughout the city, and the new Central School became Central Junior High School. (Courtesy of Elkhart Public Library.)

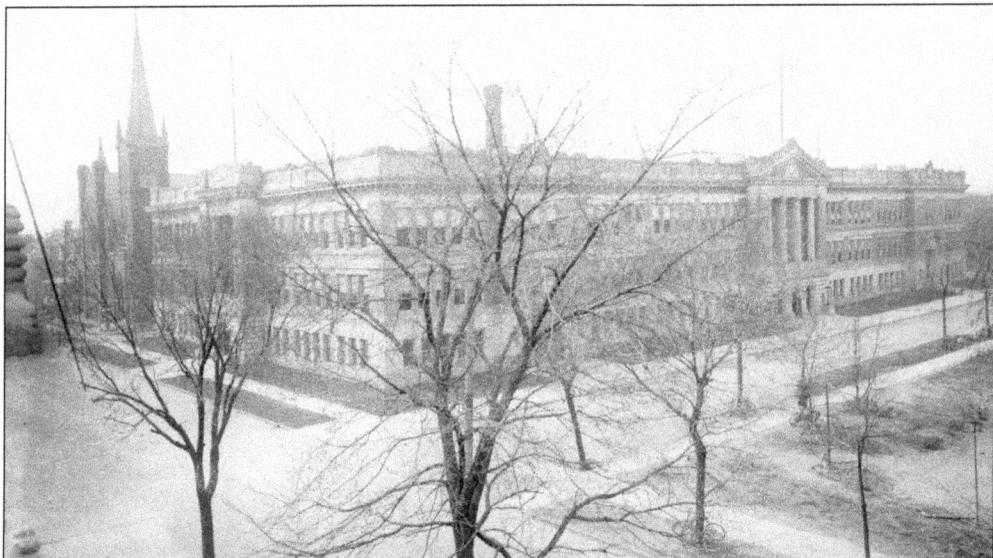

The second Elkhart High School, as it appeared in 1912, just one year after it had been built—another E. Hill Turnock design. The campus sprawled across High Street, from Second Street westward, and merged with the Central School complex, which had been built in 1908. A series of corridors linked the two structures. By 1912, grades one through six were moved to the "old" Central School, and by 1919, the "new" Central School housed students in grades seven through nine. This was Elkhart High School for 60 years, and today, the building serves as one of two Elkhart city high schools. It is now known as Elkhart Central High School—the other high school is Elkhart Memorial. (Courtesy of Elkhart Public Library.)

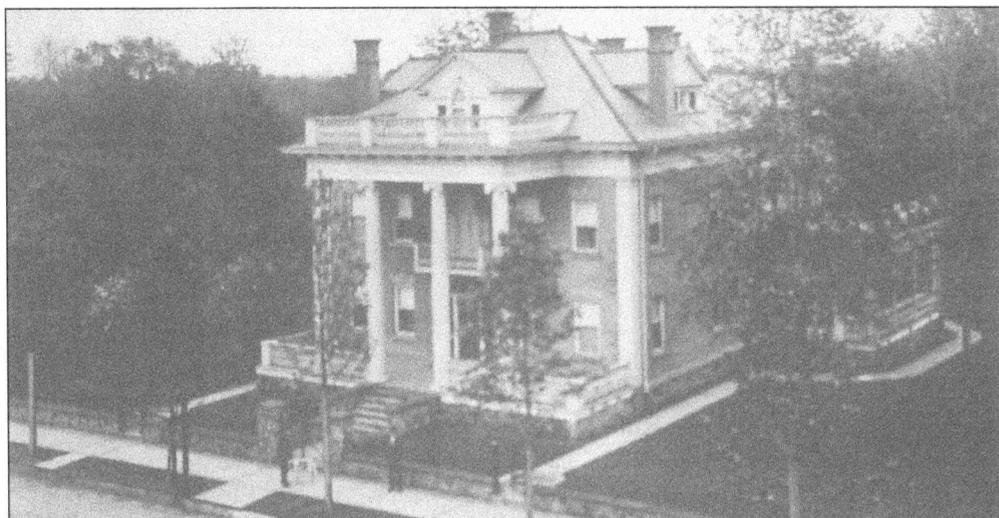

The former residence of Philo Morehous, once located at 116 North Main Street, on the east side of the road between Jefferson Street and Jackson Boulevard. The home was built in 1849 and later served as the Elks Lodge. The organization was housed there from 1938 until 1955, and was last used in 1958 by the volunteers who were instrumental in the planning of the Elkhart Centennial Observance. The home, which had been one of Elkhart's oldest landmarks, was torn down in January of 1960, and the property was later the site of the new McDonald's restaurant. (Courtesy of the City of Elkhart.)

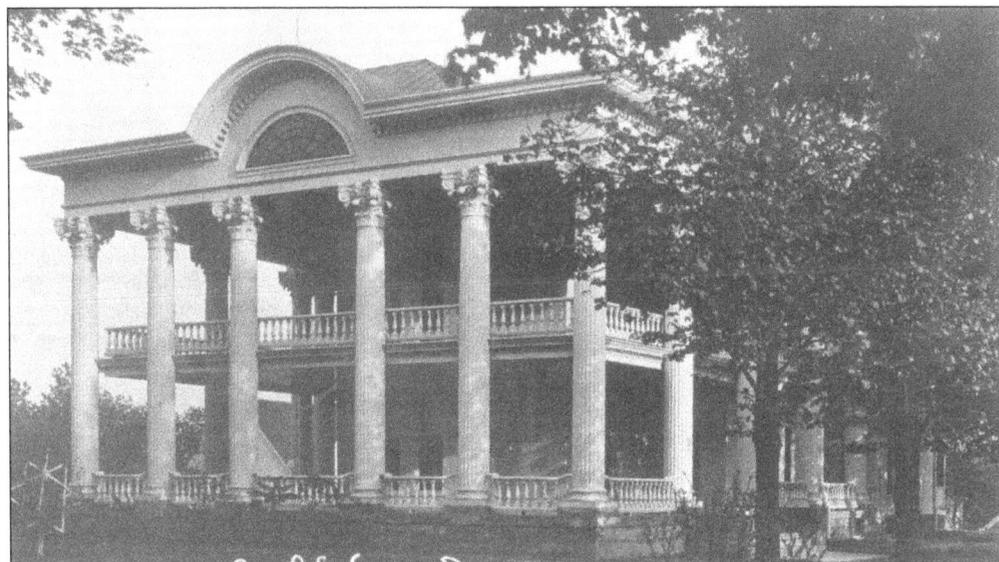

The primary residence of C.G. Conn, as it looked on August 15, 1916. The home was located at 723 Strong Avenue, and served as the family home during Conn's illustrious and legendary life in Elkhart. Though he was most renowned for his contributions to the musical instrument realm, Conn also had a very active political career. He served as Elkhart's mayor from 1880 to 1884, went on to the Indiana General Assembly in 1888, and was a member of the United States House of Representatives in 1892. Conn is also the founder of the *Elkhart Truth*, which was launched in 1889, and remains today one of the area's most widely heralded publications. (Foster photo, courtesy of Elkhart Public Library.)

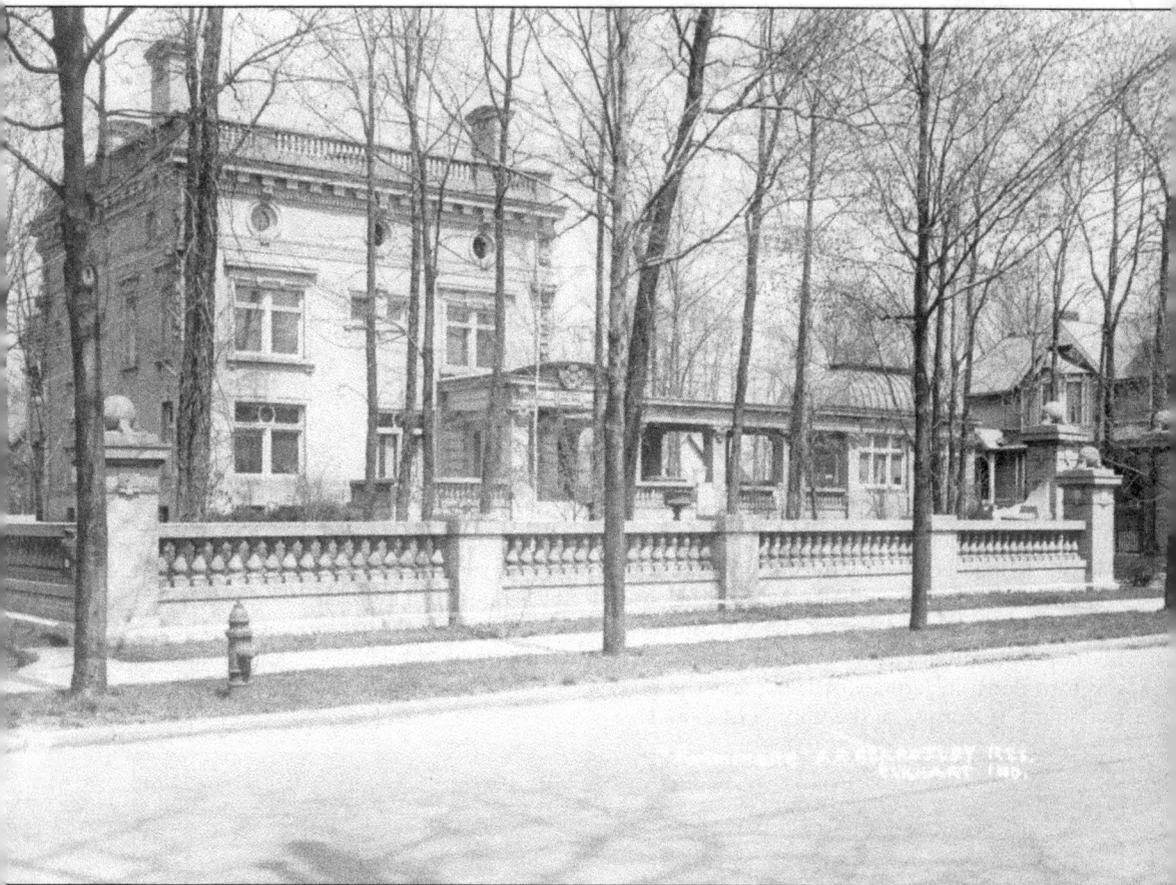

The Ruthmere Mansion located at 302 East Beardsley Avenue. The palatial home was the residence of Albert R. and Elizabeth Baldwin Beardsley, and they chose to name the estate Ruthmere, in memory of their infant daughter, Ruth, who perished as an infant in the 1880s. Ruthmere was designed by E. Hill Turnock, a master of stately and regal architecture who was responsible for creating many of Elkhart's most celebrated landmarks. In later years, the home was restored by Robert Beardsley, and in 1973, Ruthmere was opened to the public as a museum. It continues to be one of the city's most fascinating tourist attractions. (Courtesy of Elkhart Public Library.)

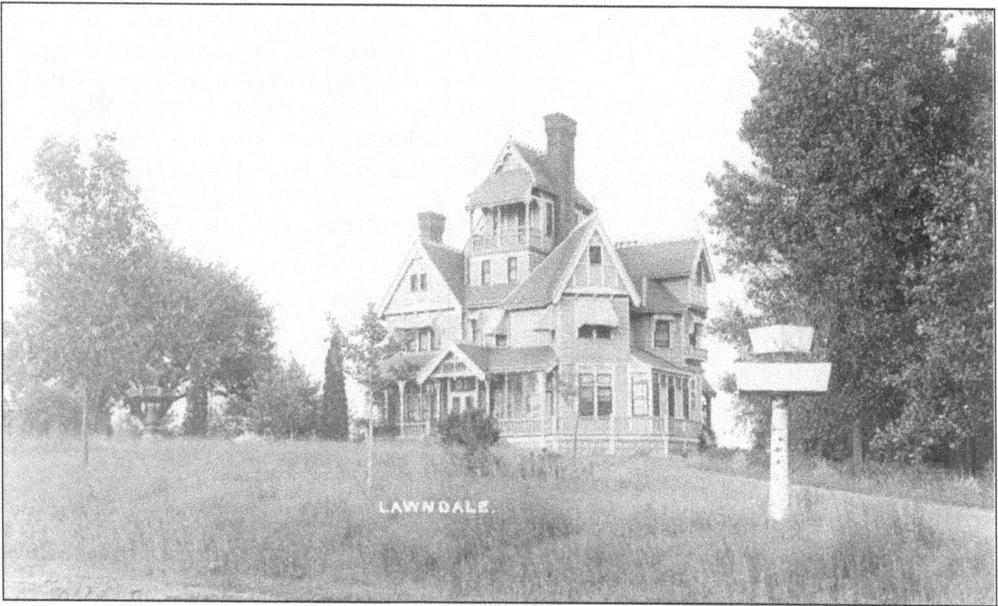

C.G. Conn's "Lawndale" home in the mid-1920s was considered to be his "country home," a respite from the bustle of city life. The house was situated at the juncture of Osolo Road and East Bristol Street. (Courtesy of Elkhart Public Library.)

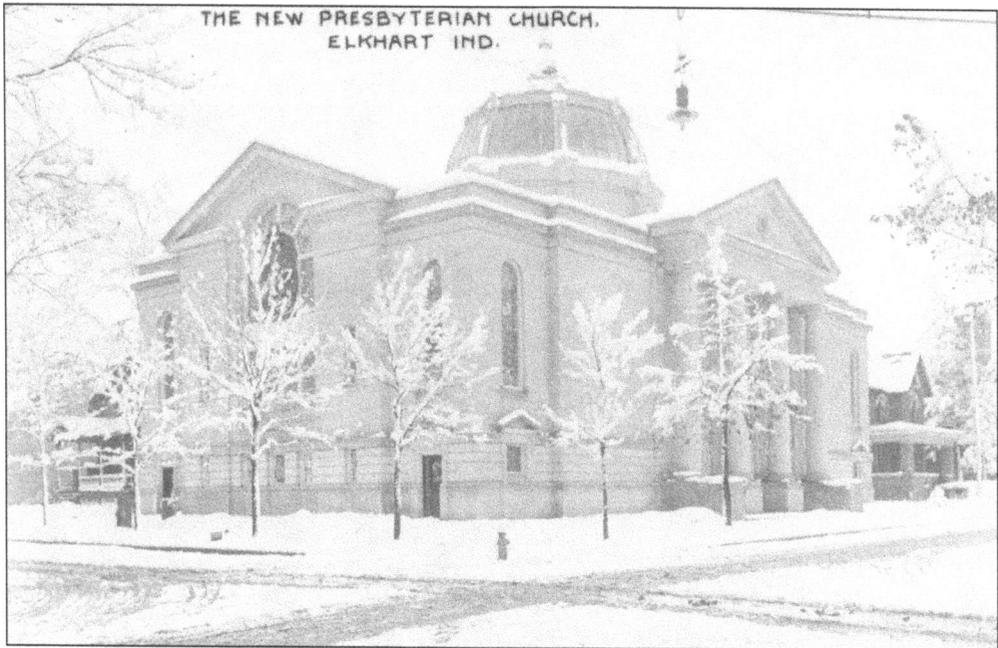

One of the most beautiful churches to grace the downtown area was the First Presbyterian Church, another creation of E. Hill Turnock. The church, which featured an exquisite domed roof, was completed in 1910, and was situated at the corner of Second and High streets. In 1954, the possibility of renovations was dismissed in favor of constructing a new church home on East Beardsley Avenue. The church was then torn down so that the current Elkhart Public Library could be built. (John Inbody photo, courtesy of Elkhart Public Library.)

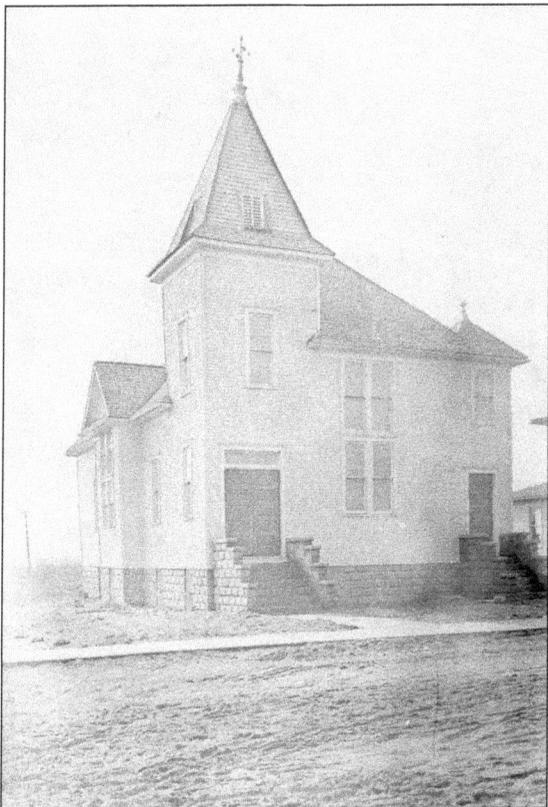

Simpson Memorial Church was a little church with an equally small history. The church, which was raised at the intersection of South Main, West Indiana, and Morehous streets, was a part of the community for just ten years, from 1913 until 1923. (Courtesy of Elkhart Public Library.)

South Prairie Mennonite Church, located along the Prairie Street corridor, around 1920. (Courtesy of Elkhart Public Library.)

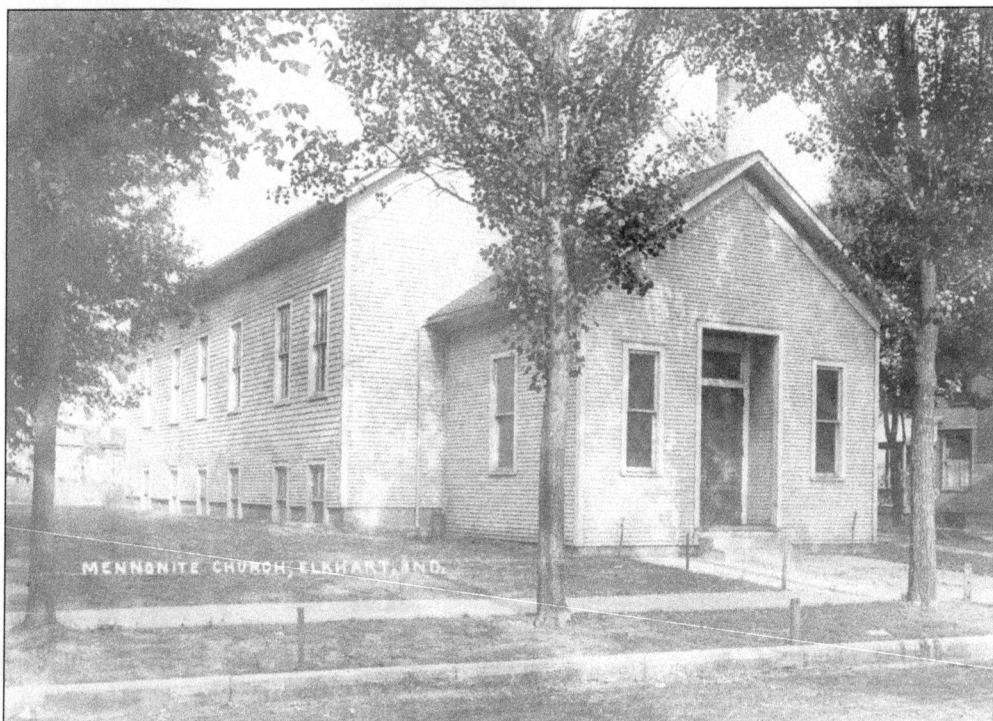

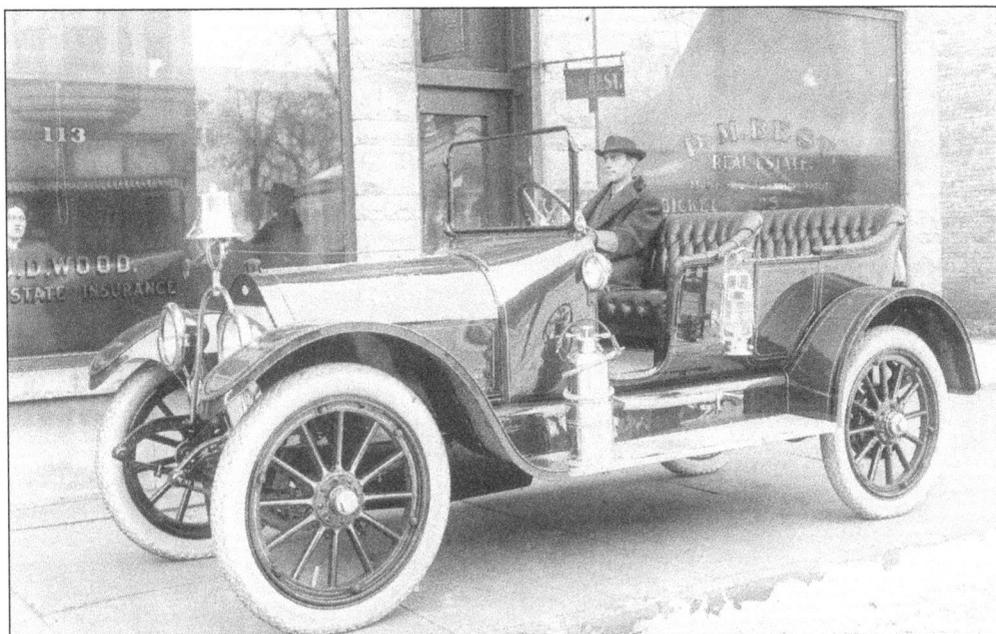

Elkhart resident and foreman Frederick Chase, the son of *Daily Review* owner Charles H. Chase, is seated behind the wheel of the fire chief's car at 111 West Lexington Avenue, the J.W. Fieldhouse Real Estate Office. The photo was taken in approximately the late 1910s. (Courtesy of Elkhart Public Library.)

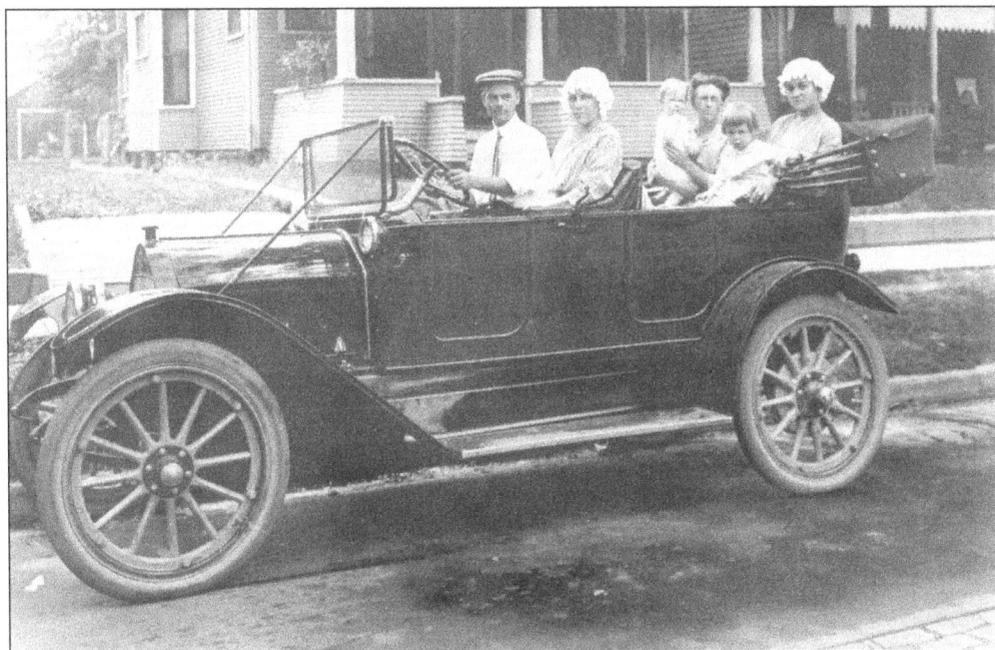

The Frederick Blessing family, going for a ride in one of the city's earliest cars. They are seen just outside of their home at 629 West Marion Street. Frederick and his wife are riding in front, while other family members are seated in the back. The photo was taken around 1912. (Courtesy of Elkhart Public Library.)

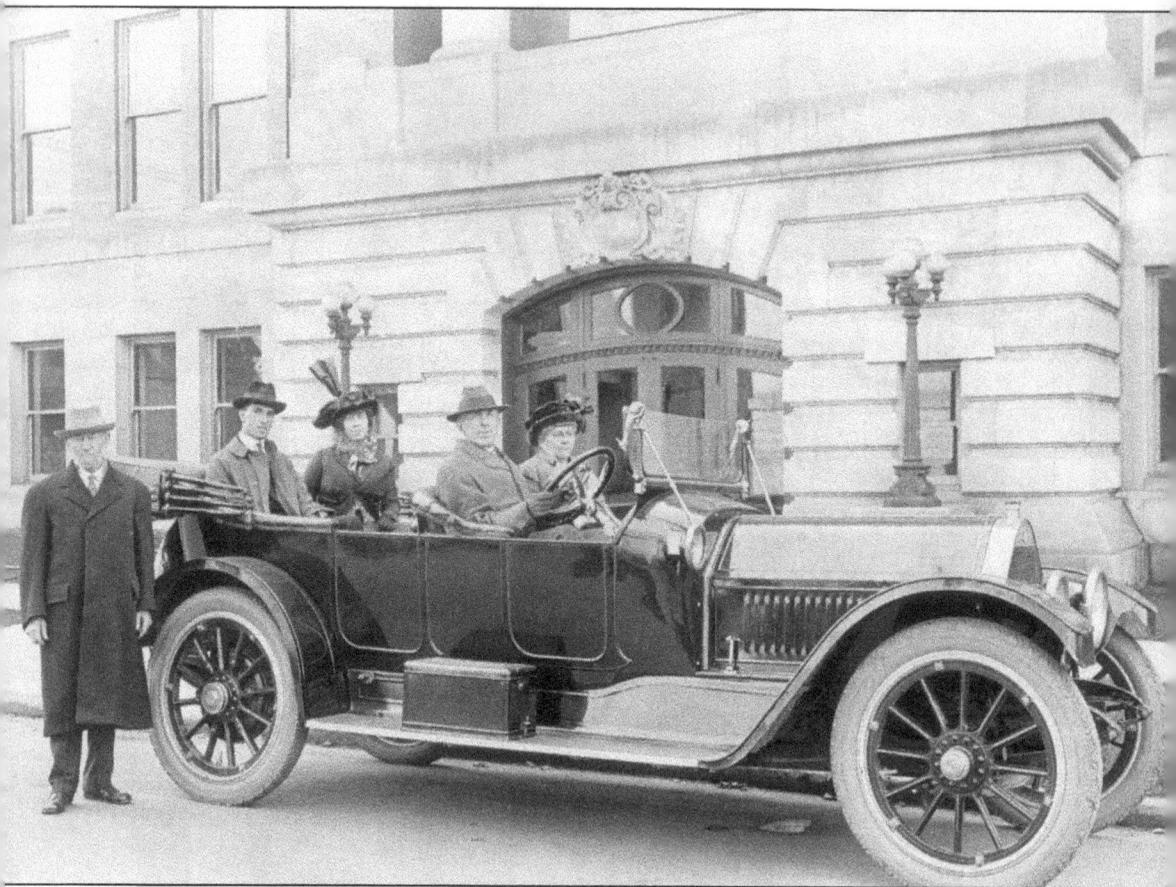

Members of the Knickerbocker and Winchester families pose with a new 1914 Cole automobile, parked outside the Second Street entrance to Elkhart High School. Charles H. Winchester is seen at the far left, William H. Knickerbocker is in the driver's seat, and Knickerbocker's mother-in-law, Elizabeth Winchester, is beside him. Knickerbocker's wife, Nellie, is in the back seat—the identity of the other gentleman is not known. The car was made in Indianapolis, for the cost of $5,000, and was touted as a seven-passenger "touring car." It featured such amenities as electric lights, clincher wheels, and a klaxton horn. It's quite intriguing to see that the driver's side was located along the right of the vehicle. (Courtesy of Elkhart Public Library.)

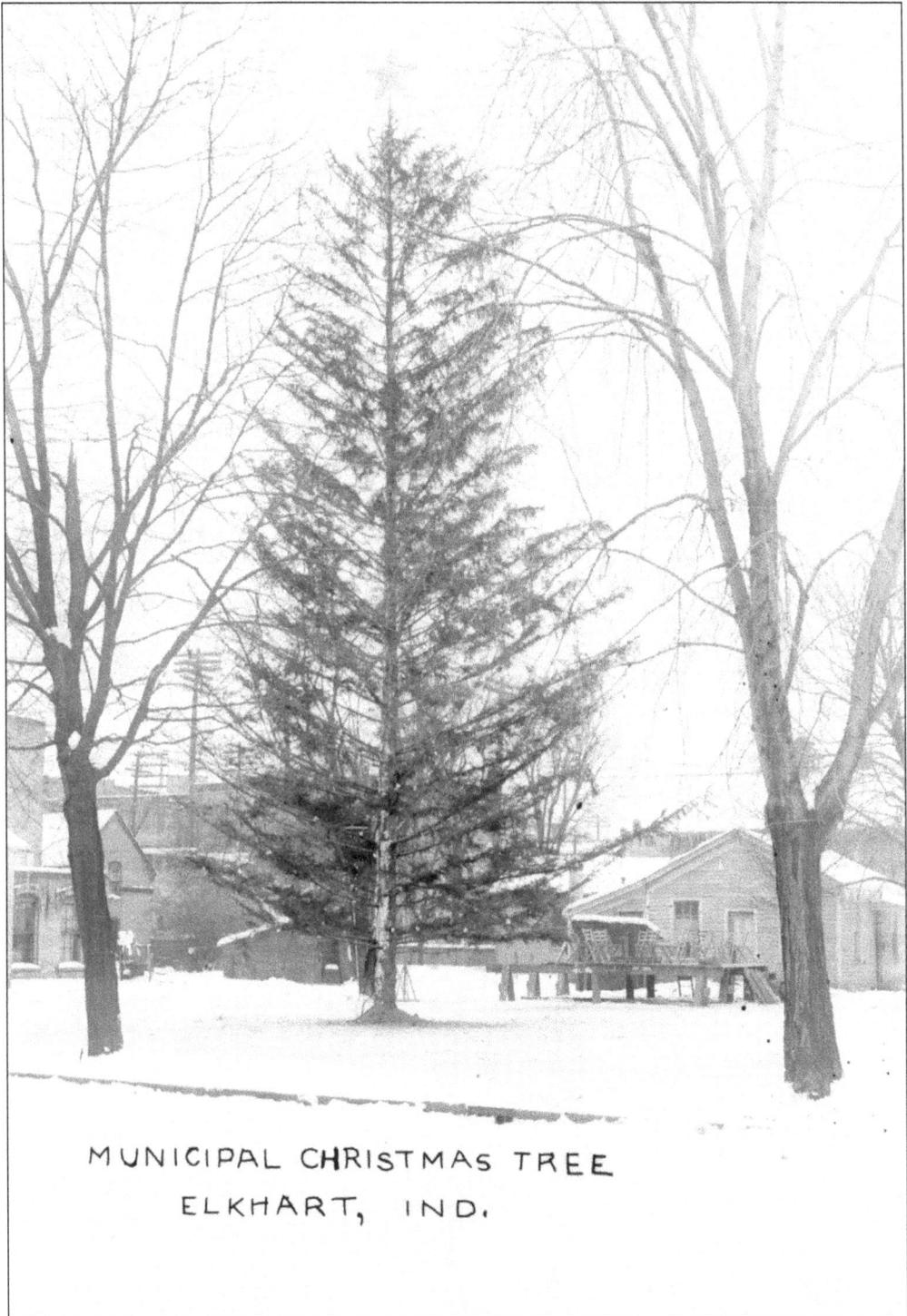

MUNICIPAL CHRISTMAS TREE
ELKHART, IND.

The tradition of raising a municipal Christmas tree is one that has endured for decades—this particular tree was the holiday centerpiece sometime during the early 1900s. (Courtesy of Elkhart Public Library.)

There is very little information to accompany this fascinating image, only to state the obvious —that it is some type of cast photo from a local theatre production. It looks like the presentation may have been held in the Bucklen Theatre, perhaps in the early 1900s. (Courtesy of Time Was Museum.)

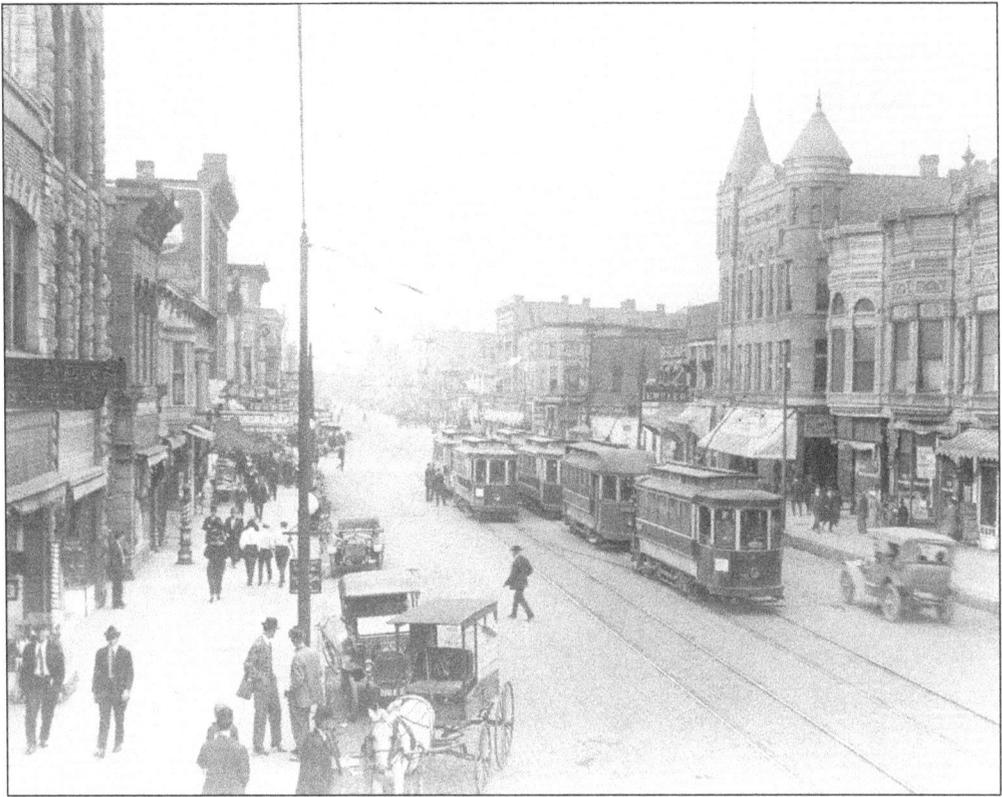

The intersection of Main and Harrison streets, along Main Street are seen looking north from Harrison, about 1905. (Courtesy of Elkhart Public Library.)

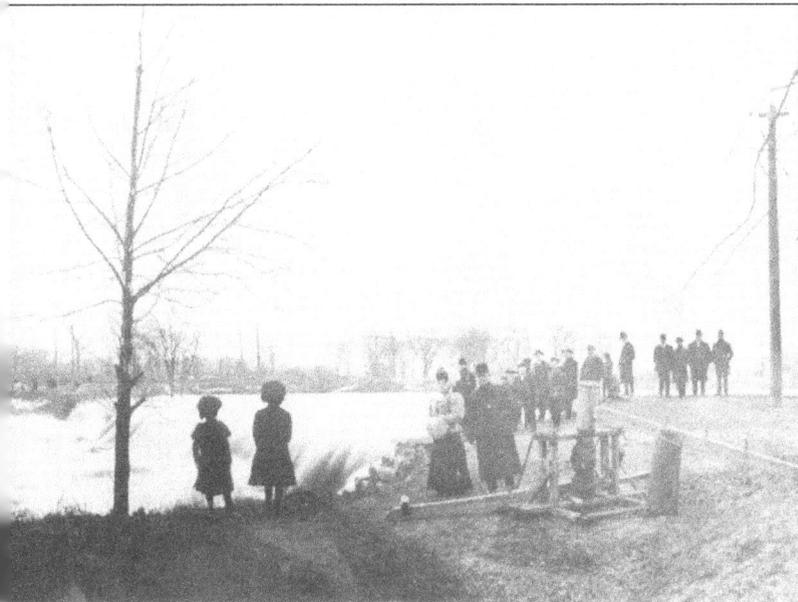

Folks opted to stay safely away from the rushing waters of a 1908 flood of the St. Joseph River, seen from the Johnson Street Bridge at the old St. Joseph River dam. (Courtesy of Elkhart Public Library.)

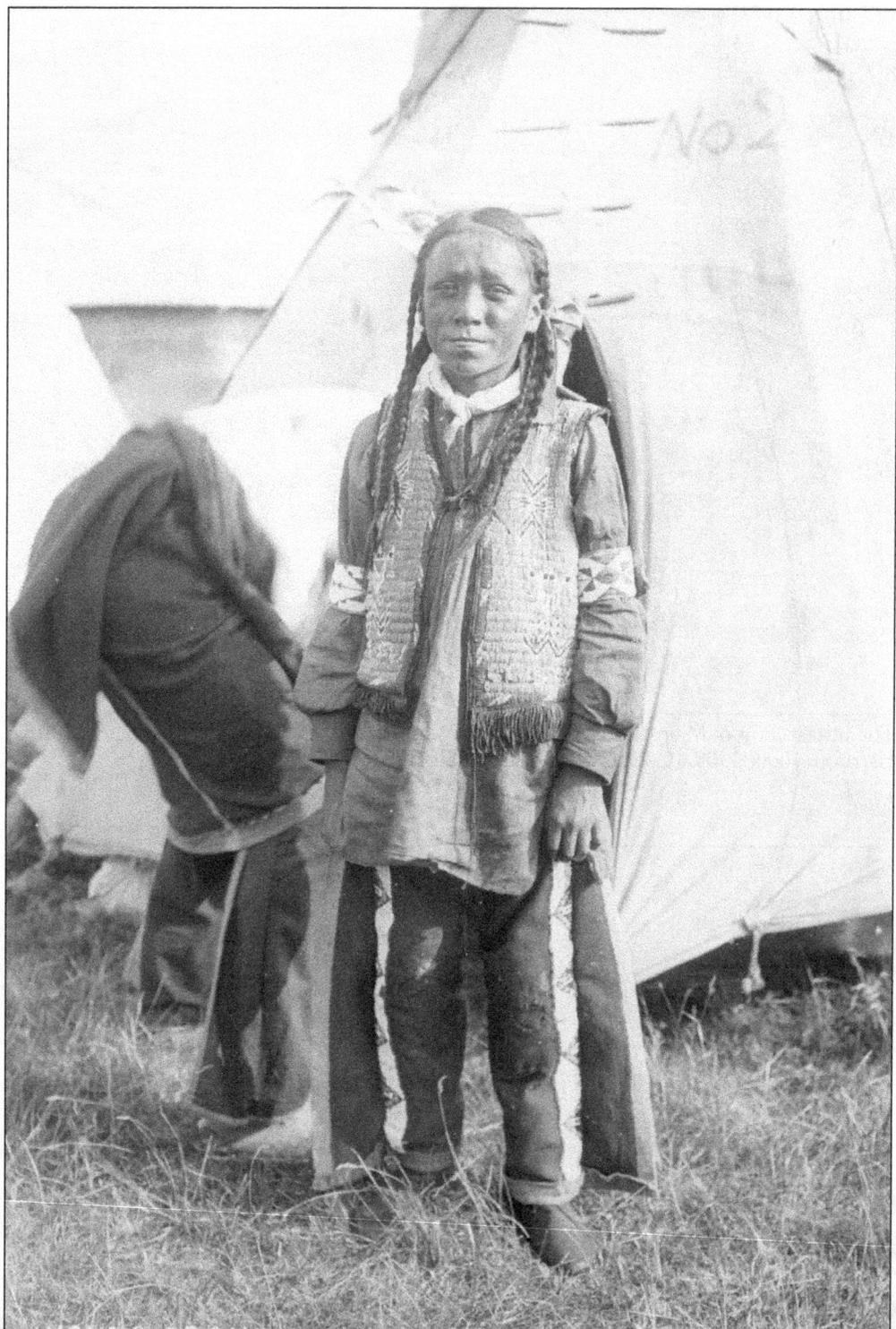

This photo captures the image of a young brave during an outing of "Buffalo Bill's Wild West Show" in 1909. (Courtesy of Elkhart Public Library.)

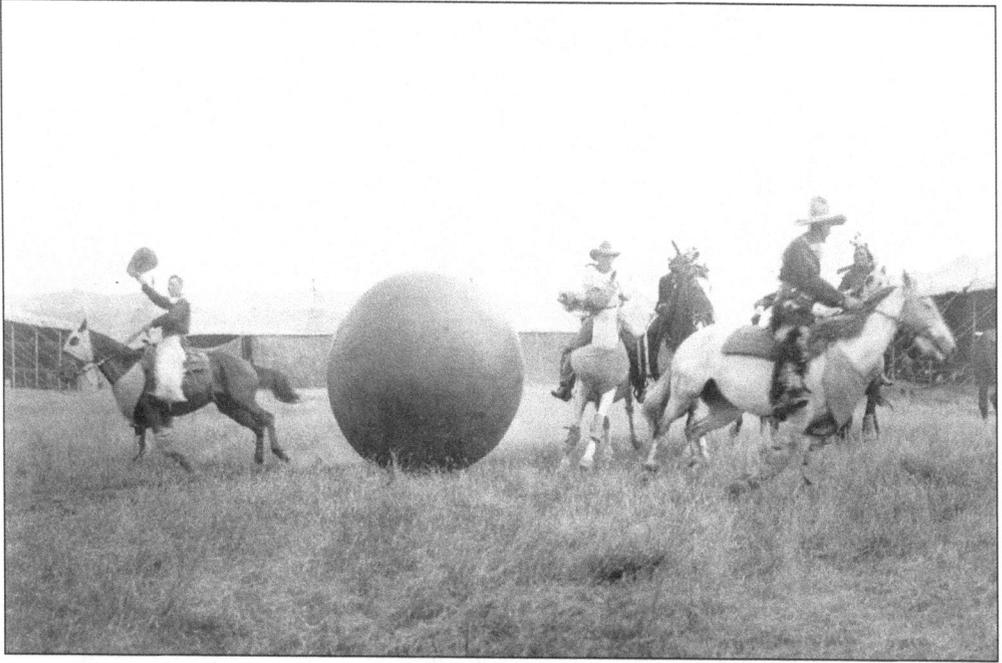

A spirited game of "foot ball" during the 1909 "Buffalo Bill's Wild West Show." (Courtesy of Elkhart Public Library.)

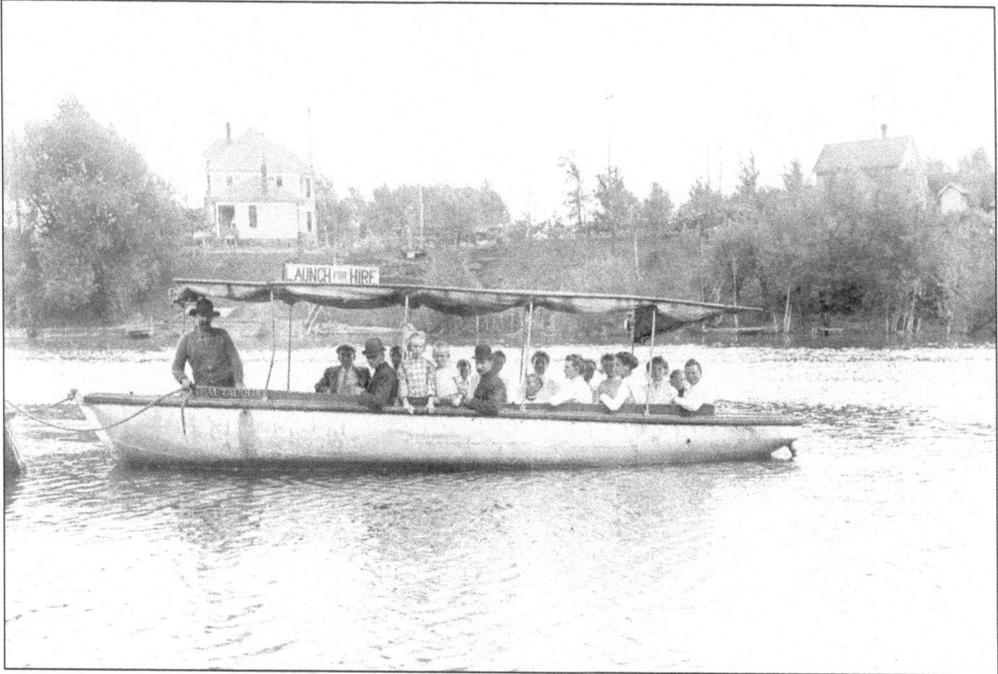

A gentleman named Fred H. Davis owned a river riding excursion boat called the "Chautauqua," and during the early part of the 1910s, he would treat his passengers to a serene sightseeing adventure. Here, he is docking his boat along the McNaughton Park shore. (Courtesy of Elkhart Public Library.)

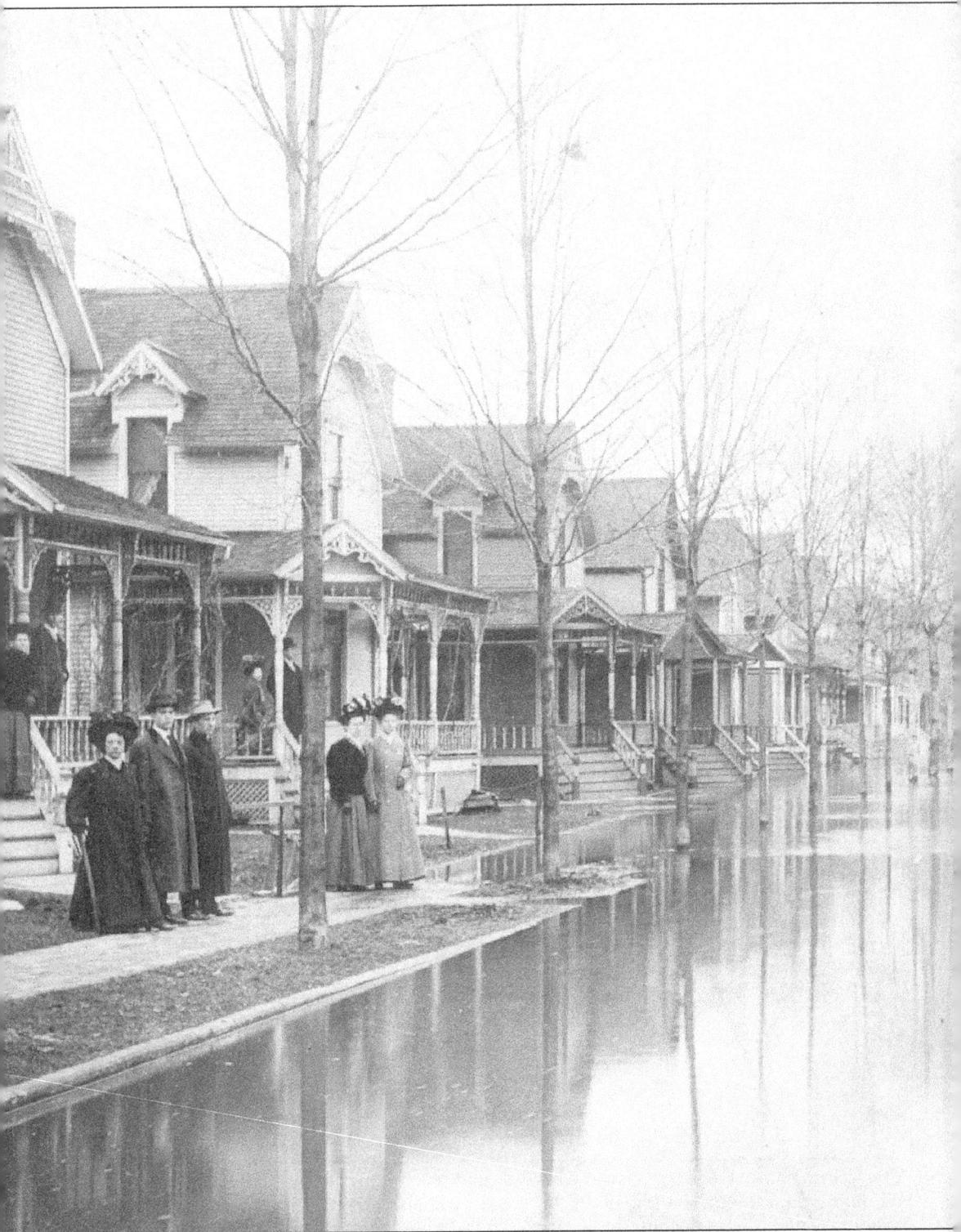

A flooded Sixth Street is pictured from approximately 1910. It seems that a few clever folks thought

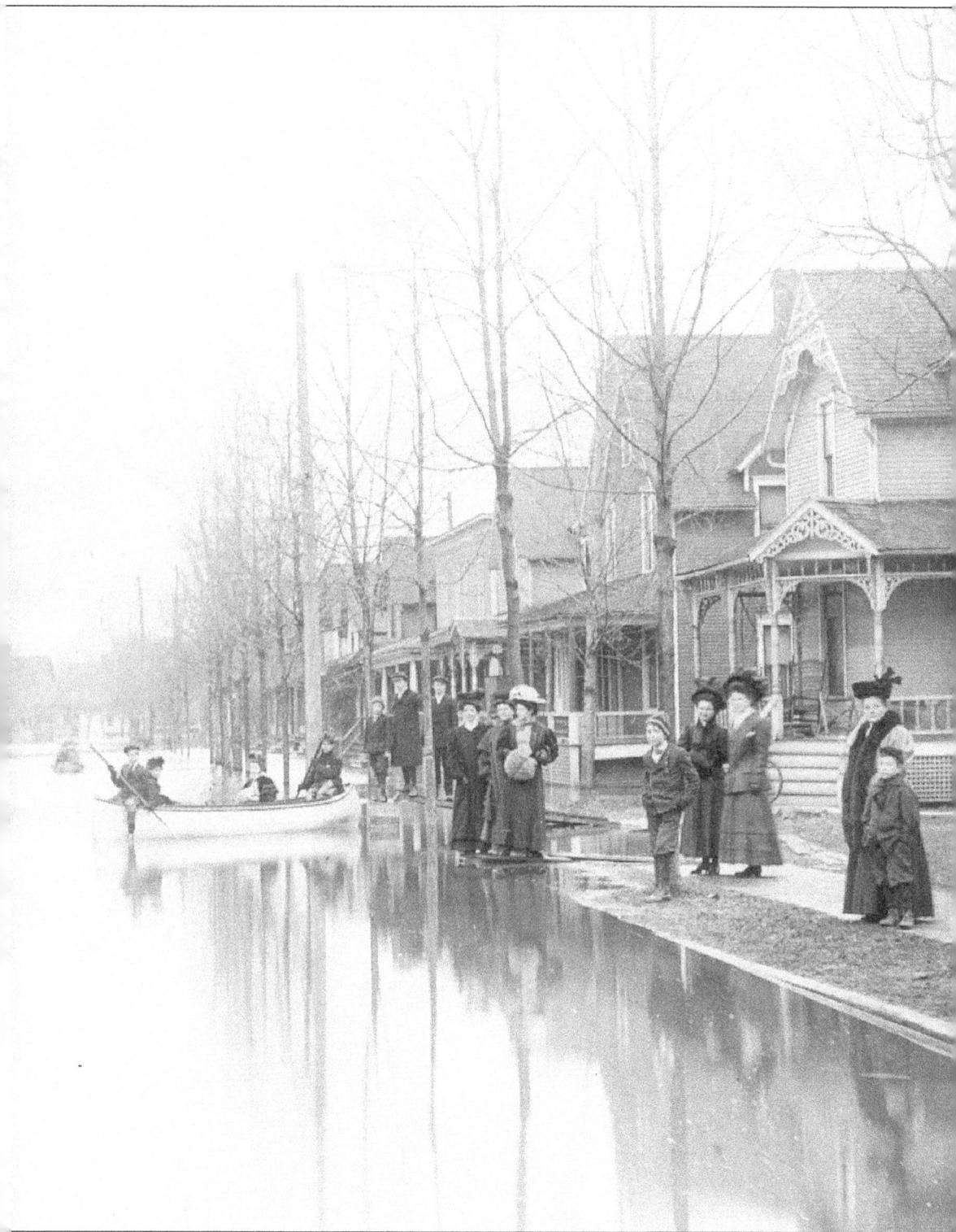

enough of the situation to make use of a canoe to get around. (Courtesy of Elkhart Public Library.)

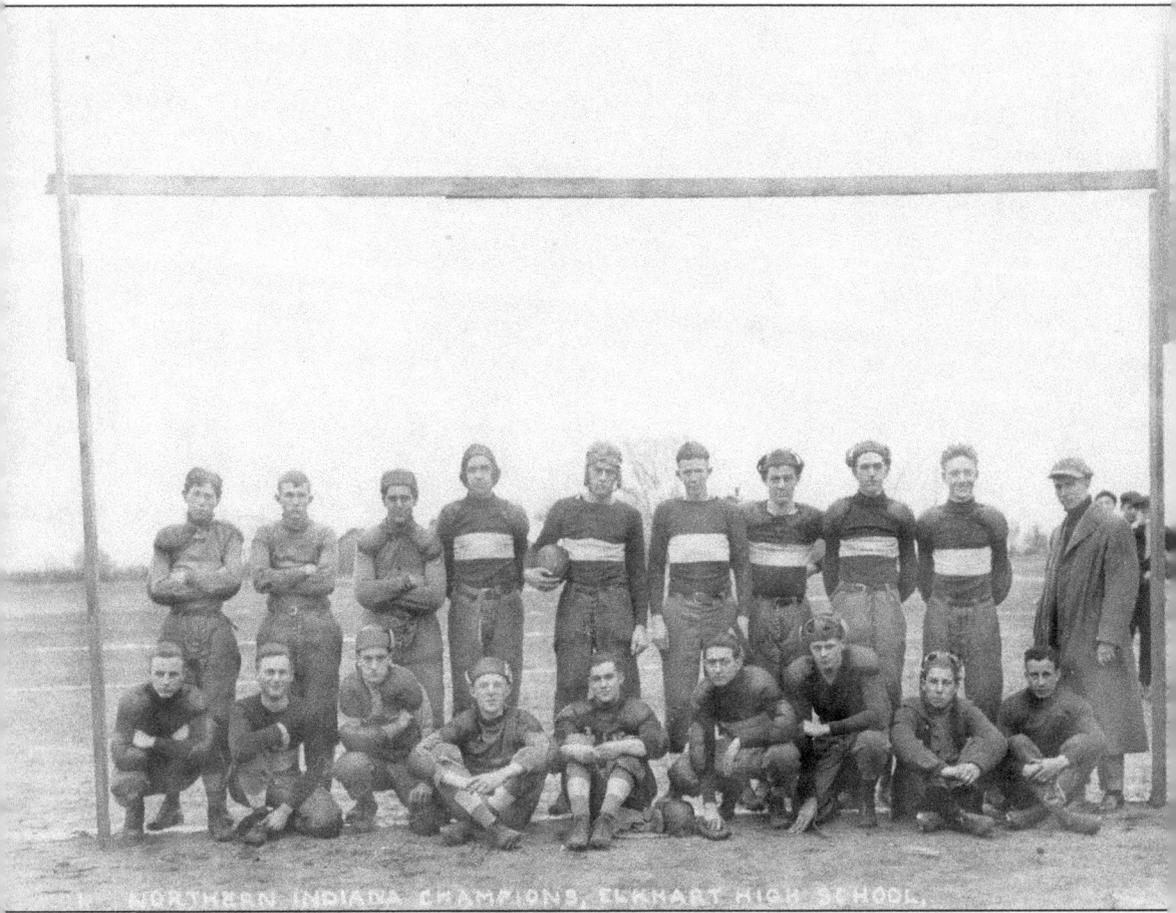

NORTHERN INDIANA CHAMPIONS, ELKHART HIGH SCHOOL,

One of Elkhart High School's earliest and greatest gridiron accomplishments, these are the young men who became champions of Northern Indiana in the fall of 1912. (Courtesy of Elkhart Public Library.)

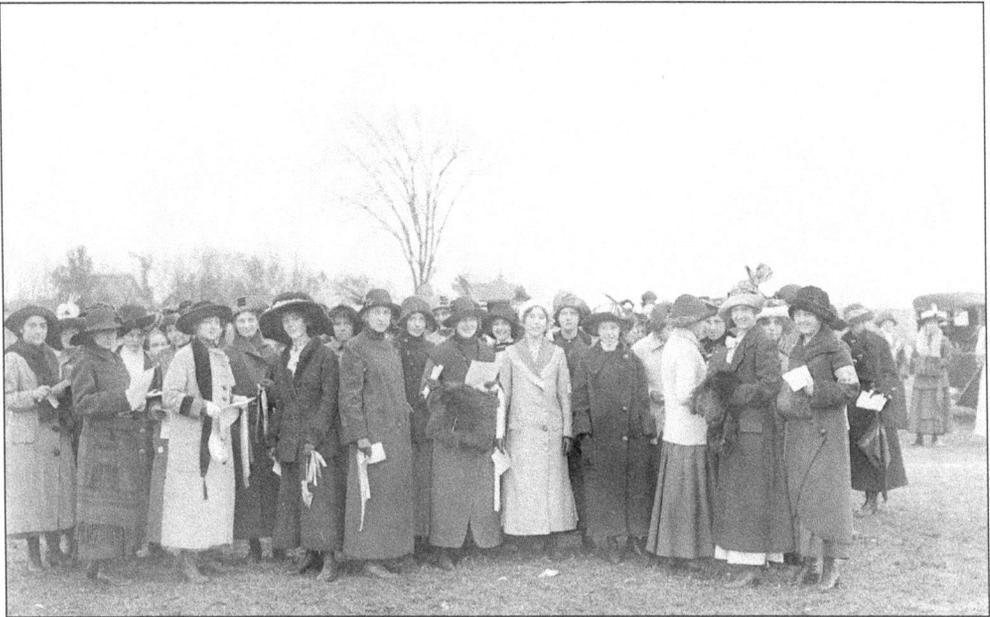

In a photo fittingly titled "A Bunch of Rooters," a bevy of students brave what appears to be a rather chilly day in order to support their school's athletics. (Courtesy of Elkhart Public Library.)

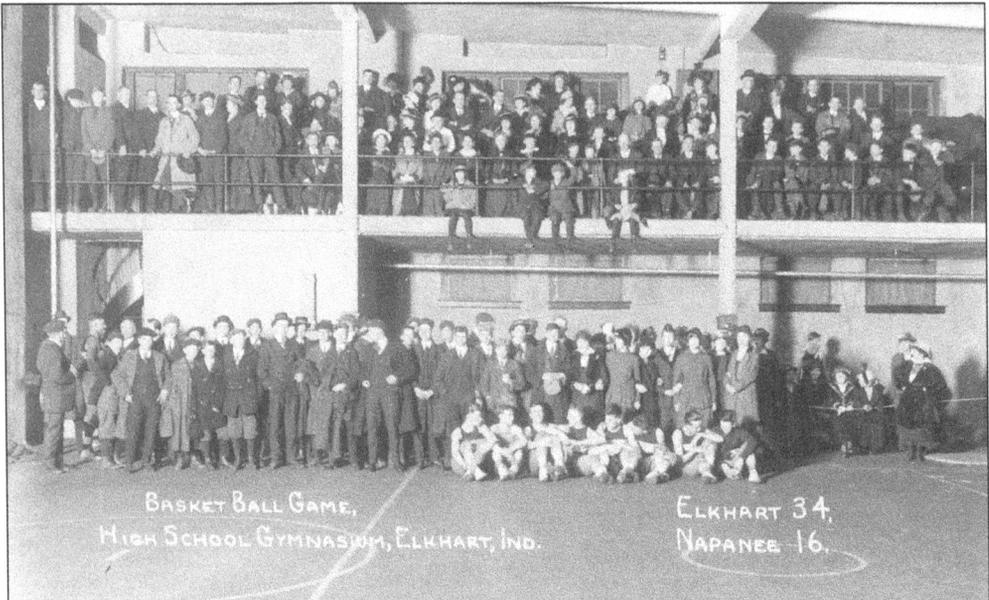

BASKET BALL GAME,
HIGH SCHOOL GYMNASIUM, ELKHART, IND.

ELKHART 34,
NAPANEE 16.

Quite an impressive crowd turned out to watch a basketball contest in the high school gymnasium. The picture was taken sometime in the early 1910s. The match-up was between Elkhart and Nappanee, and Elkhart soundly defeated their opponent by a score of 34 to 16. Years later, in 1953, a new gymnasium would be constructed which was celebrated as the world's largest high school gym. Built at the north end of Main Street, it was adjacent to the newly erected North Side Junior High School, and boasted a seating capacity of 8,000. (Courtesy of Elkhart Public Library.)

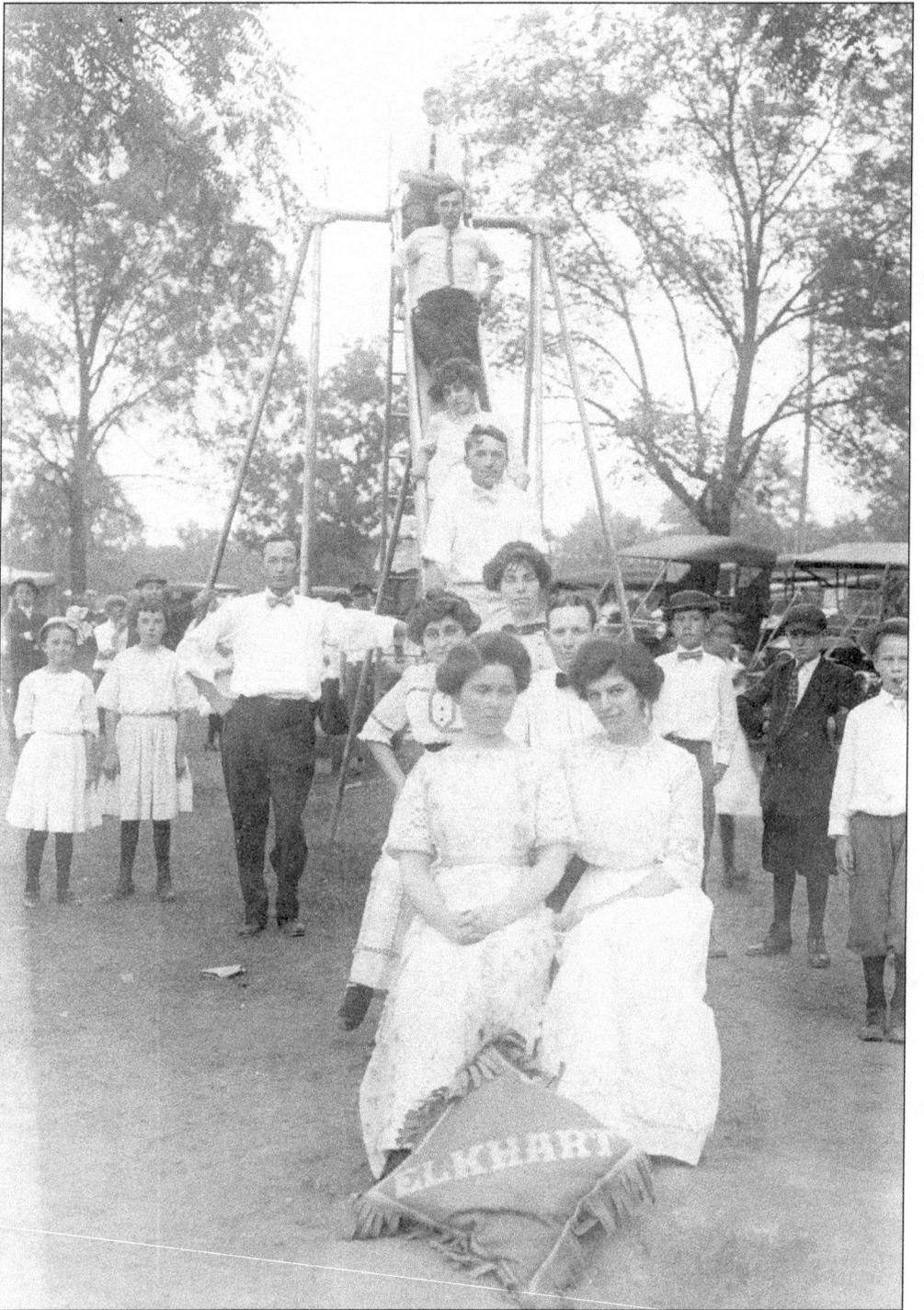

Chautaqua festivities were held at McNaughton Park, c. 1910. A chautaqua gathering typically included such attractions as musical and dance events, lectures, seminars, and demonstrations, all of which were generally held outdoors, beneath the shelter of tents. (Courtesy of Elkhart Public Library.)

North Main Street, between Jackson Boulevard and Jefferson Street pictured in 1911. Only the structure to the right is standing today—the lower level houses Paul Thomas Shoes, and the upper level is now the Time Was Museum. (Courtesy of Time Was Museum.)

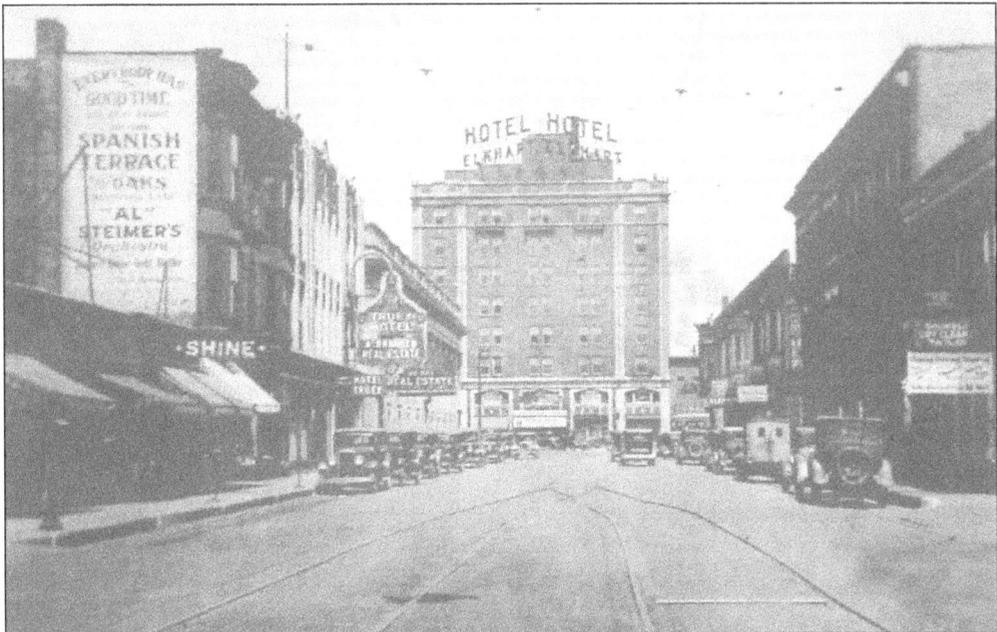

A look down the Marion Street thoroughfare, as seen from Second Street, in a 1920s or 1930s setting. The Hotel Elkhart is clearly visible at the end of the street, as is the Truex Hotel at the left. (Courtesy of Time Was Museum.)

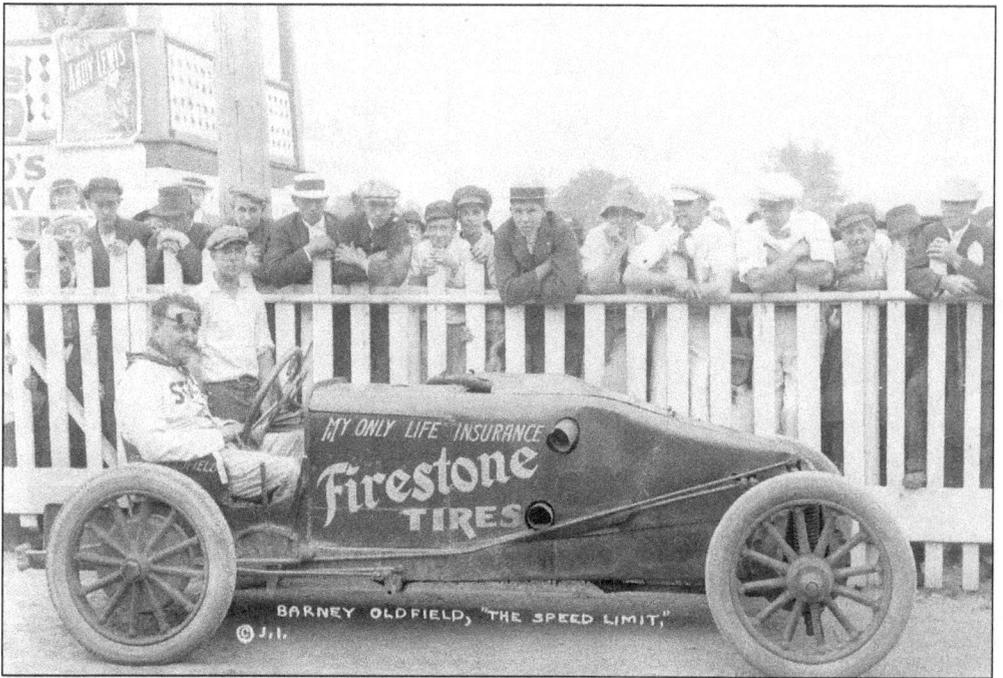

Barney Oldfield, perched behind the wheel of "The Speed Limit," during race time at the Elkhart Driving Park, approximately 1912. (John Inbody photo, courtesy of Elkhart Public Library.)

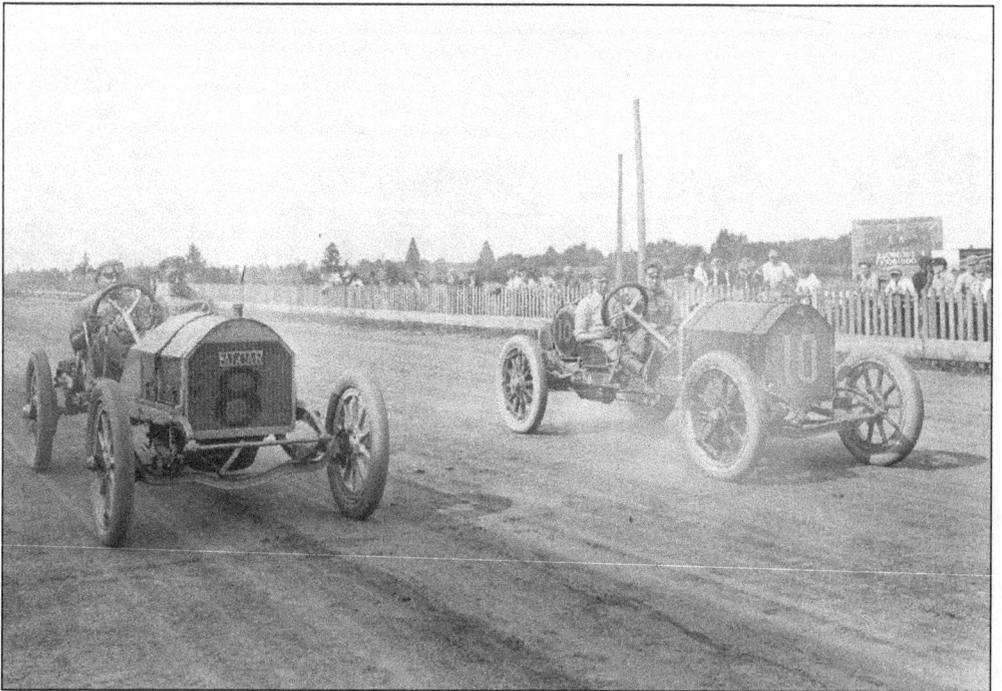

It was another day for auto racing at the Elkhart Driving Park, about 1912. (Courtesy of Elkhart Public Library.)

Spectators watch a driver making a rather precarious turn during races at the Elkhart Driving Park, around 1912. (Courtesy of Elkhart Public Library.)

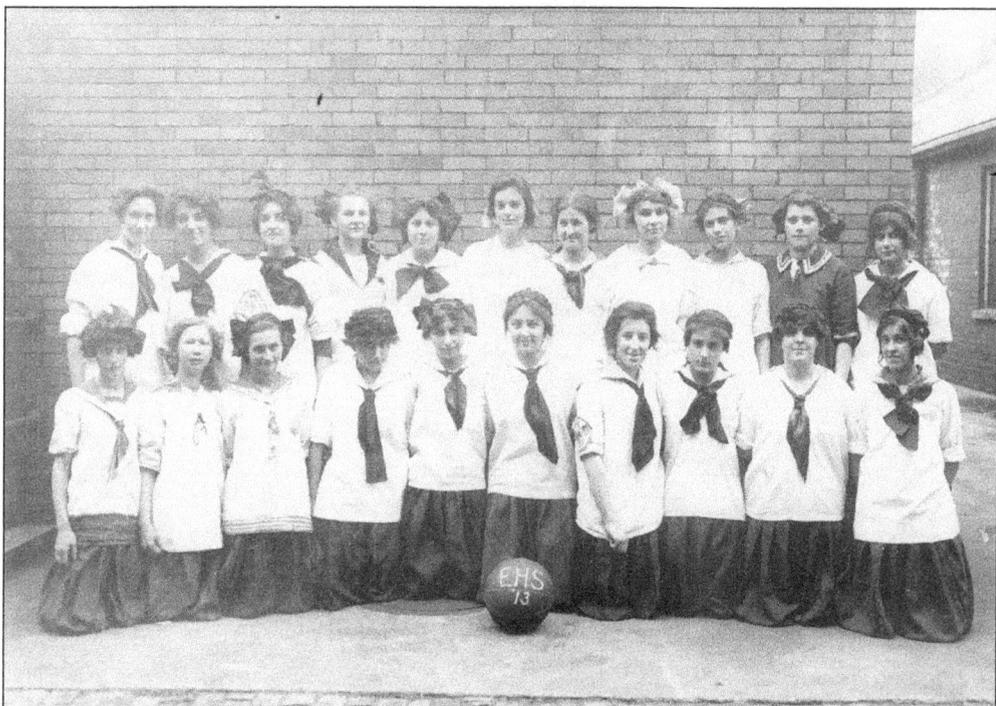

The young women of Elkhart High School's 1913 basketball squad pose for a photo in the doorway of Elkhart High School. (Courtesy of Elkhart Public Library.)

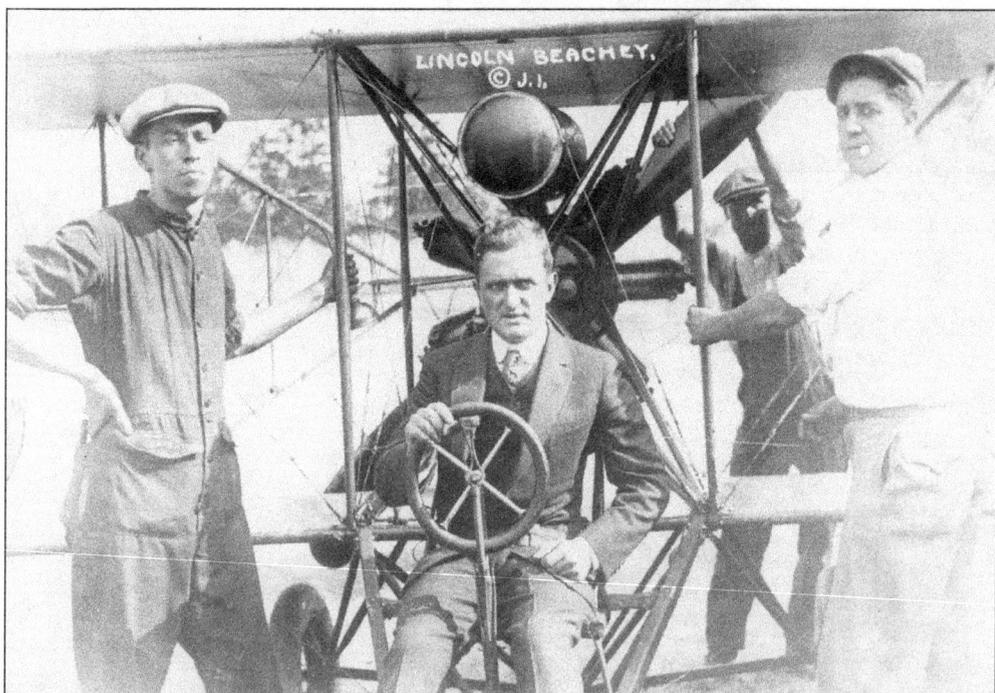

A fellow named Lincoln Beachey is seated at the controls of his biplane in a 1912 flying event held in the Elkhart Driving Park. (John Inbody photo, courtesy of Elkhart Public Library.)

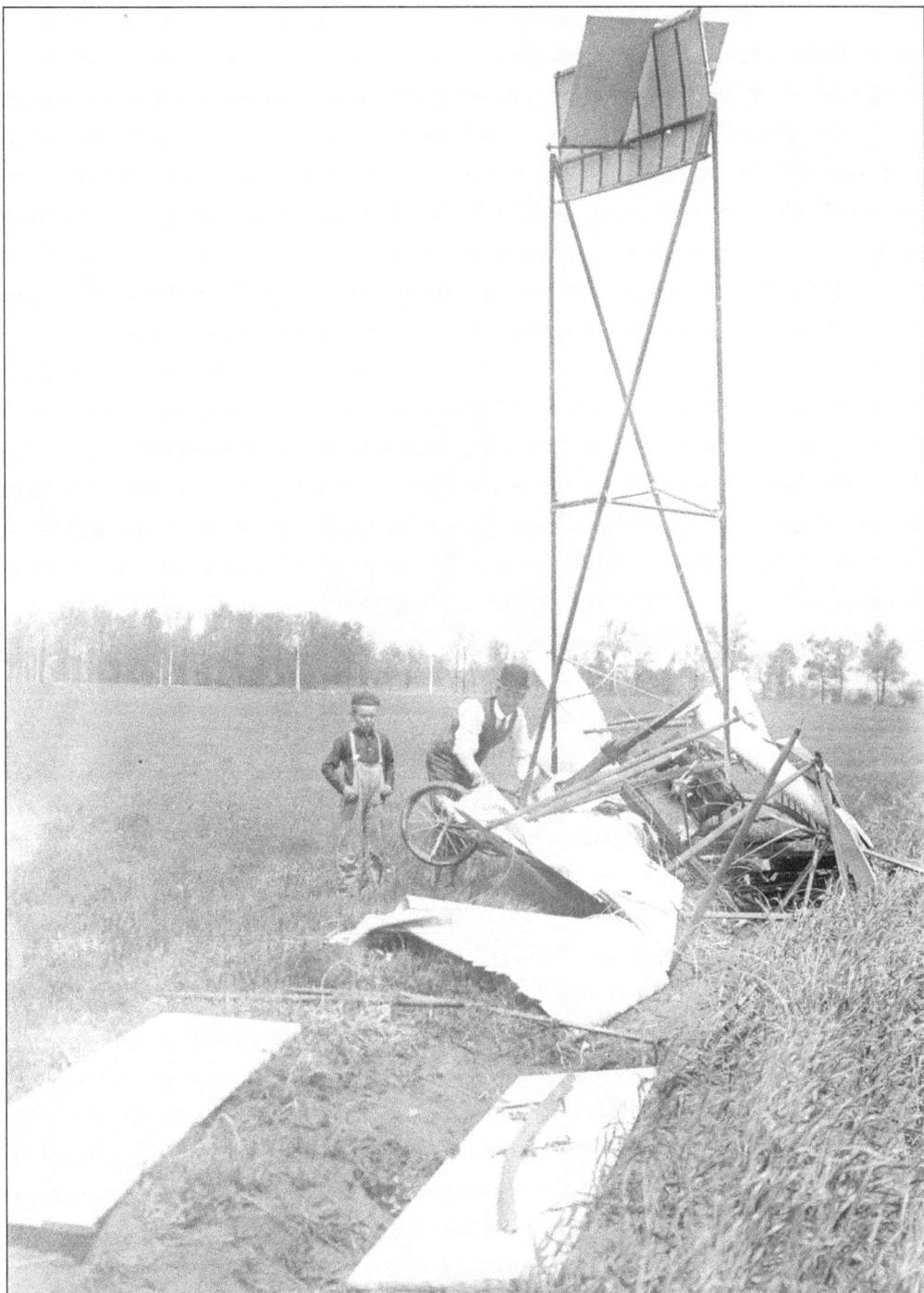

"The Indiana" pictured on May 15, 1911. This new plane had been built by McClellan Aviation Company of South Bend and was then transported to Elkhart Driving Park for a trial flight. Pilot William McGreanor was at the controls, but just as he was preparing to take flight, a power failure occurred, causing the plane to be reduced to a crumpled heap. Thankfully, McGreanor was not seriously hurt in the incident. (Courtesy of Elkhart Public Library.)

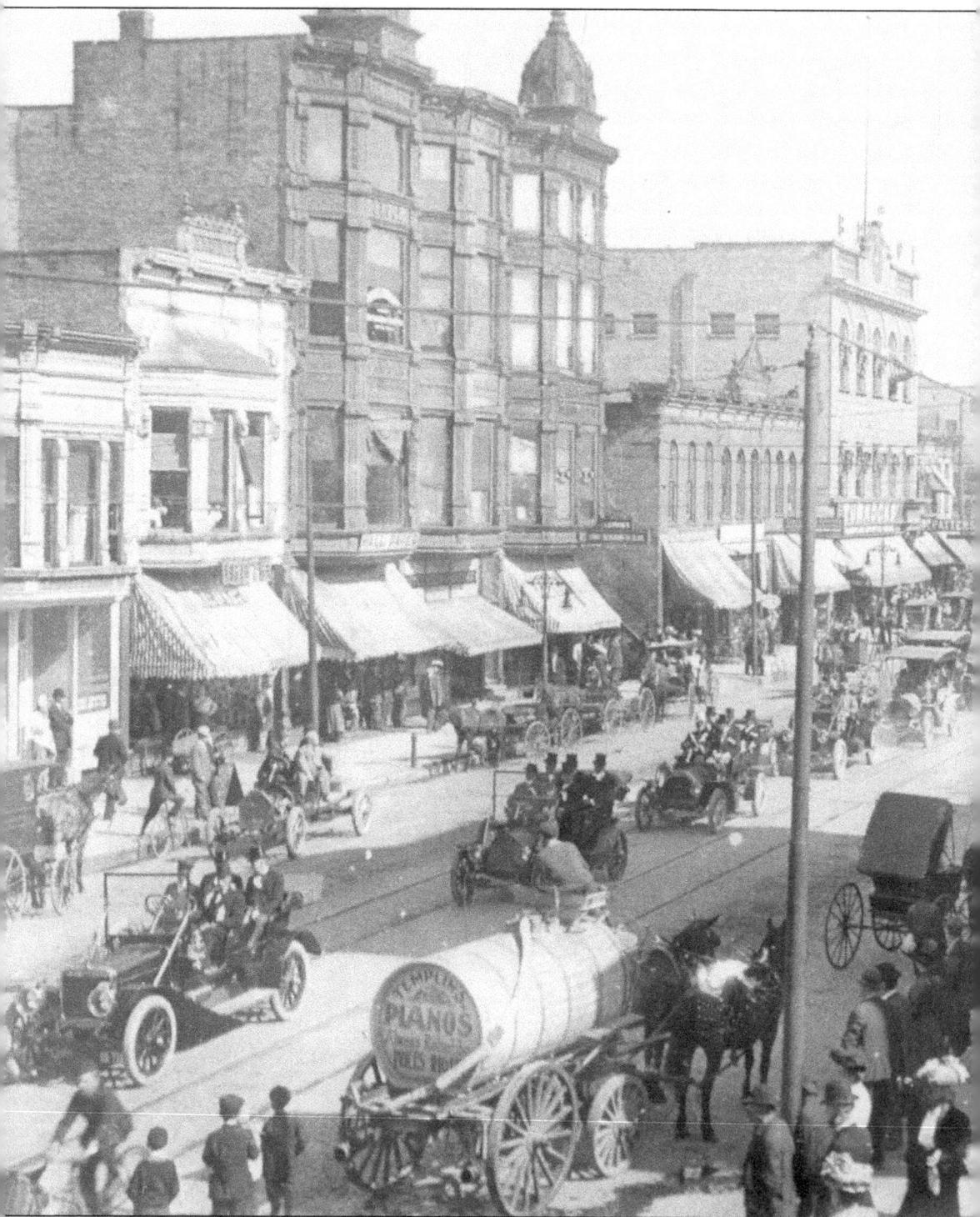

The Mason Parade, May 18, 1911, is pictured looking south on Main Street from the corner of High Street. The old Kavanagh & Pollard grocery store is at right. All of the buildings seen at the left are now gone, replaced by the Midway Motor Lodge. The vehicle in the foreground is

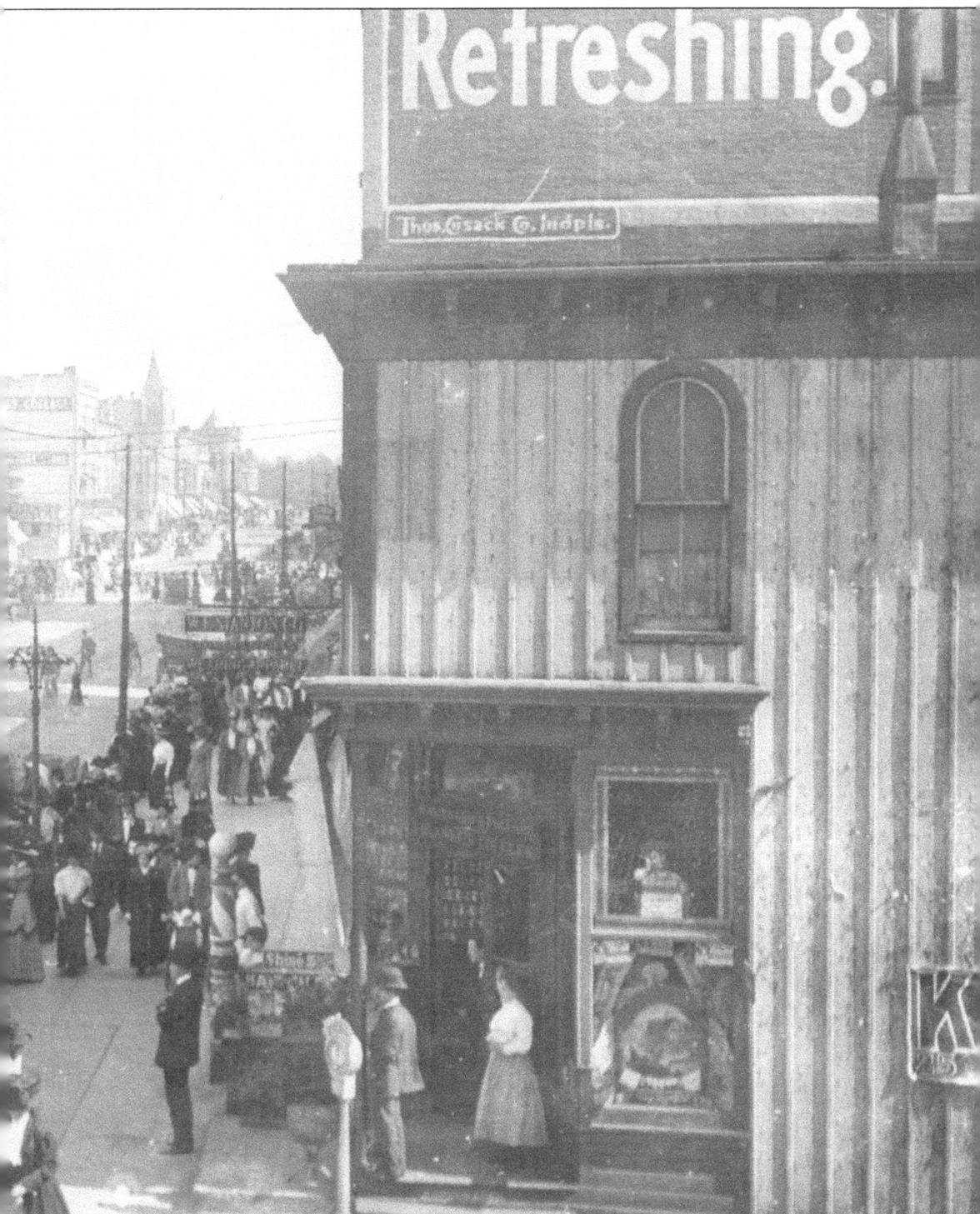

hauling a barrel of water, which was sprayed onto the dirt roadways to help prevent dust from billowing off the streets. (Courtesy of Elkhart Public Library.)

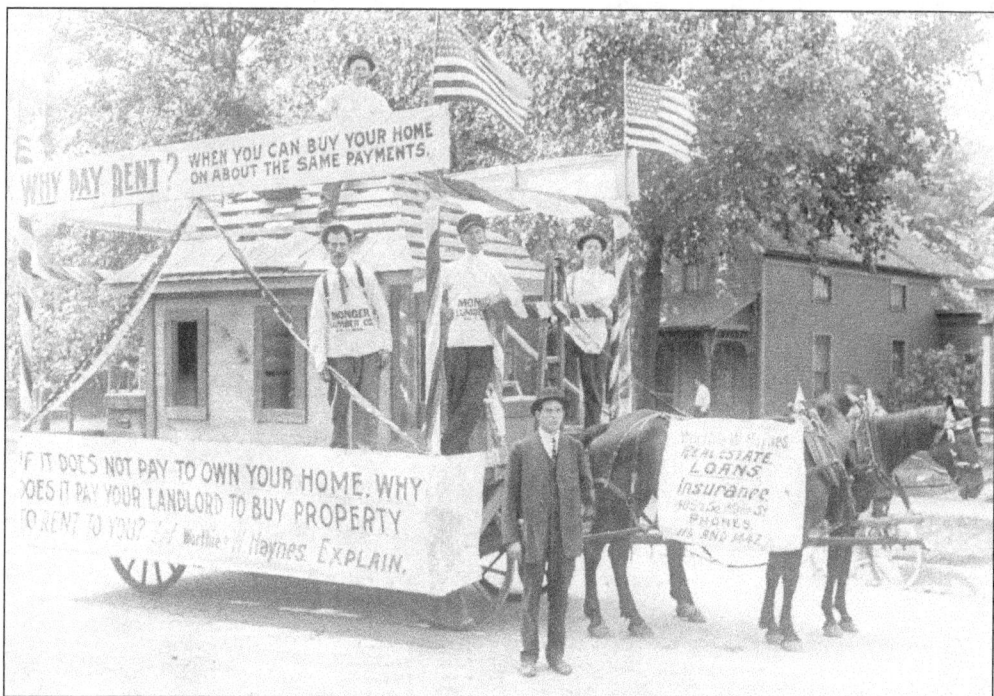

This was one of the more distinguished floats for the Industrial Parade of September 25, 1913. This particular float was sponsored by Worthie Haynes, a business that specialized in insurance and real estate loans. The business was located at 405^1/$_2$ North Main Street. (Courtesy of Elkhart Public Library.)

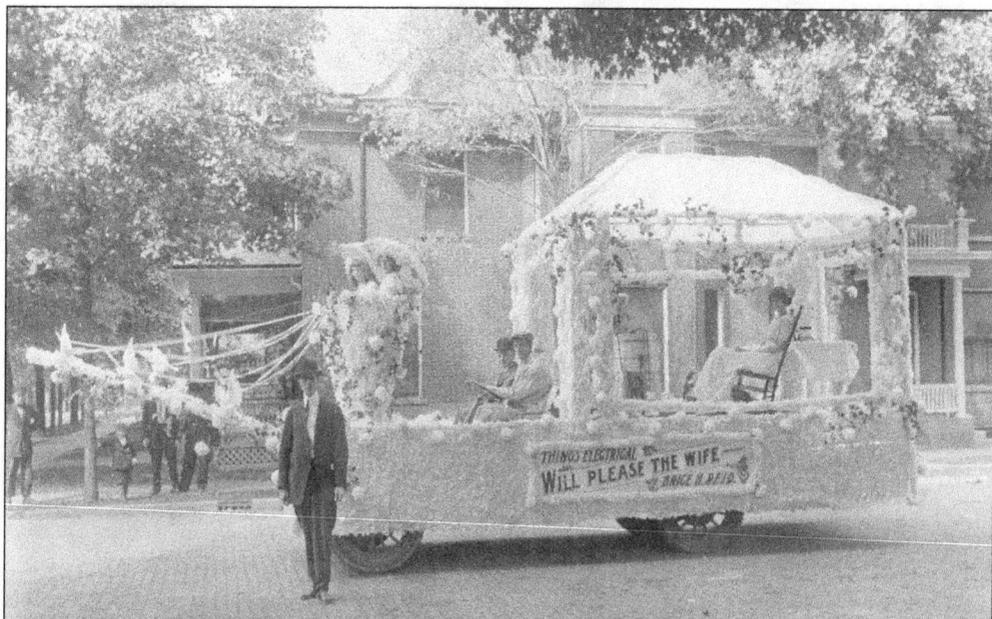

Another elaborately designed entry in the Industrial Parade, this time from the Indiana and Michigan Electric Company. The side of the float reads, "Things Electrical Will Please the Wife." (Courtesy of Elkhart Public Library.)

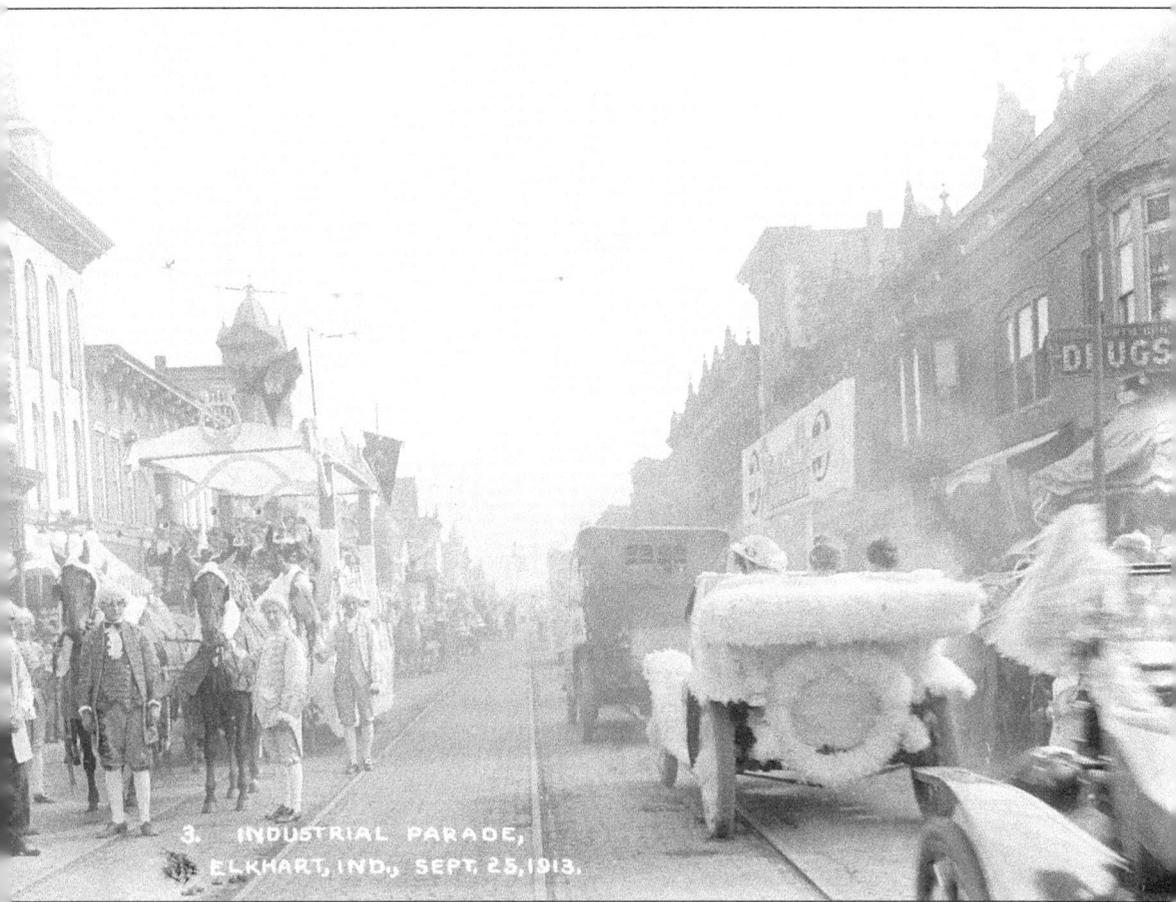

A wonderful glance from within, during the Industrial Parade of September 25, 1913, as it stretches along the Main Street thoroughfare. (Courtesy of Elkhart Public Library.)

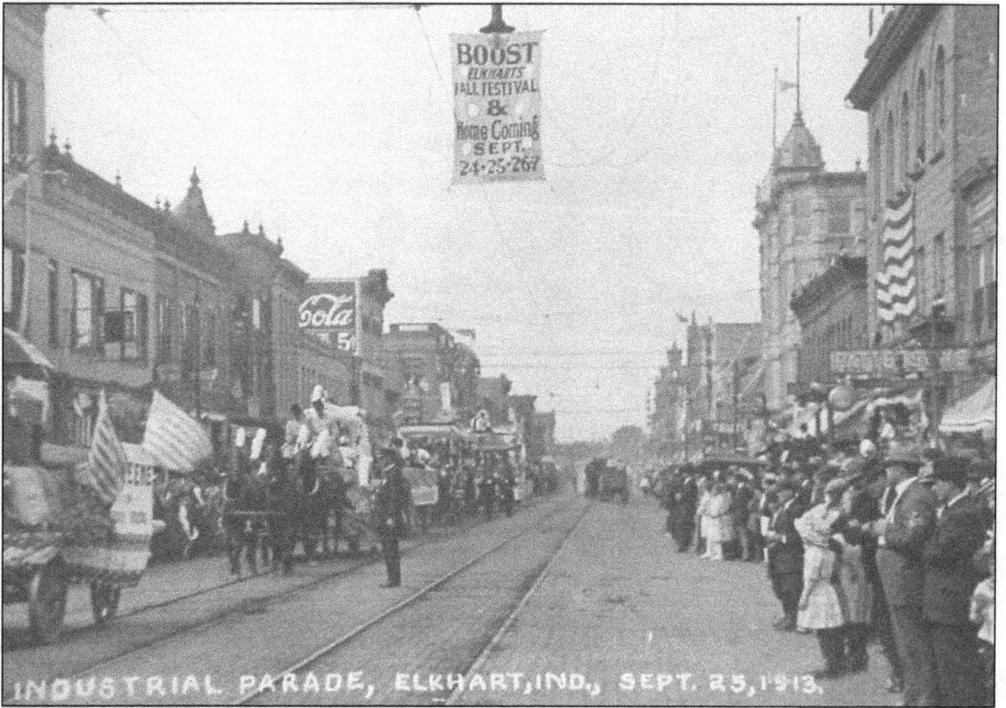

Here we have another glimpse of the Industrial Parade, September 25, 1913. (Courtesy of Time Was Museum.)

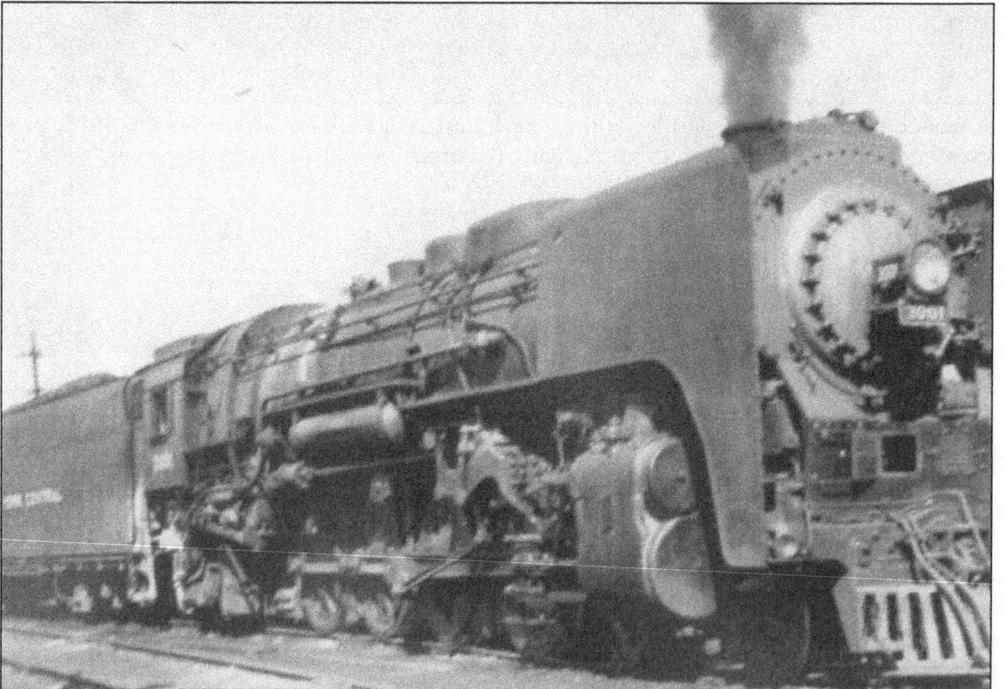

A gallant looking New York Central locomotive steams its way through the city of Elkhart—it is not known exactly when the photo was taken. (Courtesy of the City of Elkhart.)

The Miles Medical Company, as it was in 1935. Dr. Franklin Lawrence Miles was a practicing "physician, oculist, and aurist" in the late 1870s when he created a product called Nervine. His claim was that an unhealthy nervous system would cause symptoms throughout the body, so his new medicine purported to restore the balance of one's well being. In 1885, Dr. Miles, along with partners George Compton and A.R. Burns, established a business of medicine production, and by 1891, the firm had a new facility, the building shown here. It was located on the south side of Franklin Street, between Main and Second streets, and was originally called Dr. Miles' Remedies. Miles Laboratories, as it would eventually be called, was the creator of one of the most popular cold medications of all time—Alka-Seltzer, introduced in 1931. The building where Dr. Miles' Remedies was launched was demolished to build the St. Joseph Valley Bank. (Courtesy of Time Was Museum.)

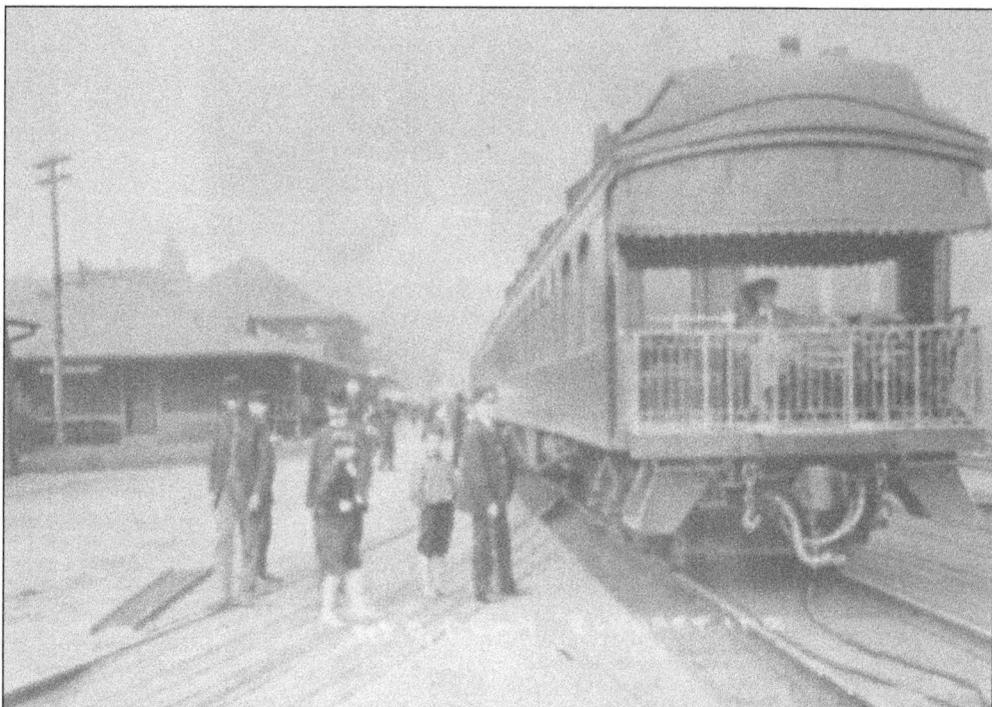

This is a look at the New York Central depot—judging by the young lads sporting knickers, the photo was probably taken around 1910. The car in the foreground was called an observation car, part of a series of cars that made up the Twentieth Century Limited. (Courtesy of Time Was Museum.)

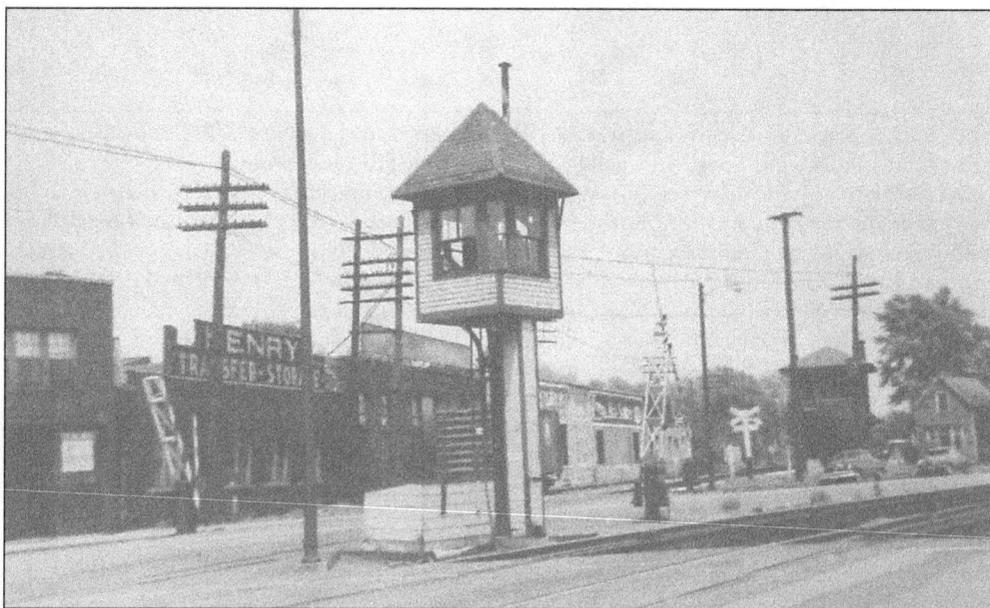

This is an old railroad gate watchtower that sat along the railway near Middlebury Street. By looking at the cars that are parked just off in the distance, the photo looks as if it might have been taken sometime in the 1950s. (Courtesy of Time Was Museum.)

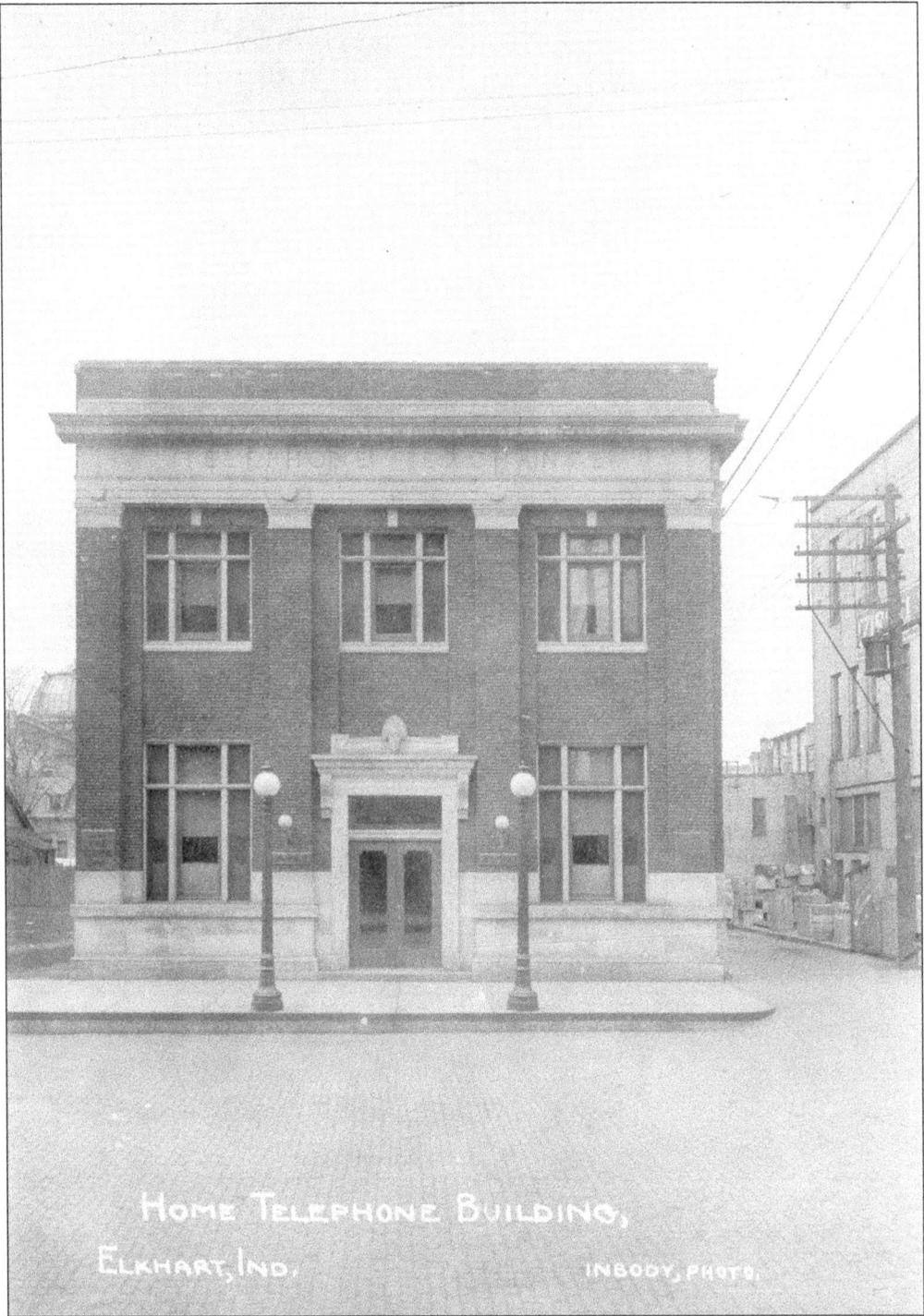

The Home Telephone Company, yet another inspiration fulfilled by E. Hill Turnock, located on Franklin Street. It served a number of purposes over the years, including the providing of office space for Ziesel's after the new telephone company came into service. The structure was torn down in 1986. (John Inbody photo, courtesy of Elkhart Public Library.)

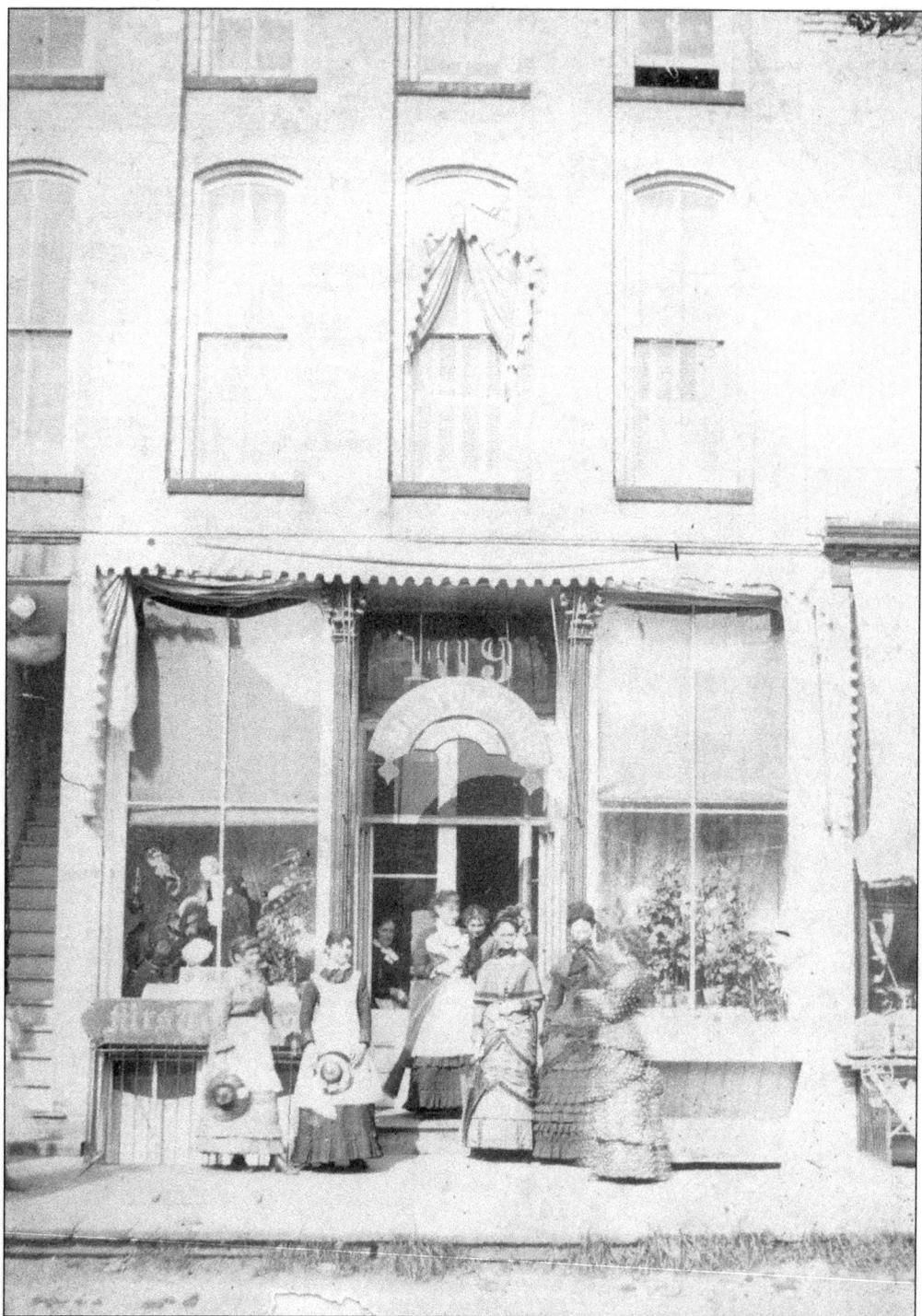

A gathering of ladies pose for a photograph near the entrance of a business curiously bestowed the name Mrs. Tompkins, at 109 South Main Street. The picture is dated March 27, 1906. (Courtesy of Elkhart Public Library.)

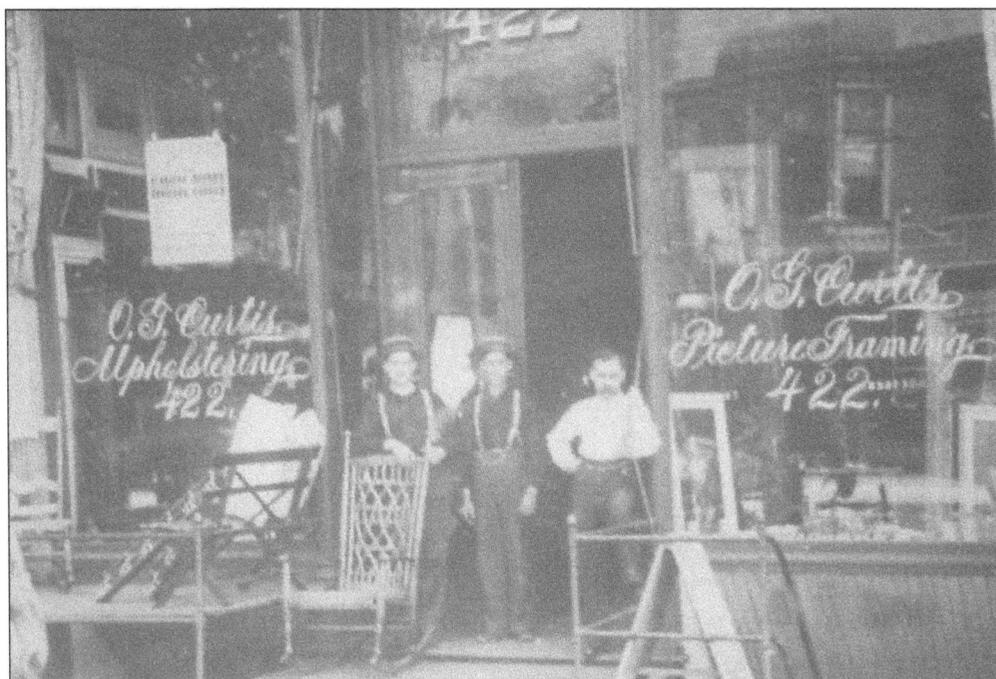

A trio of gents pause in the day's routine to be photographed outside 422 South Main Street, a business known as Curtis Upholstering and Picture Framing. (Courtesy of Time Was Musuem.)

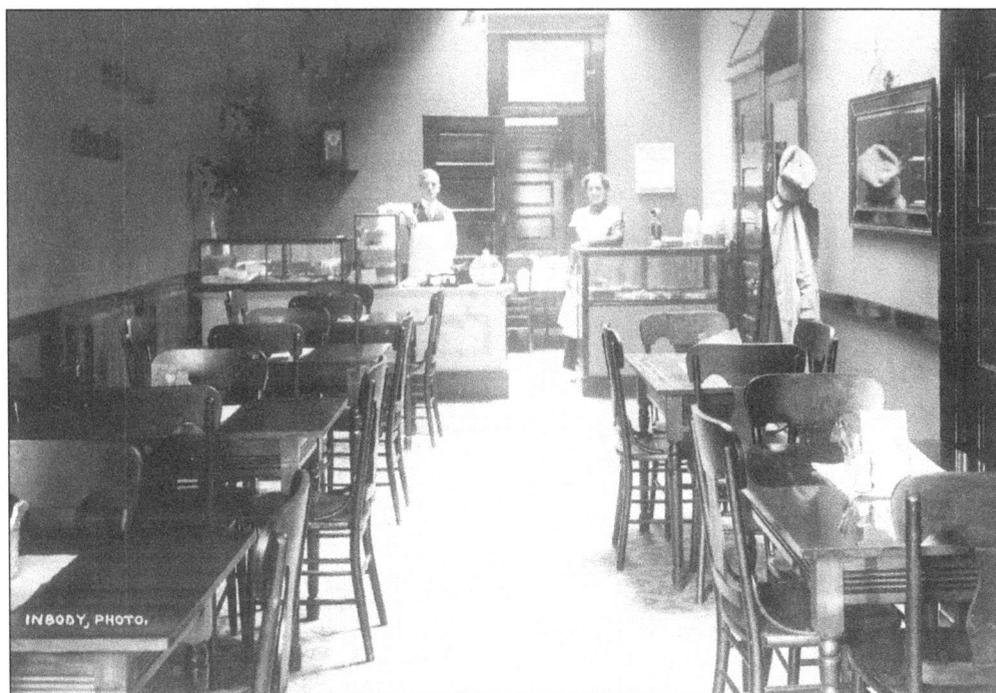

A quiet moment inside the Midget Lunch Room located at $534^1/_2$ South Main Street. The exact year that the photo was taken is not known, but a best guess is that it could have been snapped in the early to mid-1910s. (John Inbody photo, courtesy of Elkhart Public Library.)

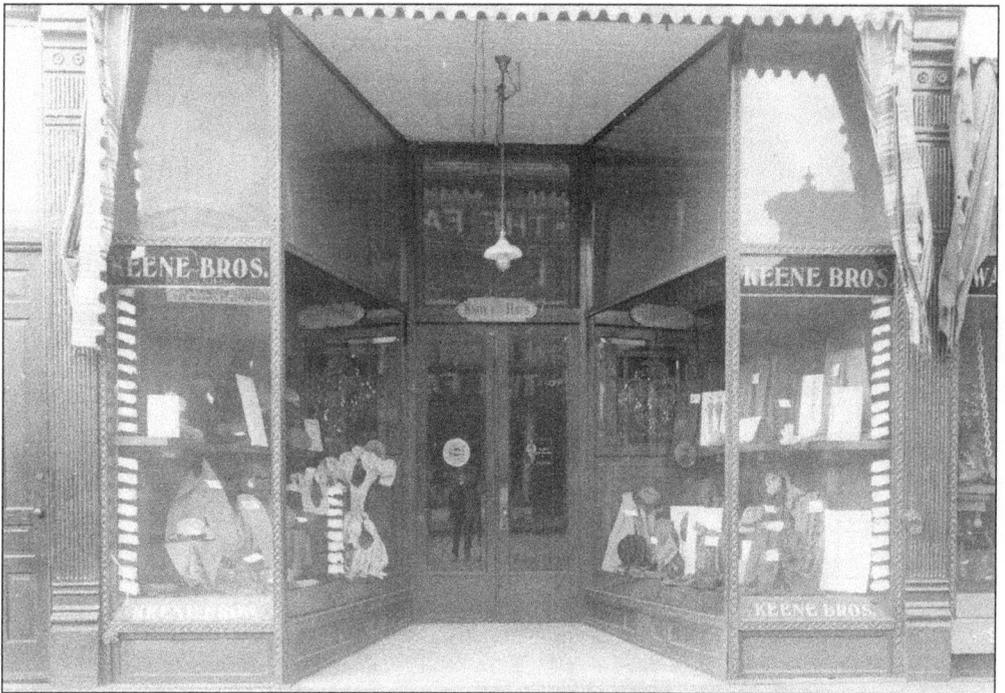

An undated glance through the window of another downtown business, the Keene Brothers Clothiers. The photo was possibly taken in the early 1900s. (Courtesy of Elkhart Public Library.)

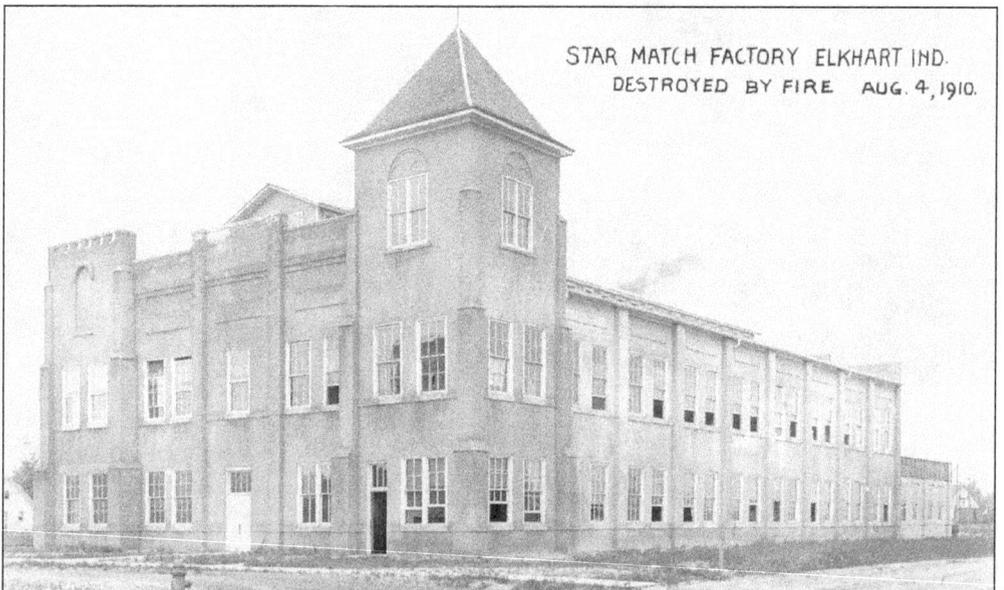

STAR MATCH FACTORY ELKHART IND.
DESTROYED BY FIRE AUG. 4, 1910.

The former Star Match Factory was later reduced to ruins by a fire on August 4, 1910. The event transpired just weeks after the C.G. Conn Band Instrument Company blaze which completely devastated that factory. The Conn catastrophe prompted the fire department to secure the purchase of a new motorized pumper, but shortly before the new truck could be delivered, this factory was lost as well. (Courtesy of Elkhart Public Library.)

Another lodging facility, the old Elkhart House, it was located on the southeast corner of Second Street and Jackson Boulevard. The exact date of the photo is not known. (Courtesy of Elkhart Public Library.)

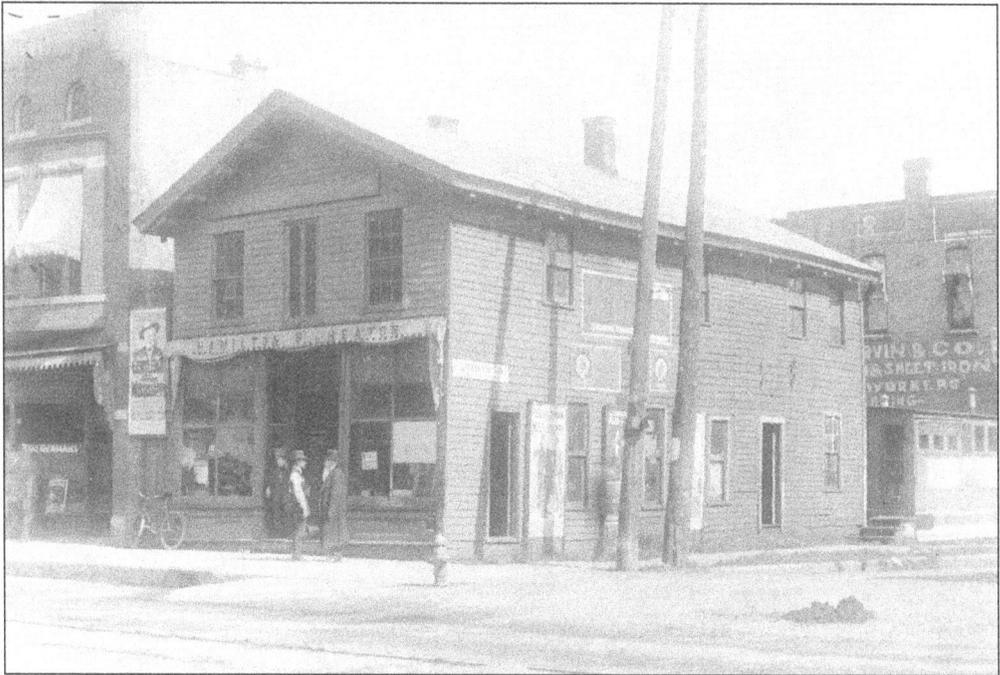

The Hamilton & Heaton Company, a small business which specialized in awning manufacturing. It was located at the northeast corner of Main Street and Lexington Avenue, at 104 South Main, and was in operation from 1904 to 1906. (Courtesy of Elkhart Public Library.)

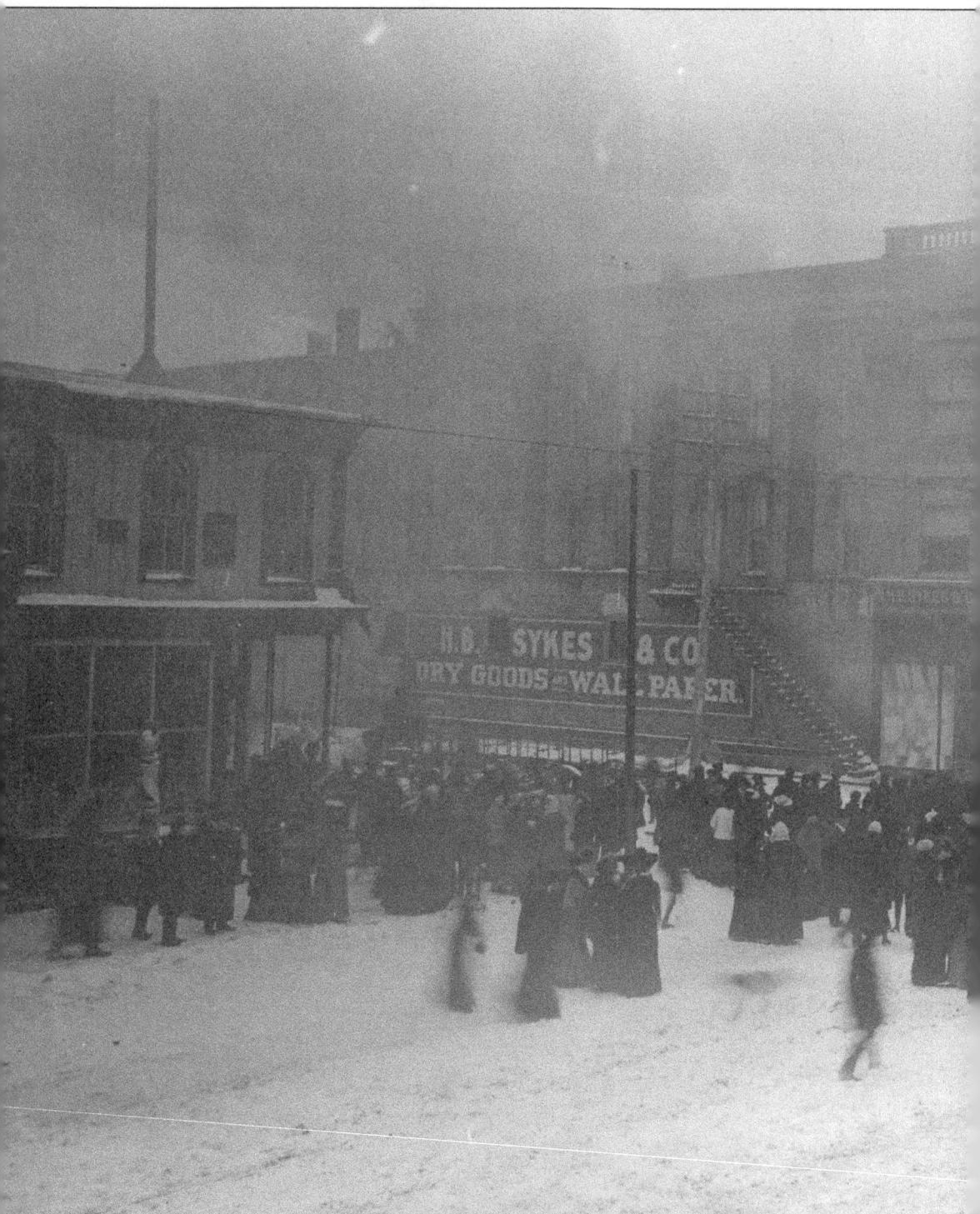

A fire ravages the H.B. Sykes and Co. dry goods store on a blustery winter day in 1904. Despite the weather, the fire was quite a spectacle for the onlookers. The store was located at the corner of Main and High Street and later became the site of the Drake's Department store, which, in

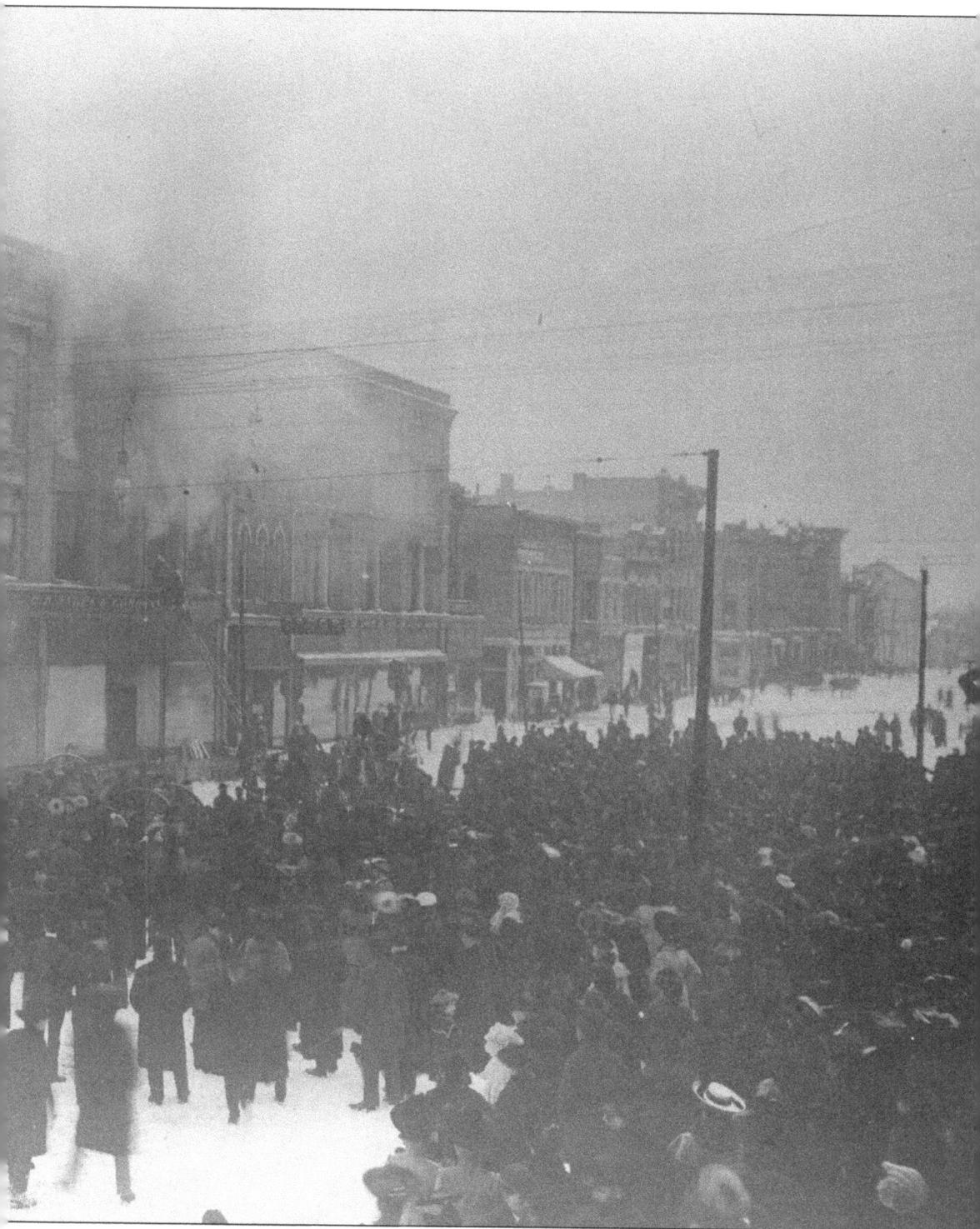

an eerie coincidence, also was heavily damaged in a winter fire about 50 years later. (Courtesy of Elkhart Public Library.)

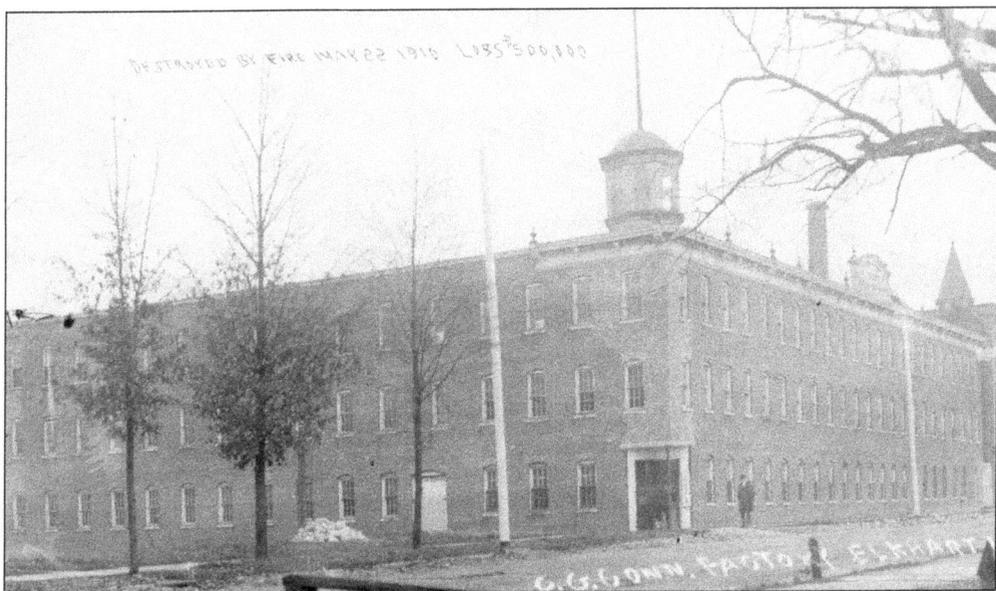

Undaunted by the loss of his first factory, C.G. Conn wasted precious little time in having a new factory up and running. This more spacious building was literally risen from the ashes, right on the very site as the first factory. Incredibly, this second factory would meet with the same destructive fate—it, too, was consumed by fire. (Courtesy of Elkhart Public Library.)

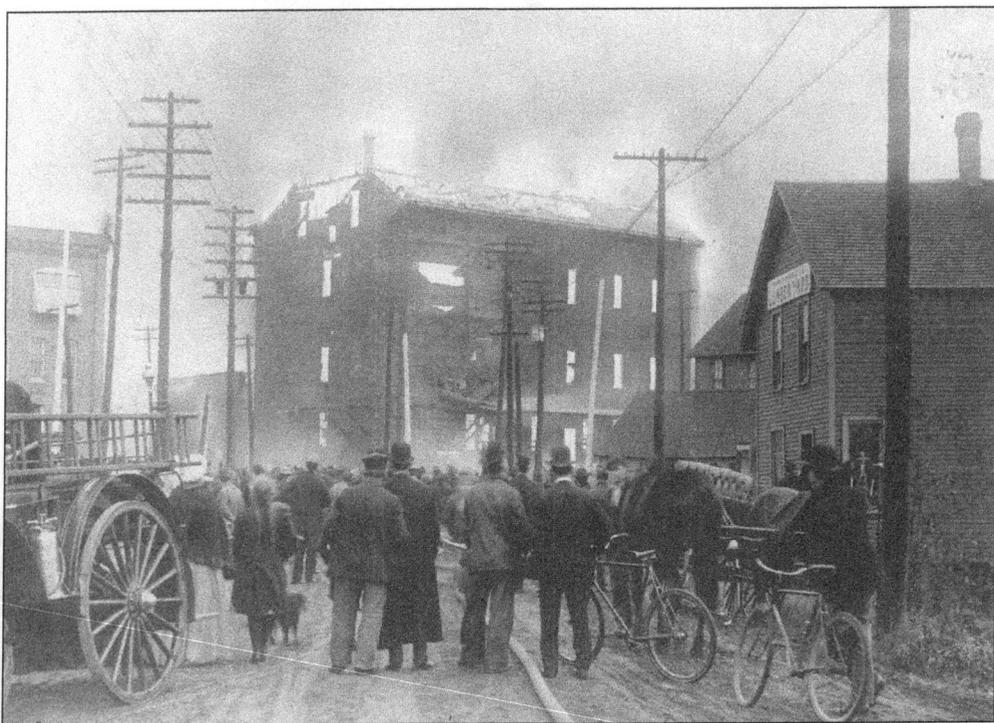

A throng of observers watches with feelings of helplessness and awe, as the Harvest Queen Flour Mill is consumed by a raging inferno which lit up the horizon. The structure was leveled to the ground by the 1909 blaze. (Courtesy of Elkhart Public Library.)

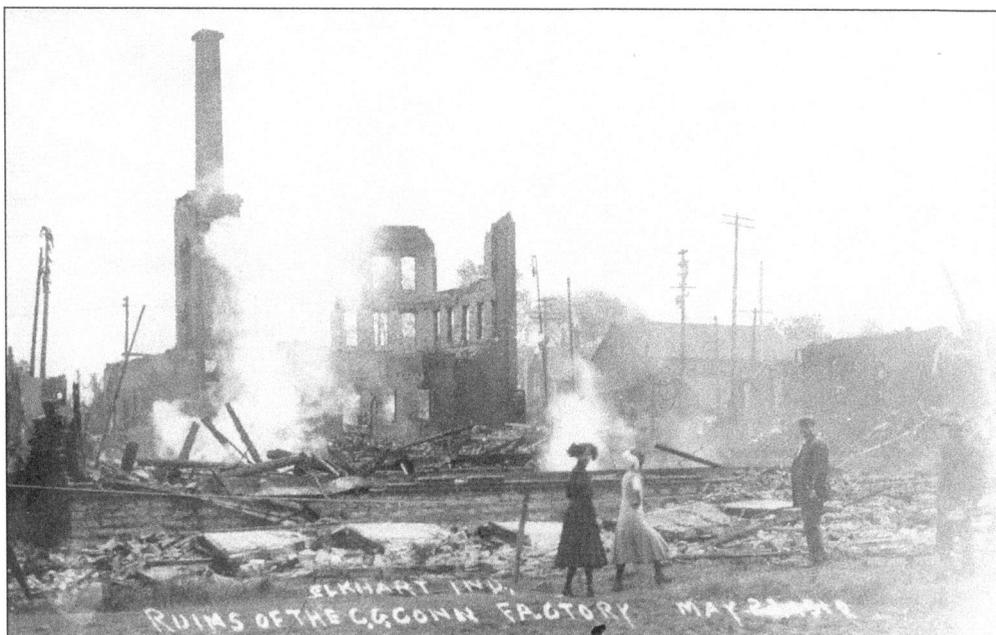

This was all that remained of the C.G. Conn factory after flames tore through the facility on May 22, 1910. The damage estimate exceeded $500,000. Just months later, Conn rebuilt his empire, but this time, he chose a different site—1101 East Beardsley Avenue. E. Hill Turnock was the designer of the new facility. (Courtesy of Elkhart Public Library.)

The Burrell Morgan Flour and Feed Mill was located at 205 East Jackson Boulevard, around 1910. (Courtesy of Elkhart Public Library.)

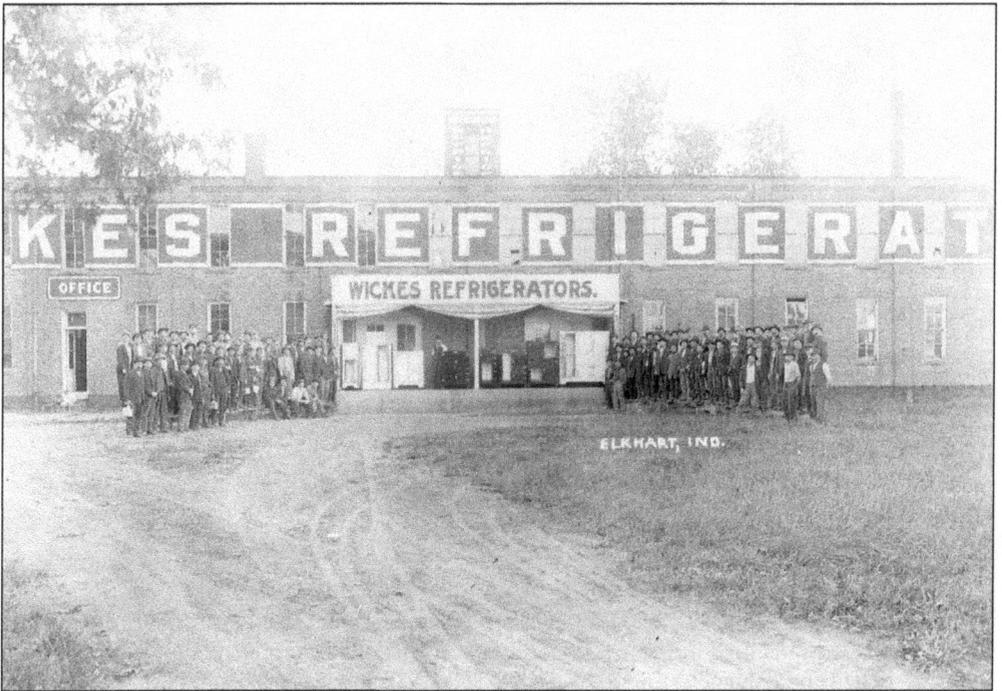

Workers pose for a photograph outside of a new business called Wickes Refrigerators, approximately 1910. (Courtesy of Elkhart Public Library.)

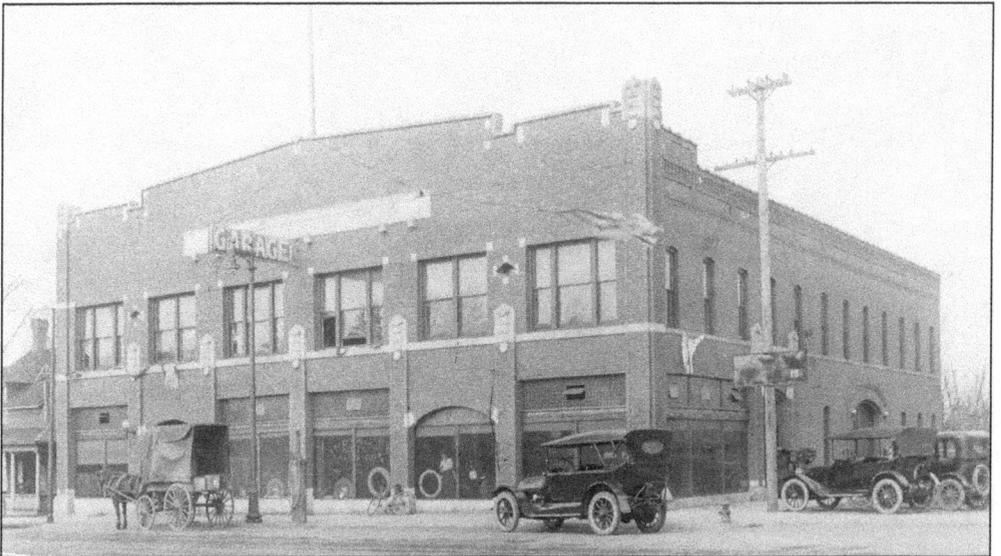

The Elkhart Armory, found at the northeast corner of Main and Jefferson streets. E. Hill Turnock is the man responsible for this building, which was created in 1910. The lot on which this building stands was at one time the site of the city's first public automobile garage. In 1911, Herbert Bucklen doubled the structure size to provide an armory for the local company of the National Guard. Turnock assisted with the expansion and redesigned the building's façade. In the years that followed, the building served as a grocery store, then a roller rink, and it presently operates as a liquor store. (Courtesy of Elkhart Public Library.)

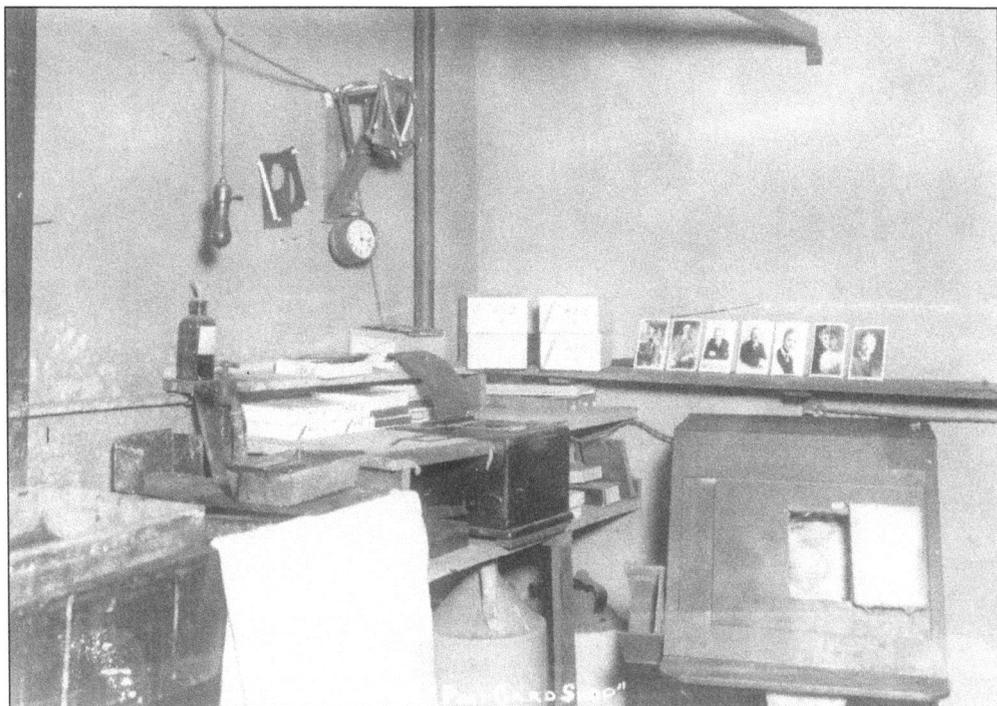

This small workshop was where many of Elkhart's early picture postcards were created. Though there is no indication of when this picture was taken. (Courtesy of Elkhart Public Library.)

The H.W. Gossard Corset Factory was another E. Hill Turnock work of art. This building was opened for use in 1907, and was located at the southwest corner of Ren and Sterling streets. This picture was taken about 1910. (Courtesy of Elkhart Public Library.)

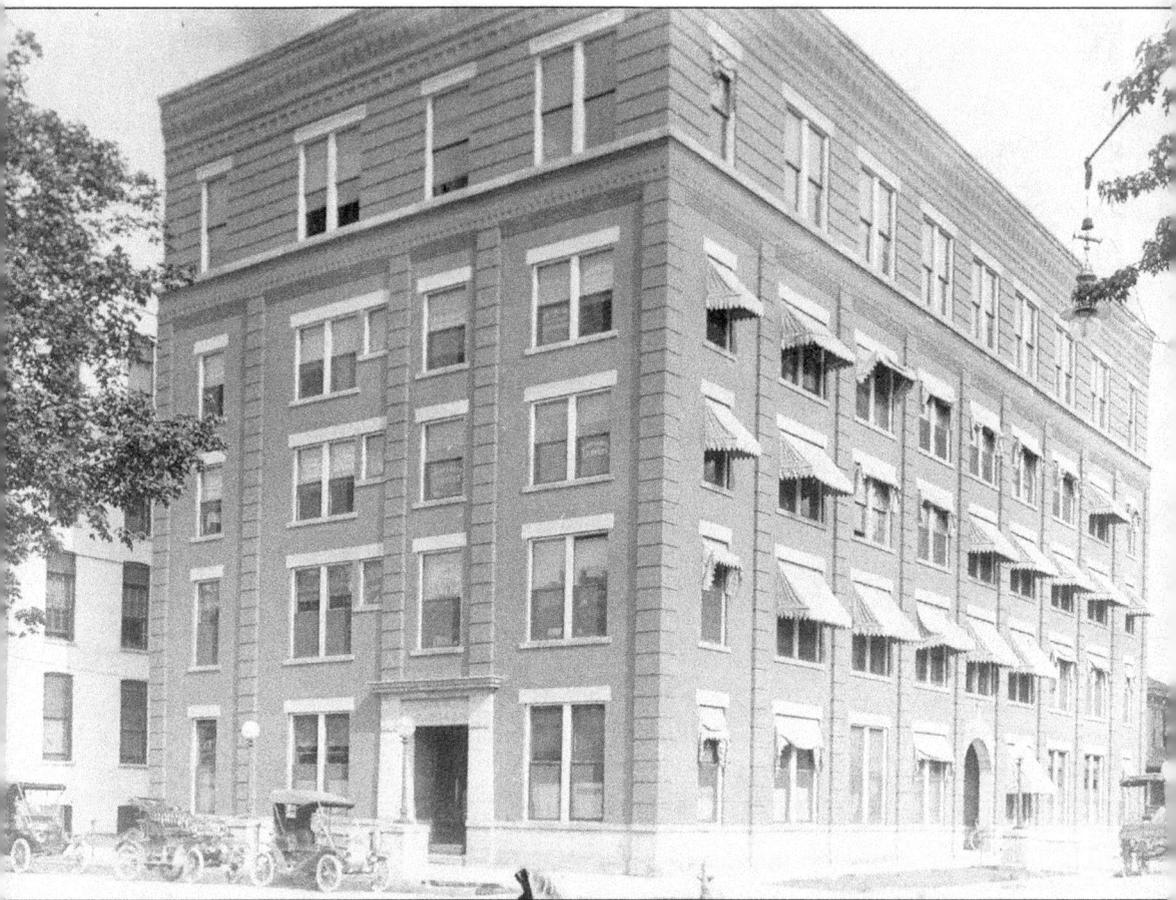

The Monger Building, as it looked around 1910. Located at the southeast corner of Second and Franklin streets, it was built in 1904 and was one of the downtown's most prominent buildings. A fifth story was added in 1907, for the purposes of conducting Superior Court, until those sessions were relocated to the new municipal building in 1916. The Monger Building was razed in 1971 to clear the way for the new St. Joseph Valley Bank. (Courtesy of Elkhart Public Library.)

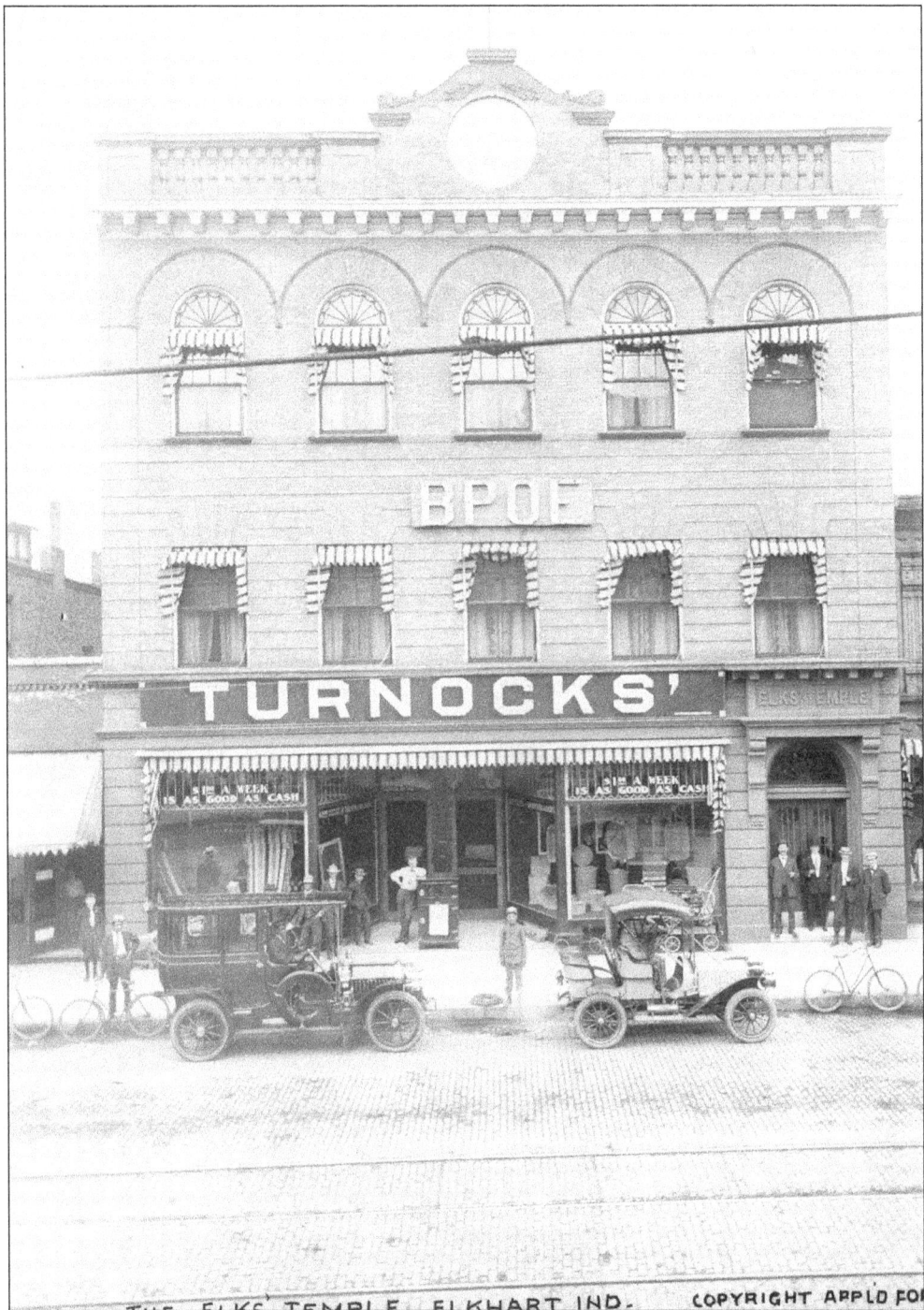

The Old Elks' Temple, as it appeared *c.* 1910. It was situated along the east side of the 300 block of South Main Street. At the time this photo was taken, the lower level of the building was occupied by Turnock's; the retail level later became Goldberg's Men's Store. The building was leveled in 1978 so that construction could begin on the new Midway Motor Lodge. (Courtesy of Elkhart Public Library.)

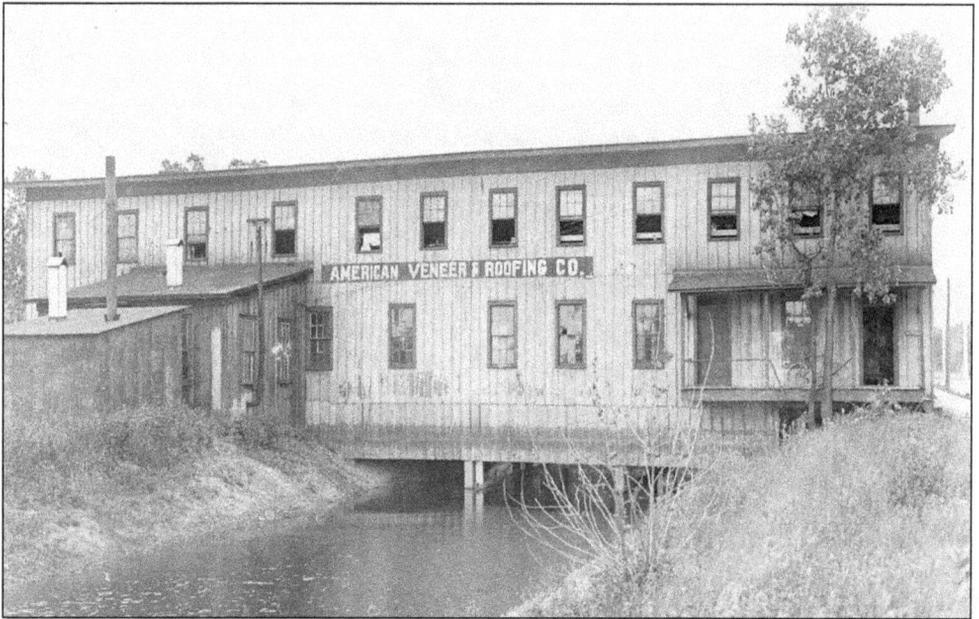

American Veneer and Roofing was located at 564 East Jackson Boulevard, around 1910. The factory specialized in the production of veneer roofing, a process that required the use of 75 tons of paper and 75 tons of asphalt each year. The waterway was used to provide hydraulic power for the manufacturing process. (Courtesy of Elkhart Public Library.)

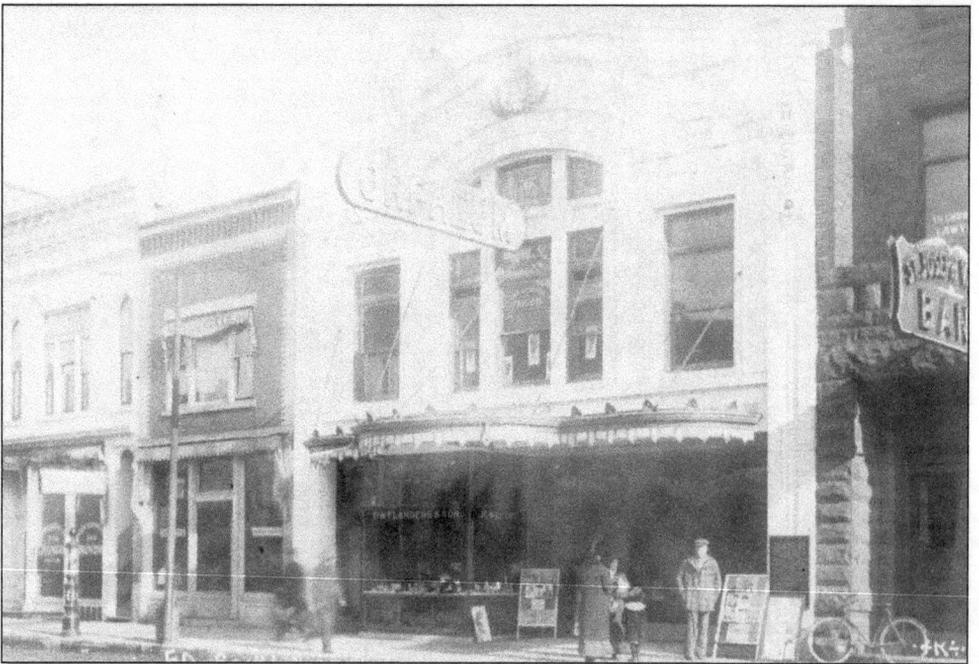

The Orpheum Theatre, right around the time of its Thanksgiving Day, 1913 opening event. The address was formerly 50 South Main Street until the block's address numbers were renumbered, and from that point, it was said to be located at 210 South Main Street. (Courtesy of Elkhart Public Library.)

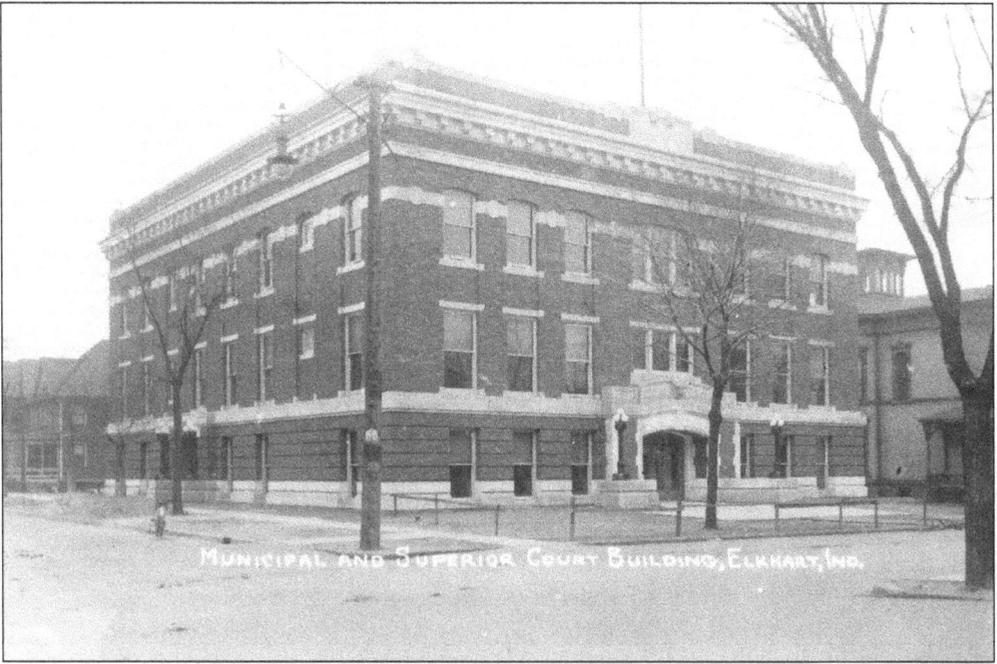

The Municipal and Superior Court Building, at the northwest corner of Second and High streets. This was an E. Hill Turnock work of art, and has endured so well over the last 75-plus years that the building continues to serve as the City Hall. (John Inbody photo, courtesy of Elkhart Public Library.)

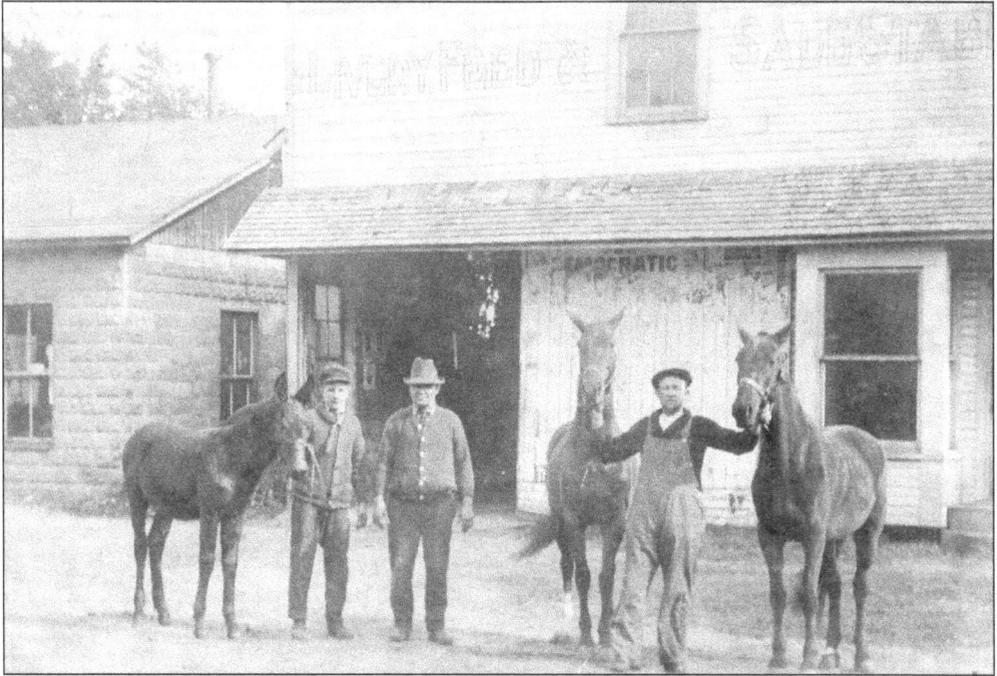

This picture of a local Livery, Feed, and Sale Stable was taken on October 13, 1916. Two of the gentlemen are identified as George and Carl Hamlet. (Courtesy of Elkhart Public Library.)

The Truth Publishing Company, formerly located at 416 South Second Street. This is the building where operations ran for nearly 50 years, from 1918 until 1965. The *Elkhart Truth* was founded on October 15, 1889 by C.G. Conn, and from 1920 on, served as the city's sole newspaper publication. In 1965, the *Elkhart Truth* took up residence in a building just across the street, in the former Equity Building. (Courtesy of Elkhart Public Library.)

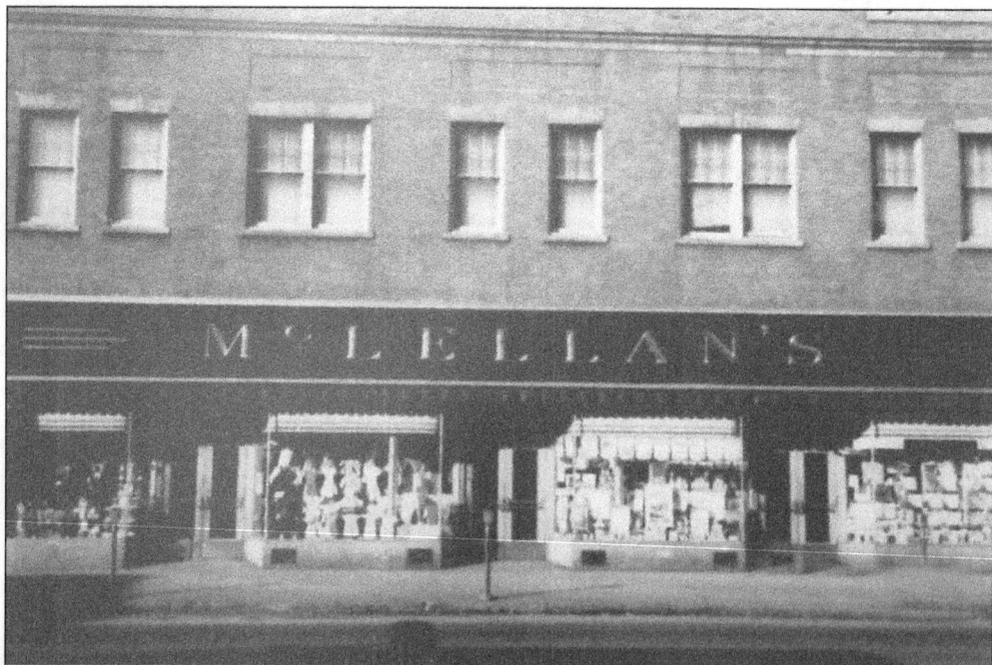

A look at the façade of the McClellan's Department Store; it was another mainstay of the downtown area. The date of the photo is uncertain. (Courtesy of the City of Elkhart.)

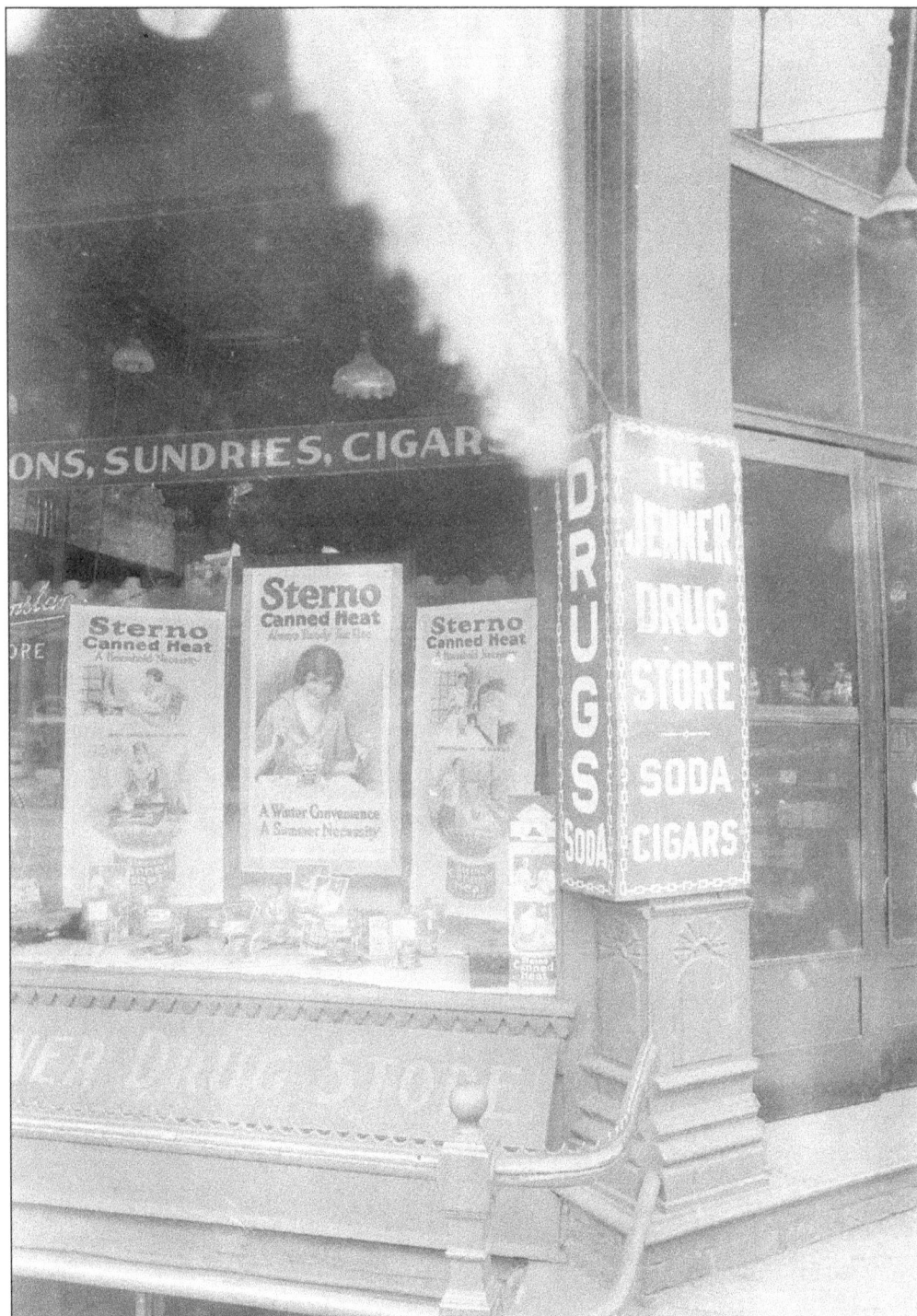

The Jenner Drug Store, in a scene from about the 1920s. Henry T. Jenner ran the store from 1910 until 1923, and was succeeded by his son, Alfred D., who continued to keep the business in the family until 1967. The store was located at the southwest corner of Main Street and Lexington Avenue, and was a popular place to savor a phosphate or soda. (Courtesy of Elkhart Public Library.)

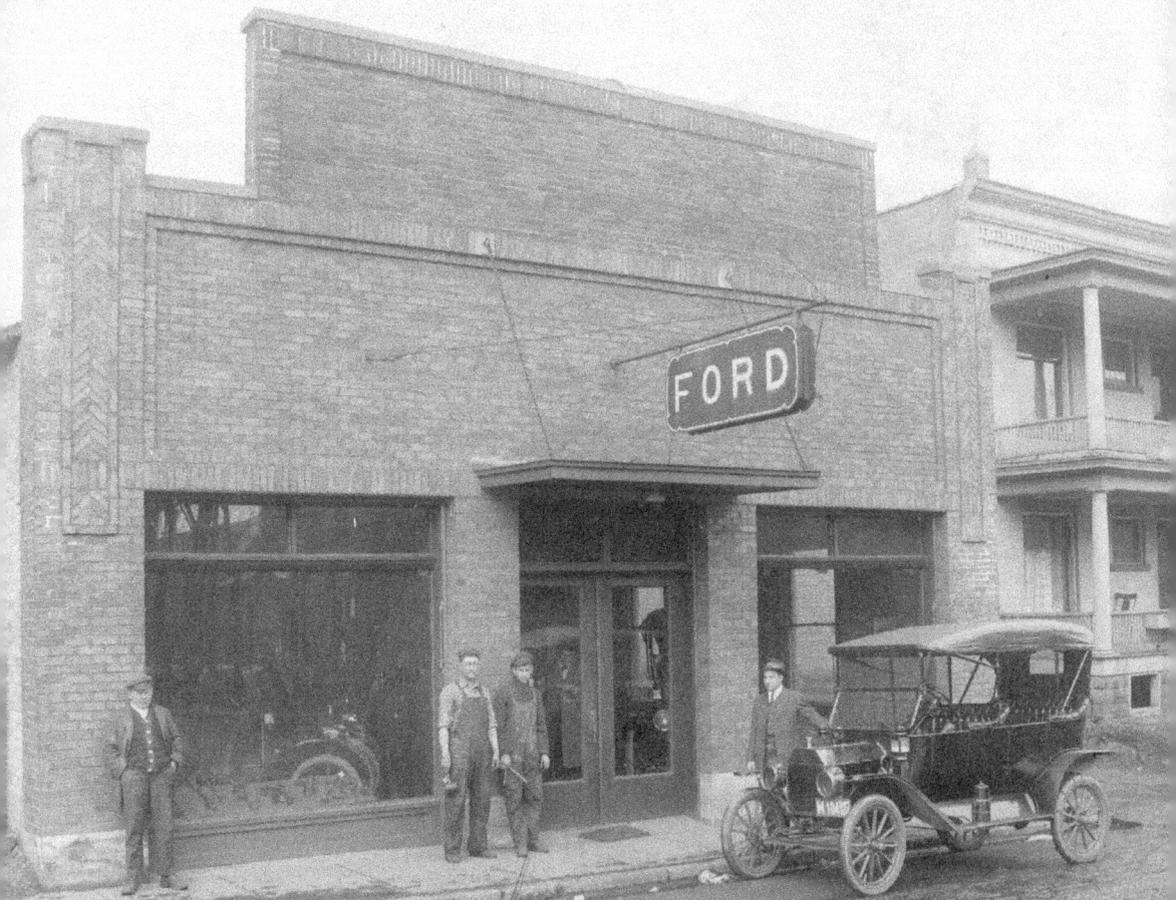

Surely, this must have been one of Elkhart's first businesses to specialize in automobile repairs and service. This was the Hamlet's Ford garage, owned and operated by Floyd Hamlet. The photo was probably snapped in the late 1910s or early 1920s. (Courtesy of Elkhart Public Library.)

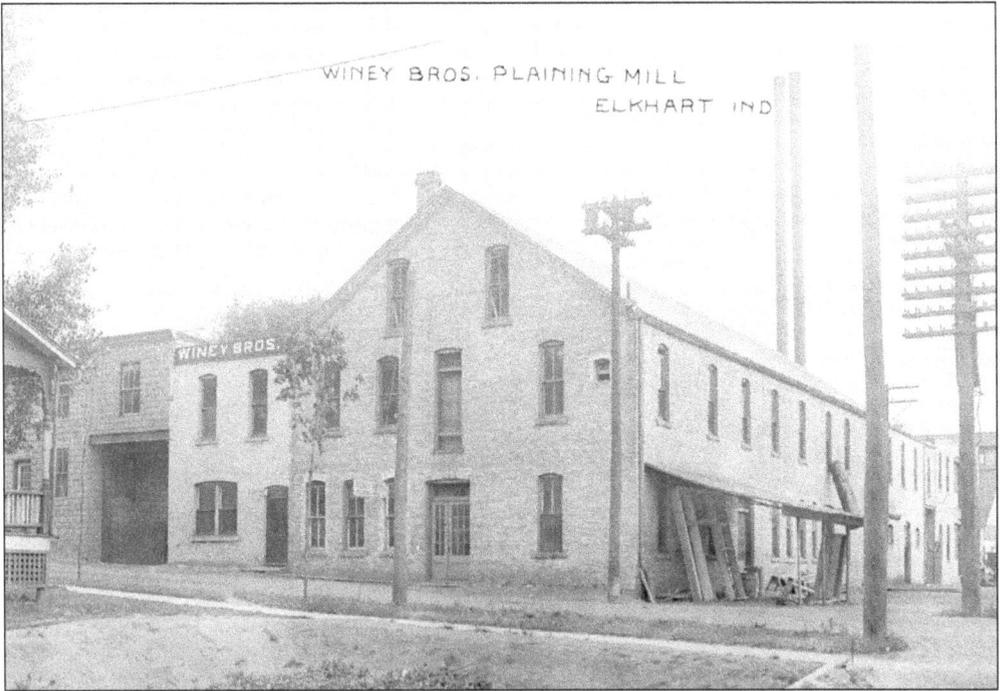

This is the Winey Brothers Planning Mill, located at 515 East Street, as it looked around 1920. (Courtesy of Elkhart Public Library.)

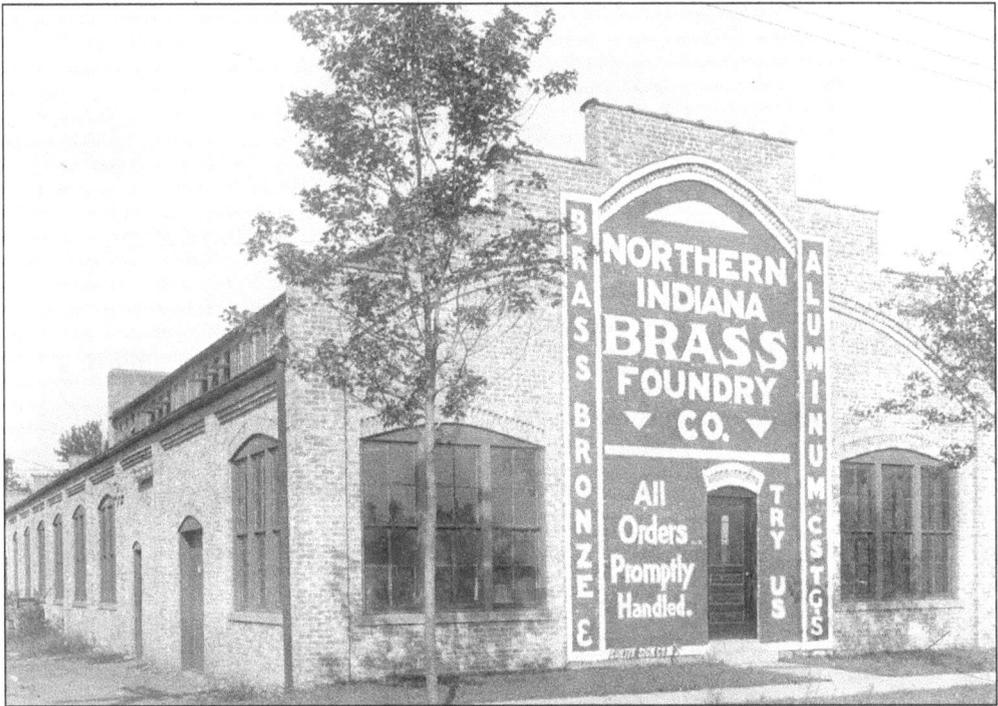

The Northern Indiana Brass Company, more commonly referred to as NIBCO, in a photograph taken in 1922. (Courtesy of Elkhart Public Library.)

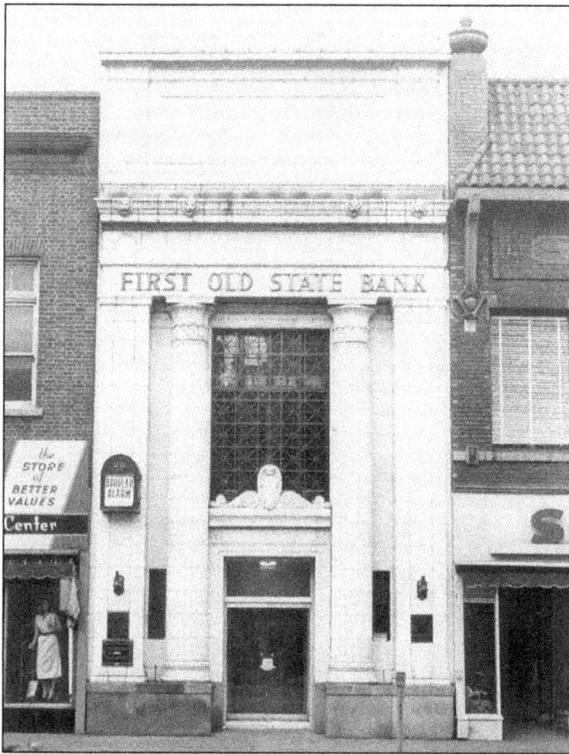

An undated look at the building façade of the First Old State Bank, located at 419 South Main Street. It was founded in 1920, and by 1952, became the first bank in the downtown sector to unveil a drive-through service. In 1966, the First Old State Bank would make an alliance with the St. Joseph Valley Bank. (Courtesy of Elkhart Public Library.)

The interior of the First Old State Bank, seen here shortly after its debut. (Courtesy of Elkhart Public Library.)

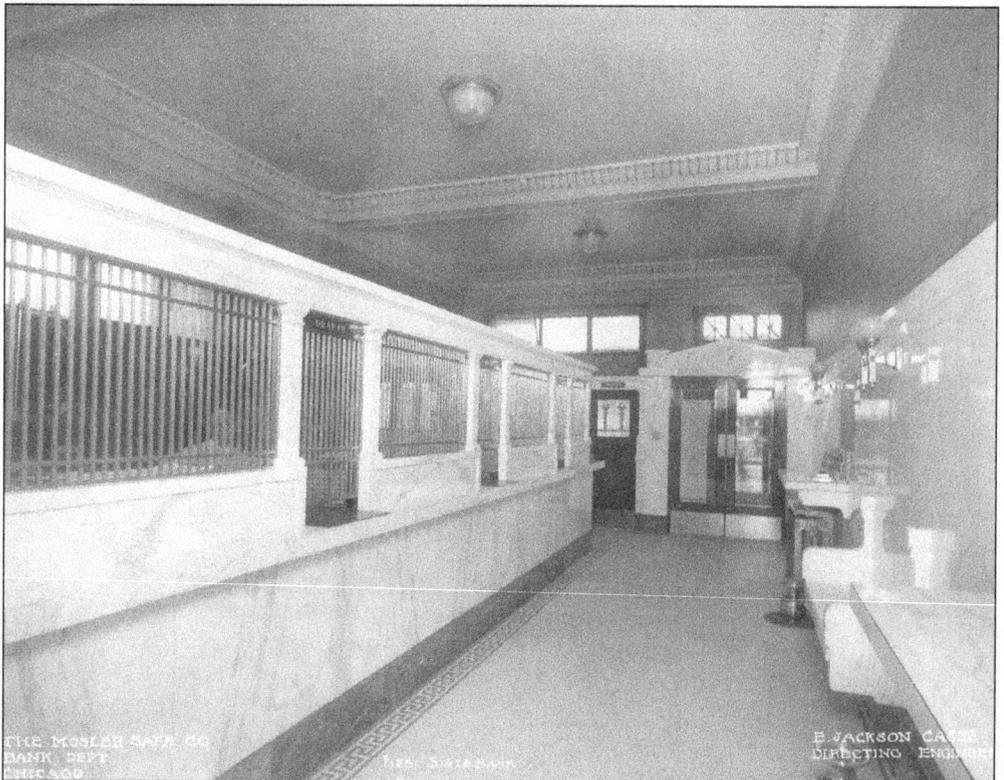

The area of the safe within the First Old State Bank was an entire wall of gleaming safe deposit boxes. (Courtesy of Elkhart Public Library.)

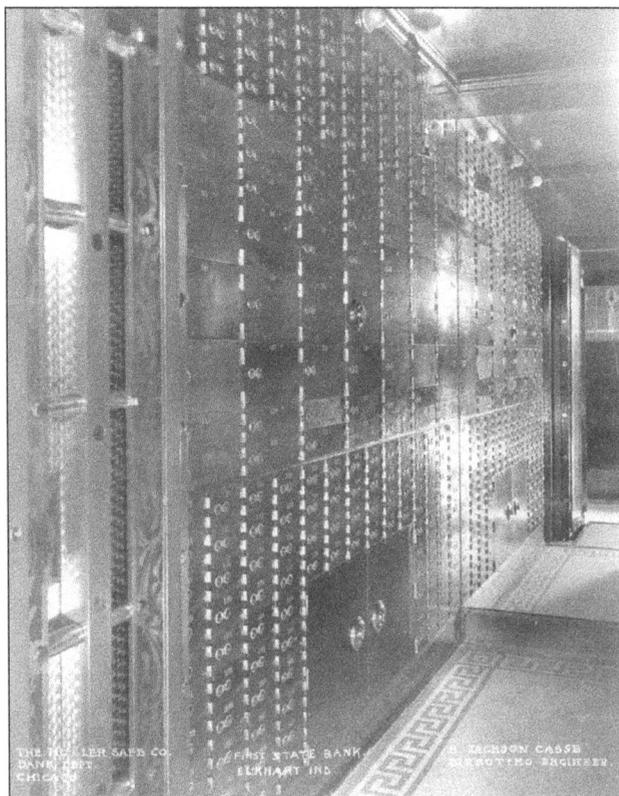

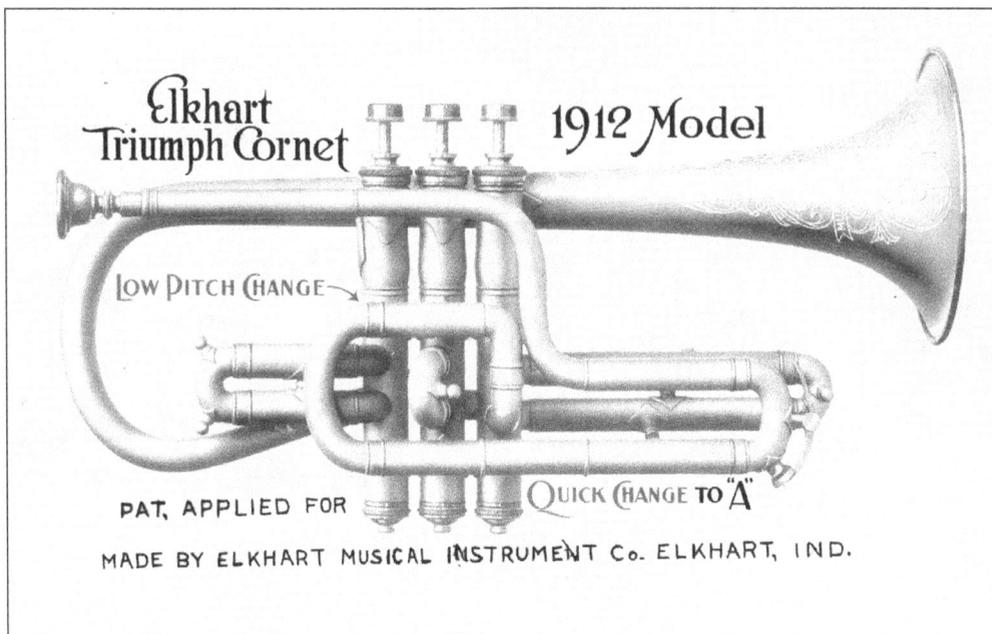

This is a print advertisement announcing the debut of the Elkhart Triumph Cornet, which premiered in 1912, and was made by the Elkhart Musical Instrument Company. (Courtesy of Elkhart Public Library.)

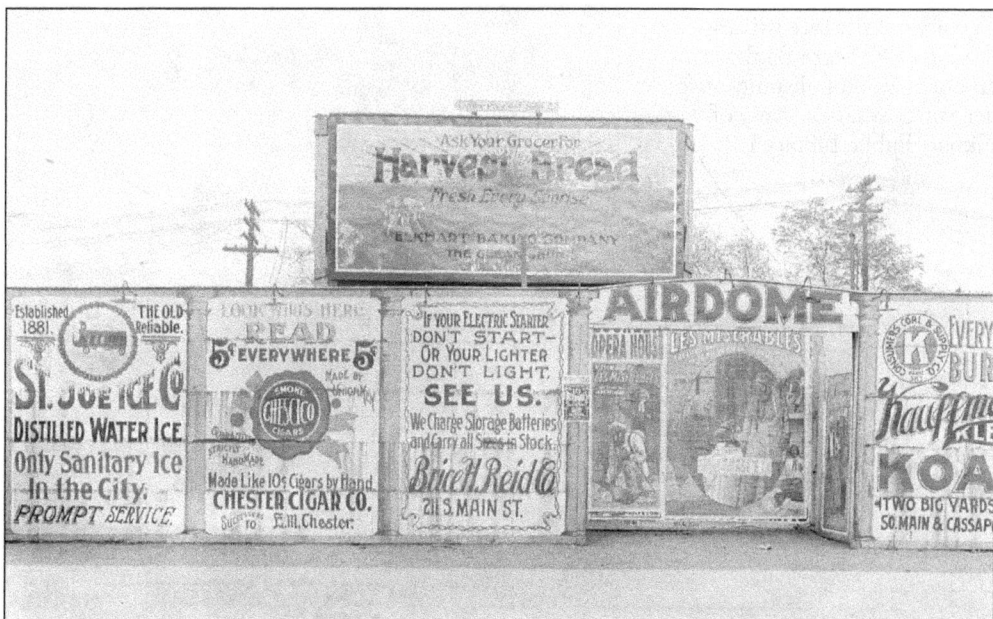

A series of billboards that were found near the downtown area in about the 1920s. Of particular interest is the one that touts "the only sanitary ice in the city." (Courtesy of Elkhart Public Library.)

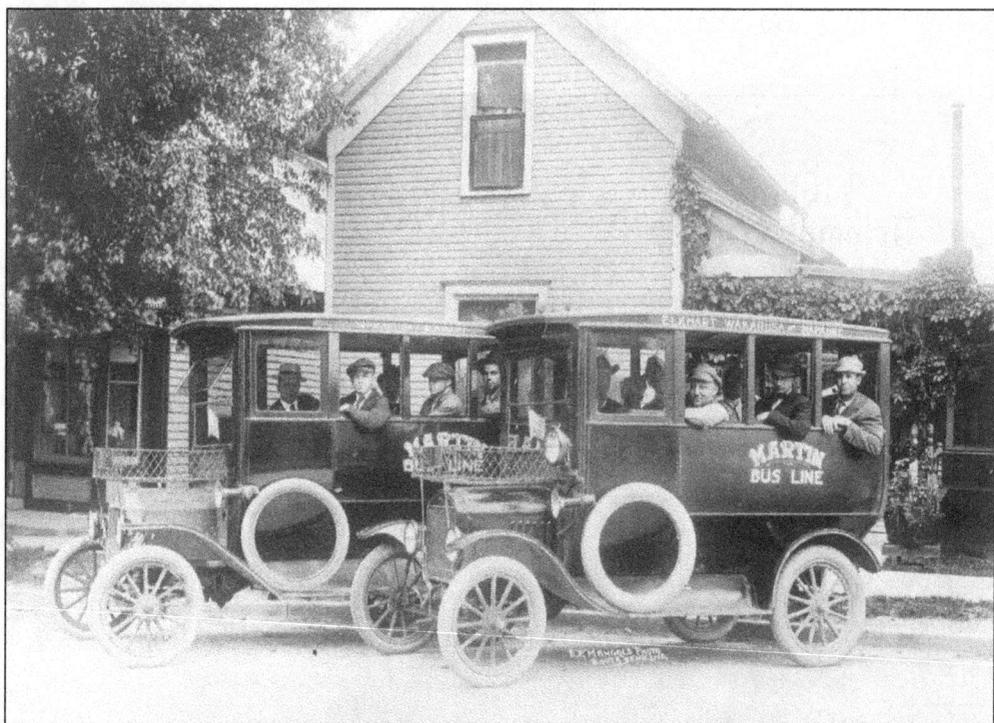

These vehicles were part of a small fleet for the Martin Bus Line, which served passengers through travels in the Elkhart, Wakarusa, and Nappanee areas. This photo illustrates the way the company looked in 1910. (Courtesy of Elkhart Public Library.)

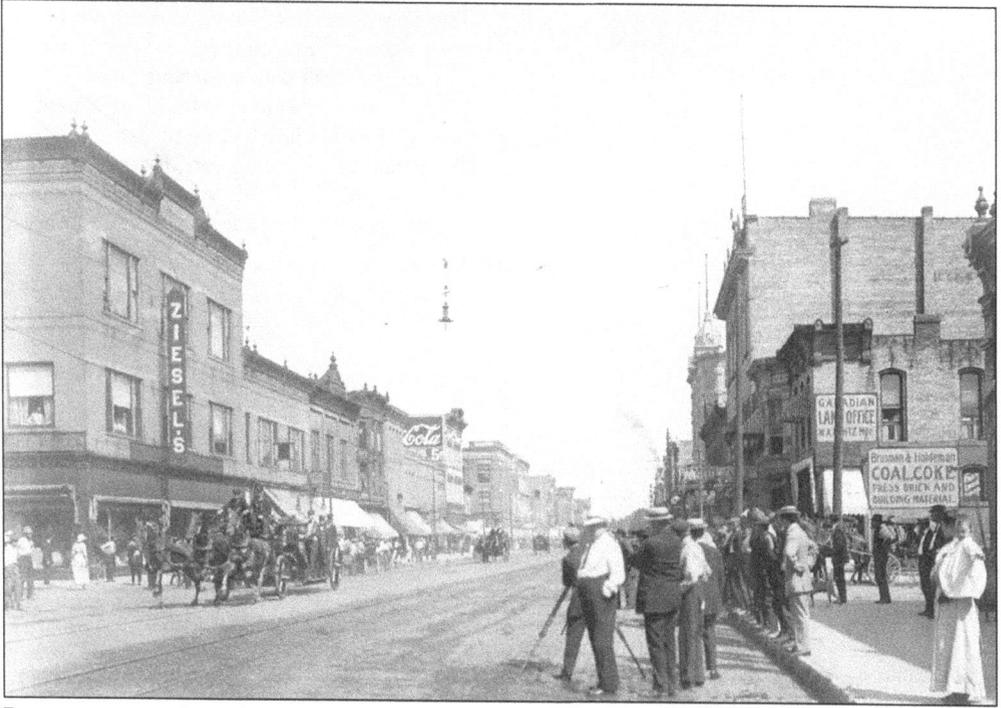

Representatives from the city fire department make an appearance along Main Street in a city parade, c. 1910. (Courtesy of Elkhart Public Library.)

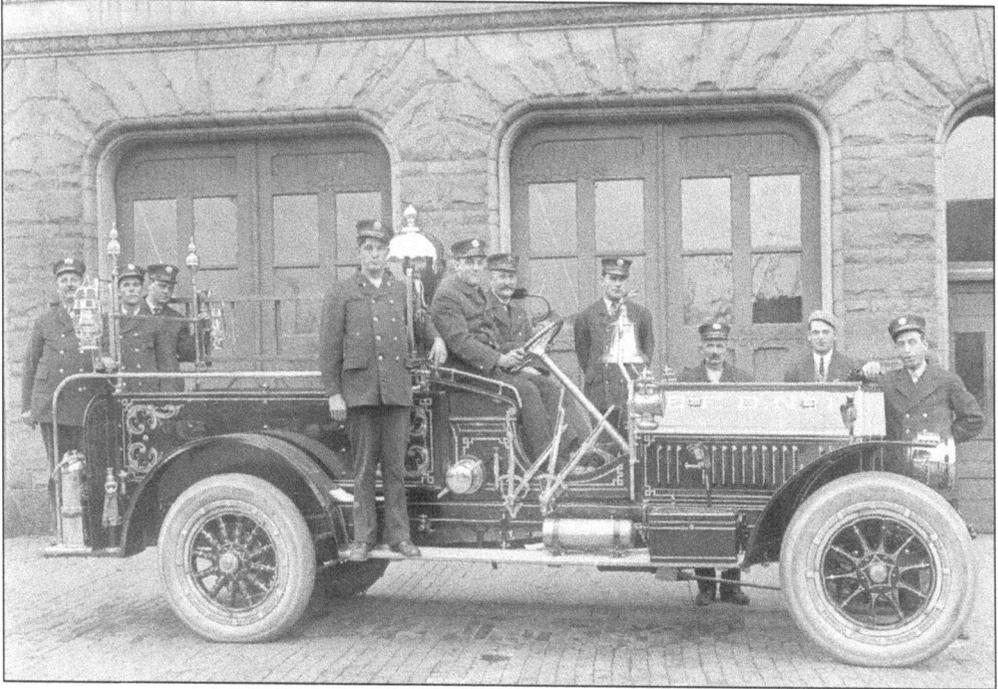

Members of the Central Fire Department make a presentation of a new, motorized fire engine, around 1910. (Courtesy of Elkhart Public Library.)

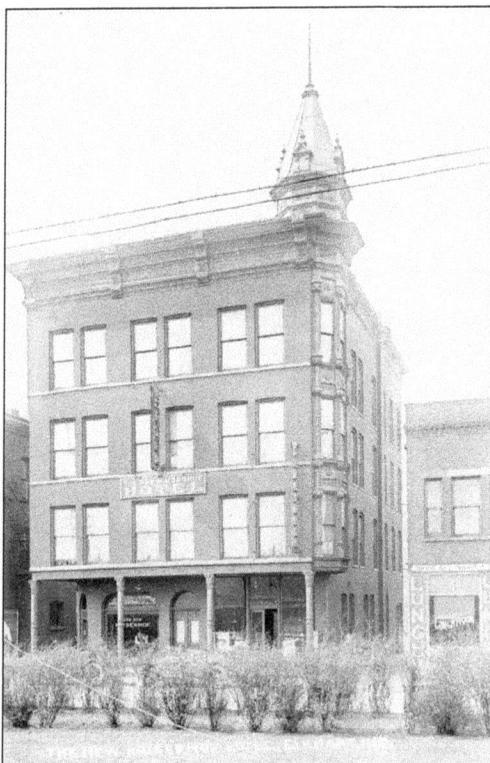

The new Kaiserhof Hotel, is seen from its front vantage point along 112 Tyler Street. This photo was taken sometime around 1910. Patrons who lodged here found many amenities, including a close proximity to the heart of the city, a short distance to the railroad, and best of all, sumptuous German cuisine. (Courtesy of Elkhart Public Library.)

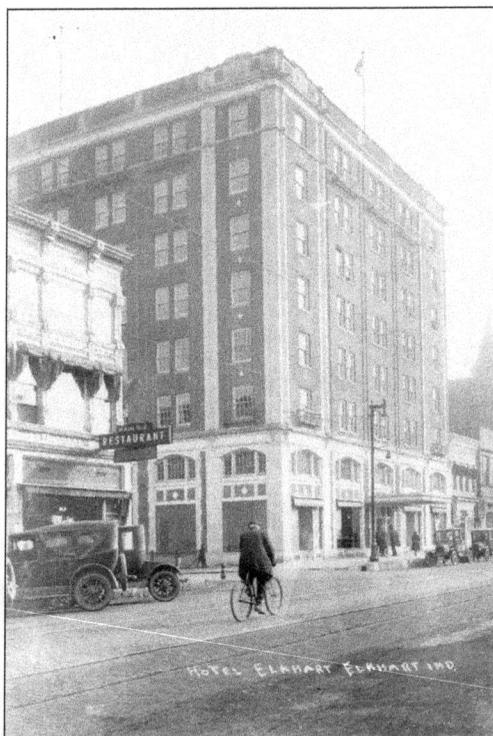

This formidable and graceful facility was known as the Hotel Elkhart, and it was created in 1924, along the crossroads of Main and Marion streets. It was one of the city's finest and most reputable establishments and was the setting for many galas and society functions for those of privilege and esteem. The building would later be purchased by the Mennonite Board of Missions and renamed Greencroft Center. By 1986, the name changed once again to Greencroft Towers Apartments, and it was opened to senior citizens as a retirement apartment complex. (Courtesy of Elkhart Public Library.)

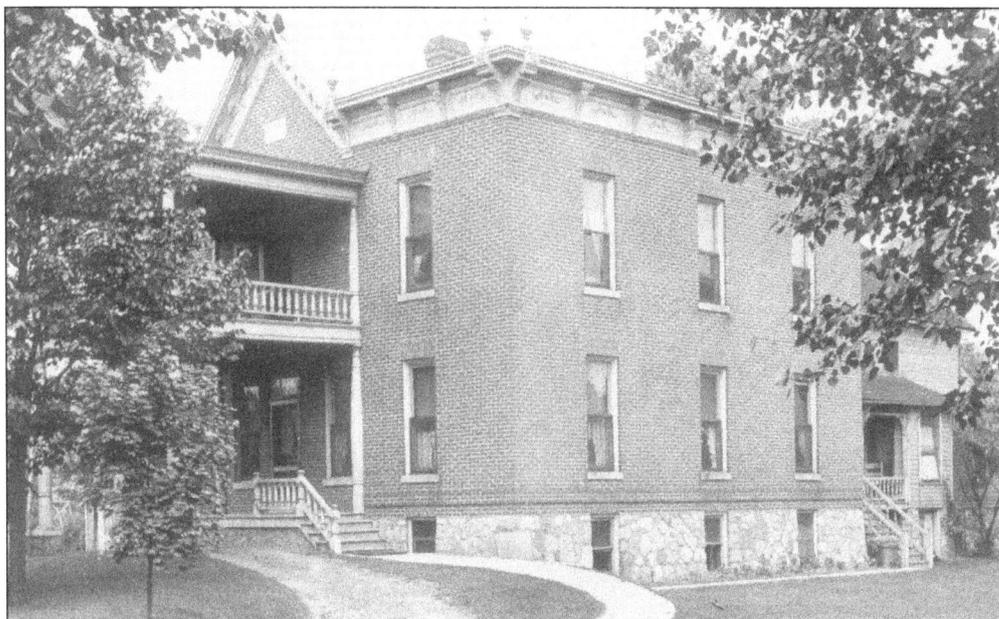

One of the city's earliest hospitals, this is the Clark Homeopathic Hospital, at 126 North Clark Street. It was founded in 1899 by the trust of Mrs. Hannah Whiting Clark. She and her husband, James E., came to Elkhart in 1845—he passed away in 1863. The hospital was staffed by all city physicians, plus nine nurses. The maximum patient capacity was 17. When plans began circulating to create a new city hospital, the Clark property was sold for $3,315, with the funds given over to the Elkhart General Hospital Fund. The building was later used as apartment housing. (Courtesy of Elkhart Public Library.)

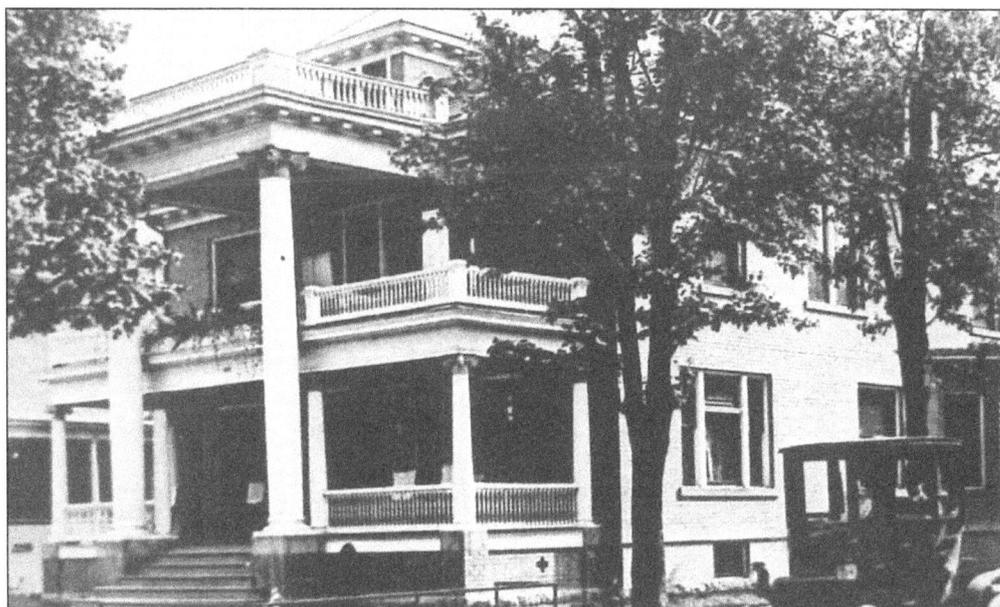

This former medical facility was known as Dr. Crow's Osteopathic Home, and it was located at the southwest corner of Second and Franklin streets. This photo was taken in about 1905. The home still stands today, though it no longer has the gabled porches. (Courtesy of the City of Elkhart.)

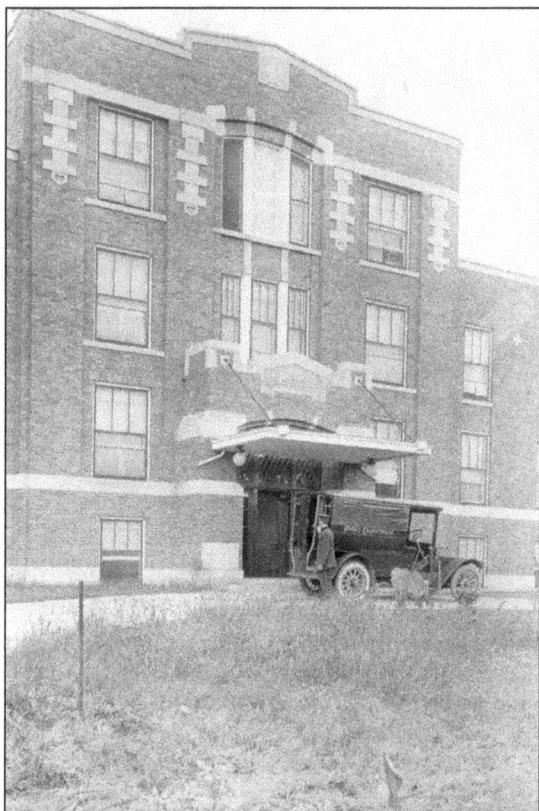

One of E. Hill Turnock's mightiest accomplishments was the Elkhart General Hospital. This picture was taken around 1914, just one year after construction had been completed. Note the Elkhart Police Department ambulance parked at the main entrance. As the project was growing community interest in 1910, Dr. Franklin Miles offered to donate $10,000 to the building fund, with the stipulation that $30,000 must be raised from other sources. By 1912, the site for the new hospital was chosen—near McNaughton Park. Outside donations far exceeded Dr. Miles' expectations, with an additional $47,000 pouring in. The hospital was ready to serve patients in 1913. (Courtesy of Elkhart Public Library.)

The nursing staff of Elkhart General Hospital is pictured here c. 1915. (Courtesy of Elkhart Public Library.)

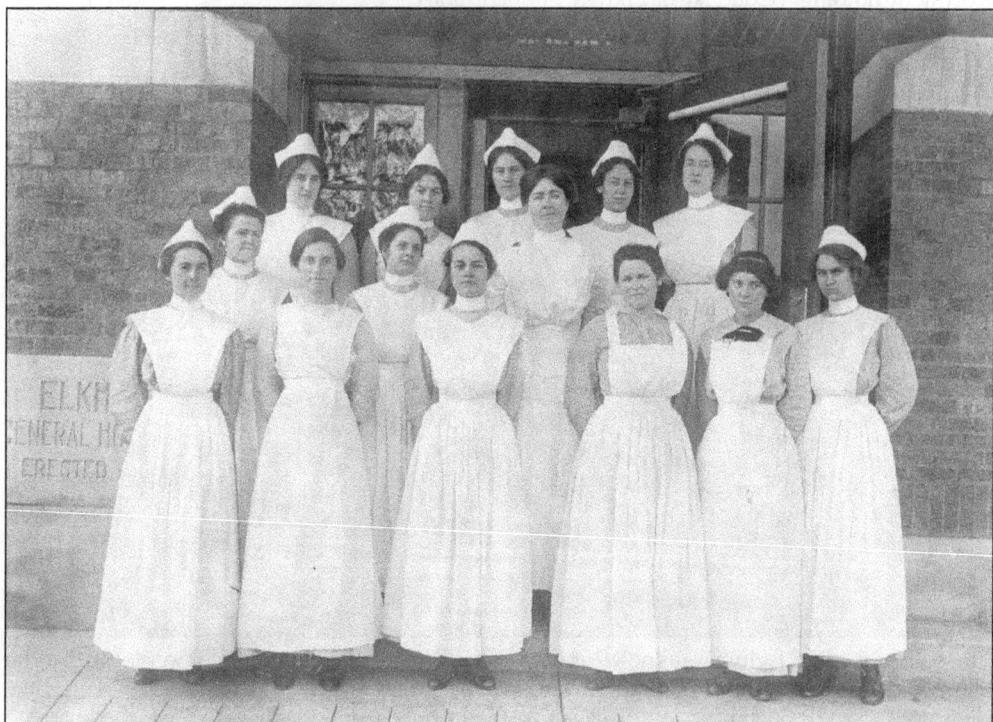

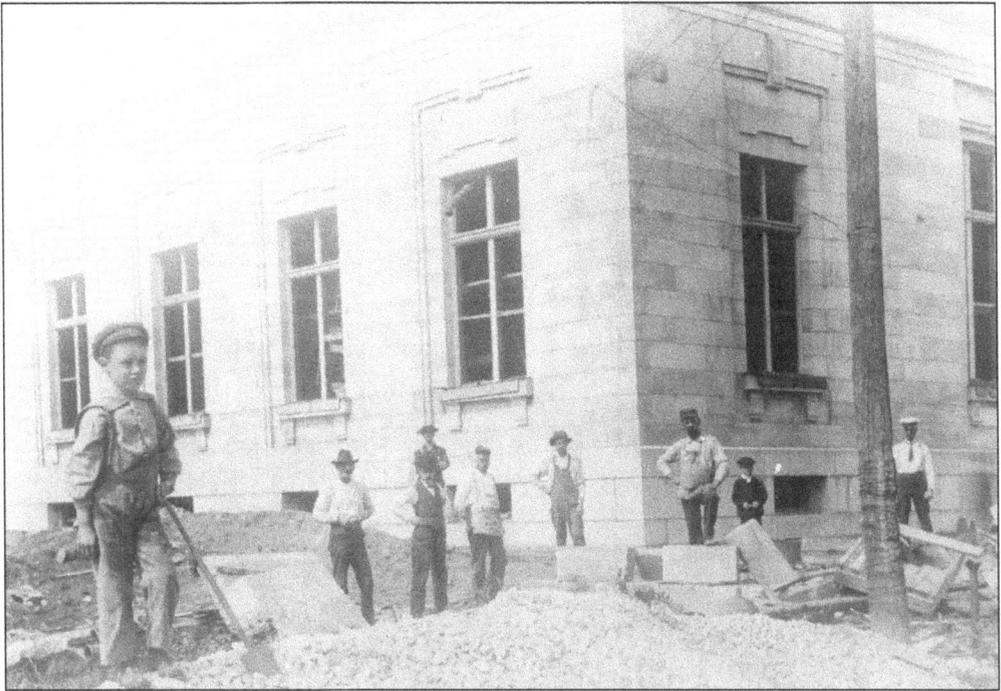

The construction of the city's third post office was being built at the northwest corner of Main Street and Jackson Boulevard. This phase of the project took place in 1905, the same year the work was completed. Nearly 100 years later, the building is still standing. (Courtesy of Elkhart Public Library.)

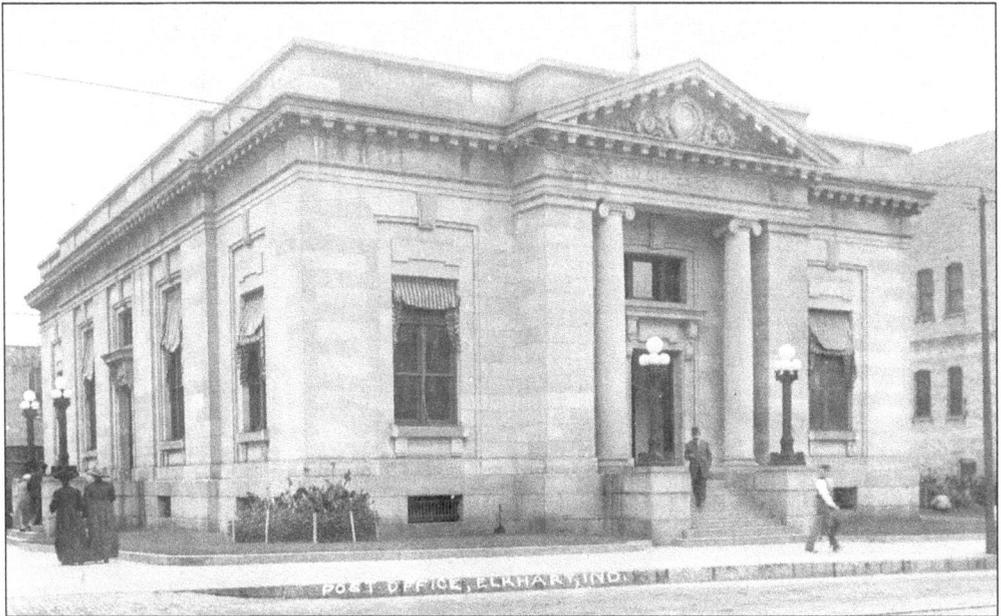

The new Elkhart Post Office, located at 101 North Main Street, shortly after its premiere in 1905. It has had a most unusual history over the last century—in the 1970s, it was actually a disco! Presently, it is the site of National City Bank. (Courtesy of Elkhart Public Library.)

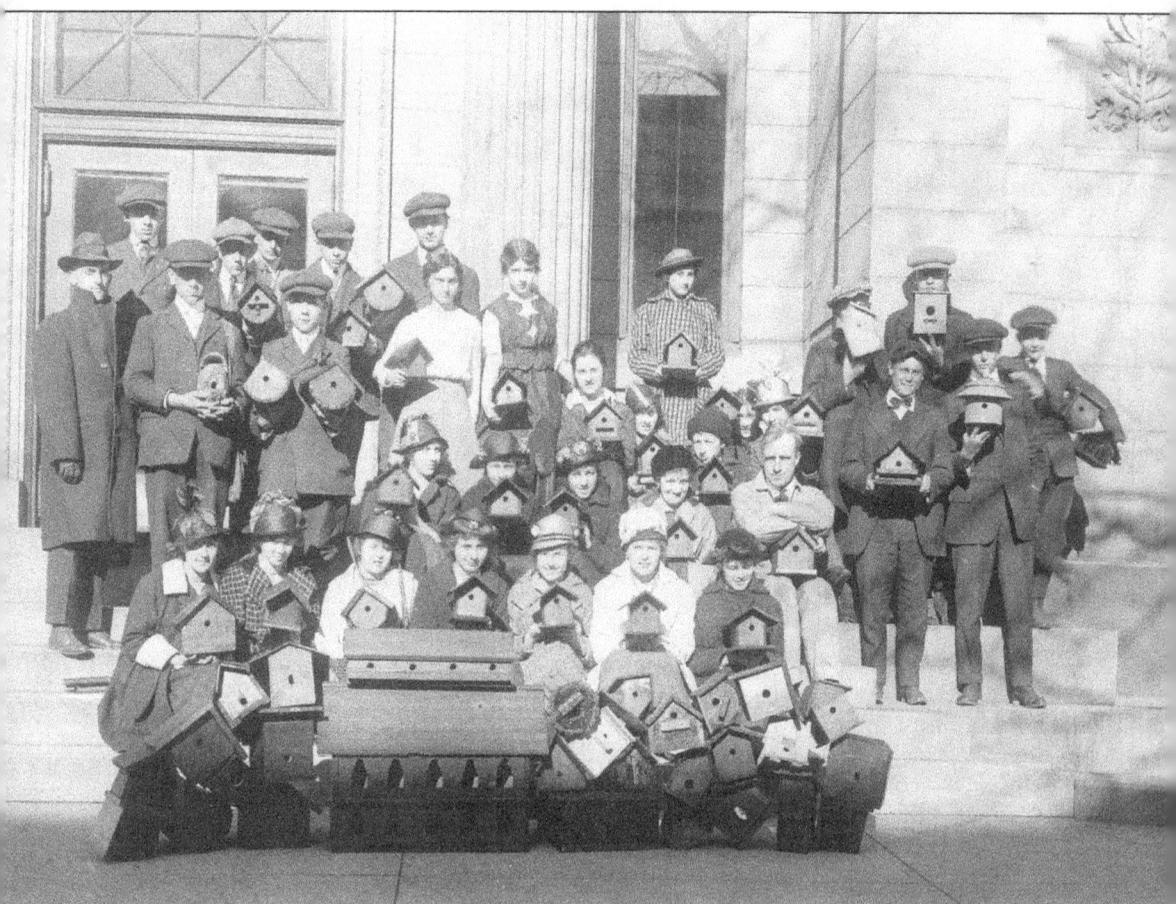

A group of library patrons showing their finished works as a part of the library's special "Birdhouse Project, 1917-18." (Courtesy of Elkhart Public Library.)

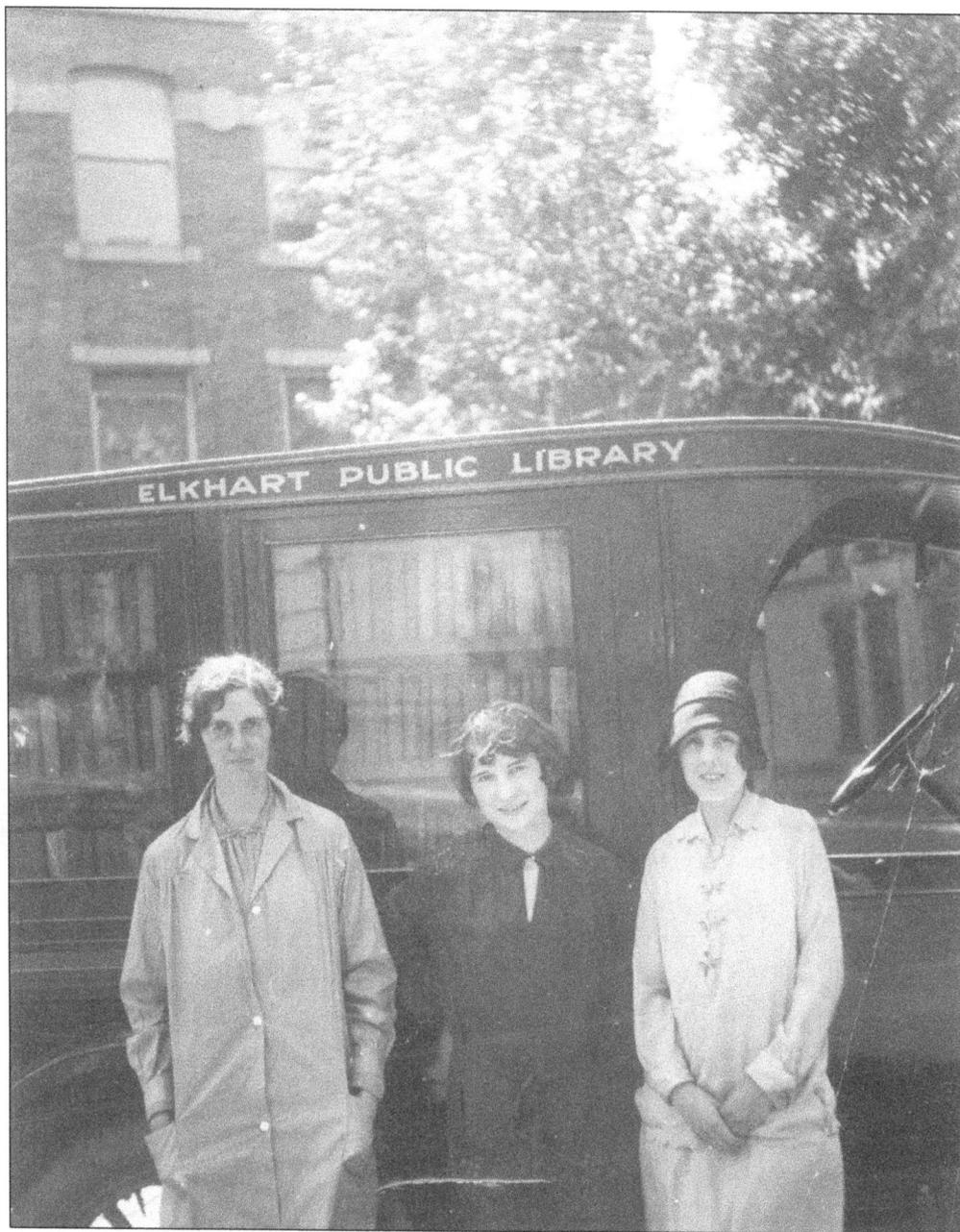

The Elkhart Public Library book wagon, along with three of its assistants. Pictured are Mary Houseworth, Frances Platter Cullen, and Frances Houseworth Thompson. (Courtesy of Elkhart Public Library.)

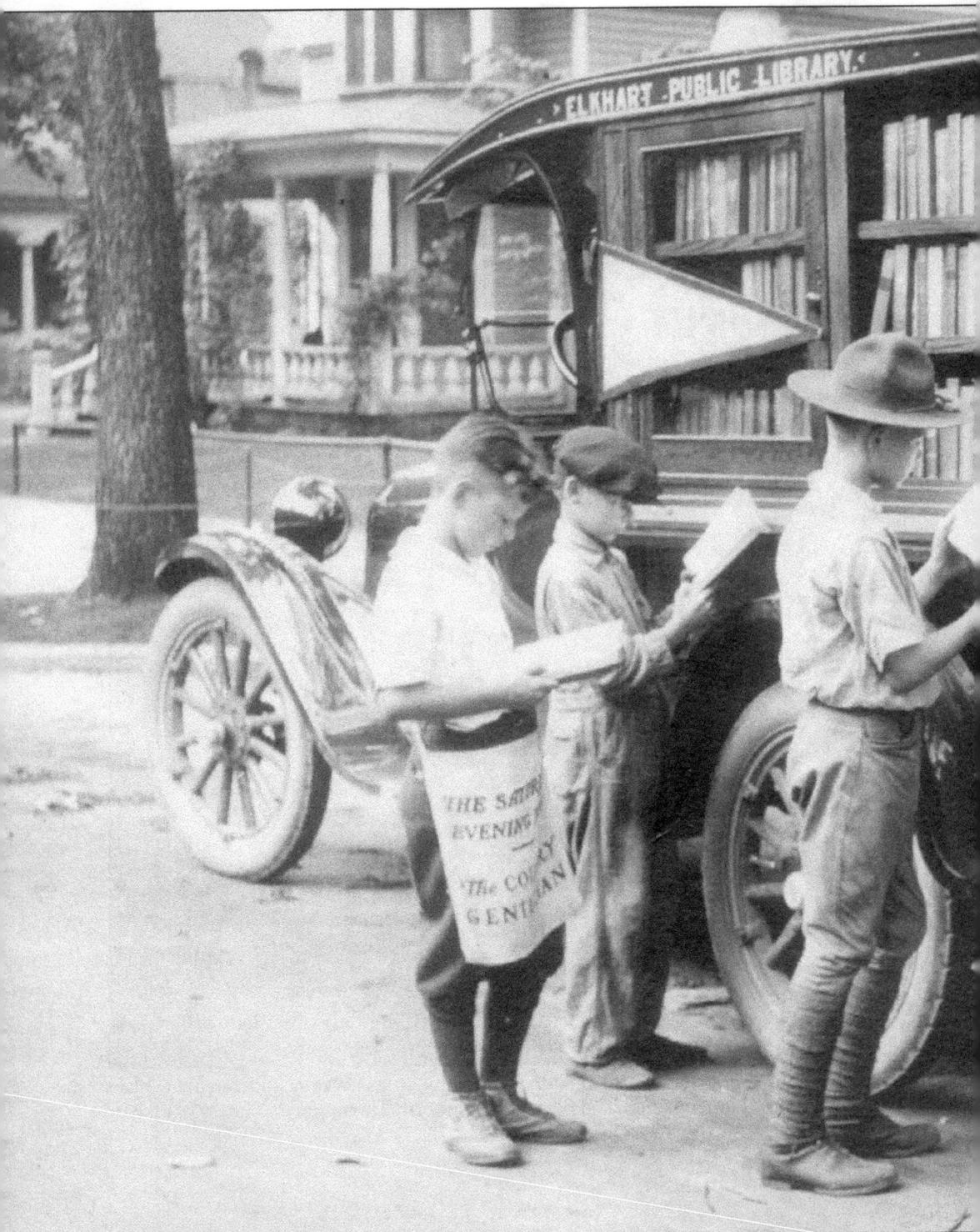

The Elkhart Public Library Bookmobile was the city's first such kind of amenity. It was donated to the library in 1921 by Mrs. A.H. Beardsley. The staffers and young readers are shown

sampling the materials directly in front of the former Carnegie Library. (Courtesy of Elkhart Public Library.)

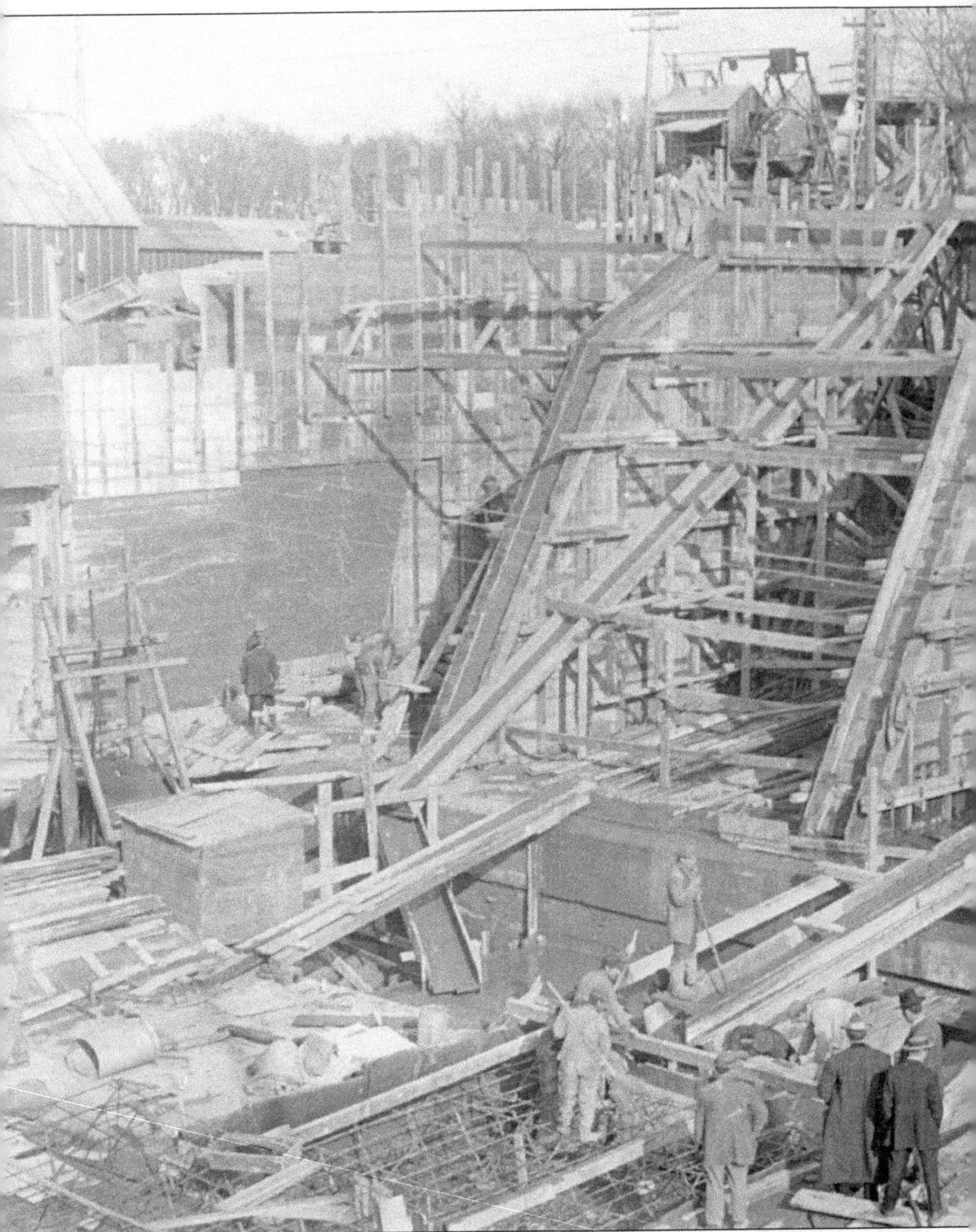

Construction is actively underway in this 1911 scene of the new St. Joseph River dam. Completed in 1912, the dam was fashioned from concrete, and was built just downstream from

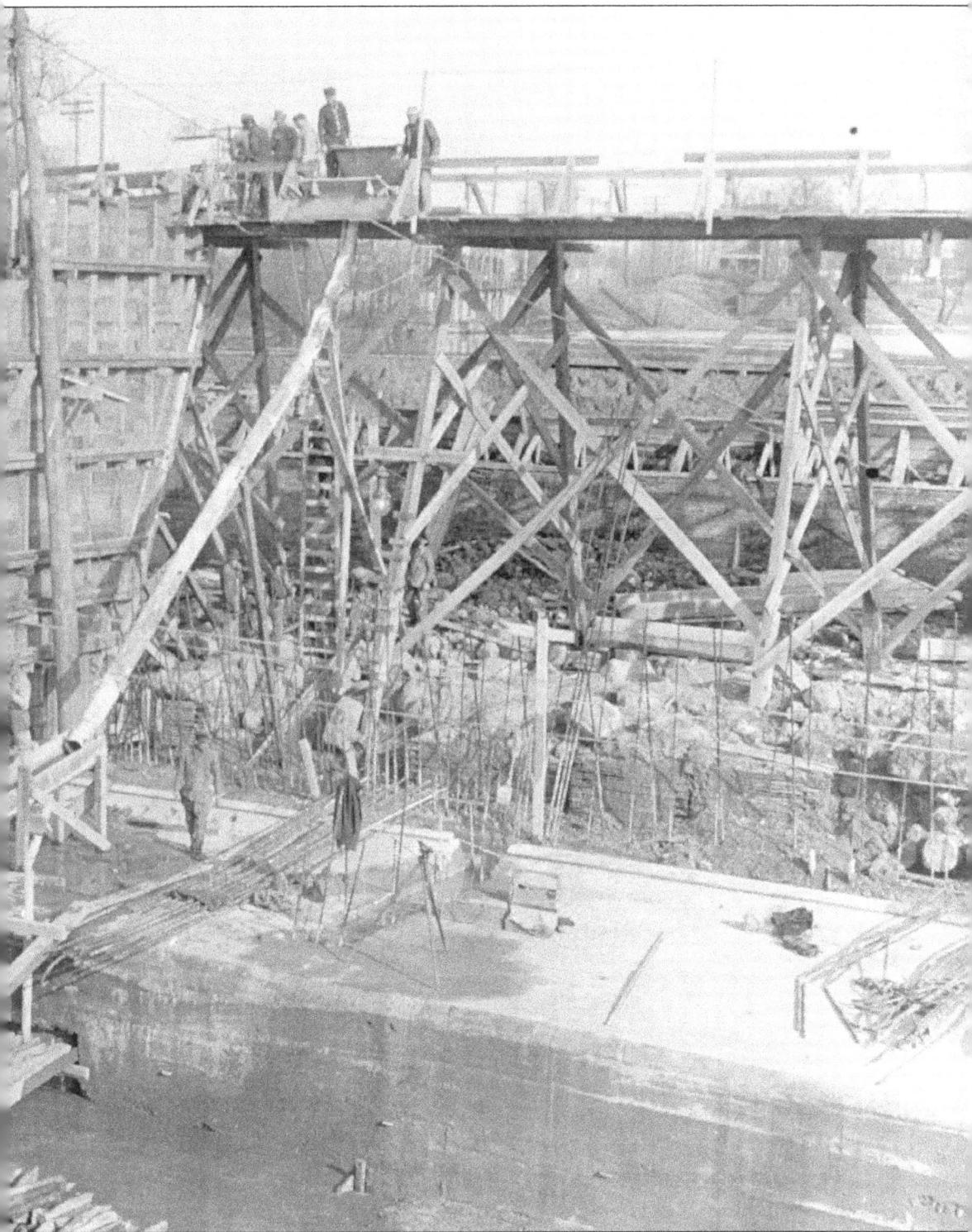

where the original St. Joe dam had been raised in the 1860s. In 1913, a hydroelectric generating plant was added to the south end. (Courtesy of Elkhart Public Library.)

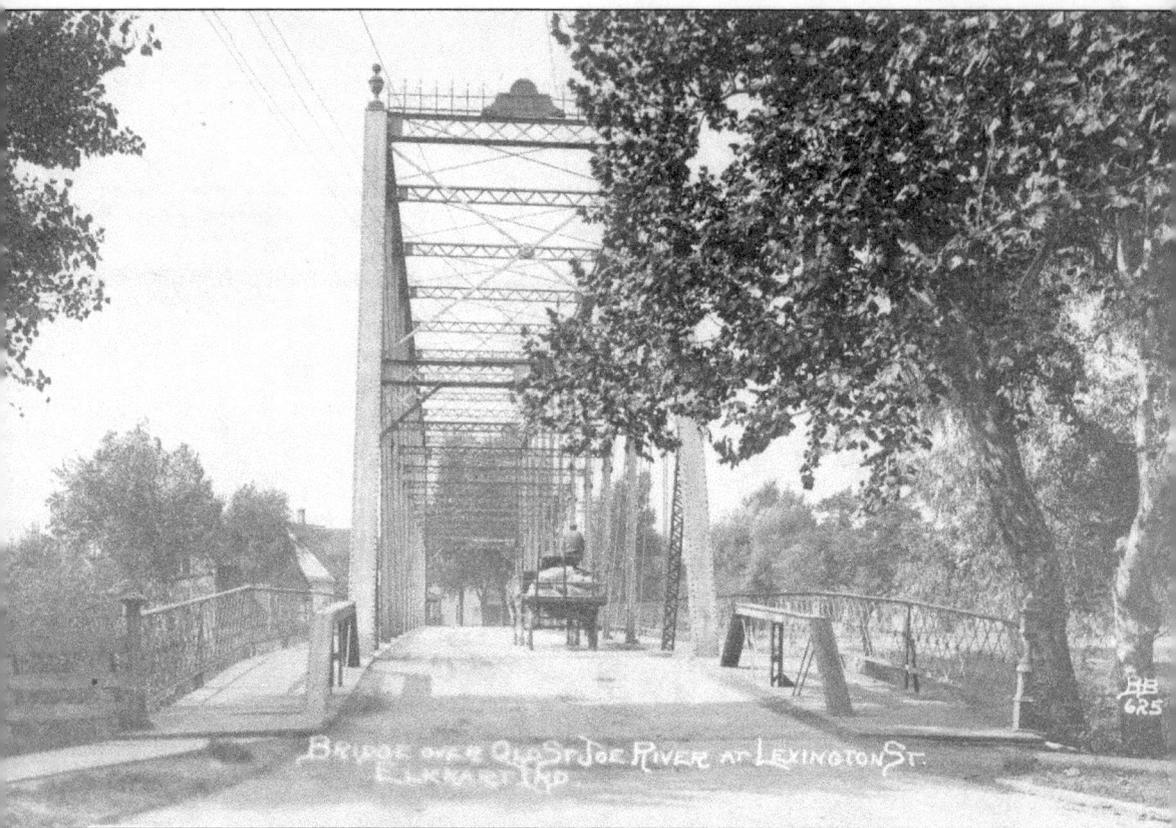

A lone wagon carries its passenger across the St. Joseph River, by way of the Lexington Avenue Bridge, in 1912. (Courtesy of Elkhart Public Library.)

Three

THE PROGRESSIVE MOVEMENT
"REACHING NEW HORIZONS"
1930 AND BEYOND

Without question, the advent of the 1930s signaled a rather bleak period in the lives of many Americans. The devastation of the stock market crash of 1929 had far reaching and lasting repercussions, marking the beginning of an era most refer to now as the "Great Depression." Survival was tough both personally and financially. And the downtrodden economic state reverberated through Elkhart as well. Among the most crushing blows locally came about in 1929 when the New York Central railroad chose to relocate its locomotive shops to Ohio, and with that move, came the loss of jobs, certainly at a most inopportune time. Slowly but surely, however, as the sun rises and sets, there would be new reasons for hope and optimism.

In 1933, Mishawaka resident Milo Miller came up with a new type of vehicular unit which would enable him to bring his family along on road trips while he worked in sales. With parts that he obtained in auto salvage yards, he created one of the first trailers. Miller was an innovative spirit—he built windows for the trailer using old auto glass and wooden frames. He took a sheet of rubberized canvas roofing material and secured it to the plywood sides with adhesive made from Karo syrup. And in the interior of the makeshift trailer, he included a gas stove for cooking and a separate coal-fueled stove for heating. While demonstrating his new creation on one particular national excursion, he realized the interest in his product was growing. So in 1933, he founded the Sportsman Trailer Works, and turned out four units in that maiden year.

The following year, he moved his operations to Elkhart, and by 1936, he expanded once again, this time renting space from a national distributor named Wilbur Schult. With the demand for these new trailers continuing to rise, Miller opted to sell the company to Schult, and the Schult Corporation was born.

It was rather serendipitous that Schult would become one of the early entrepreneurs behind the new industry of recreational vehicles. Schult had attended the World's Fair in Chicago in 1933, and was quite taken with a trailer model he had seen there, something very similar to the one Miller was working to create.

The man who is often recognized as being among the first to develop "house trailers" was Harold Platt, who along with his brother, Oliver, purchased the former Doloretta furniture company for the express purpose of producing the fairly new concept. Platt had been sought out by a fellow who was the inventor of the waffle ice cream cone, and he had been looking for a means to travel with his wares so he could sell them at carnivals. "Mr. Rice," as he was known, wanted a special trailer with a large side window that would swing up and away, protected by an ample awning. The front of the trailer would have a limited amount of space for living quarters.

Platt was instrumental in bringing about the nation's first trailer show, called the "Tin Can Tourist Convention" in 1937, and he was a charter member of the Trailer Coach Manufacturer's Association. In 1937, one of the Platt production models was the first in the country to offer

a complete bathroom with a tub. Platt was also one of the first manufacturers to include a full kitchen gas range in his units.

When Platt's brother, Oliver, died in 1939, Harold Platt then became CEO and president of the company, and he remained an integral part of recreational vehicle history throughout the 1940s and 1950s. Platt was also one of the chief promoters and developers of the Midwest RV and Mobile Home show, which debuted in Elkhart in 1953. By the end of that decade, that event would be heralded as the largest of its kind in the entire country. In the years to follow, the city would become the frontrunner for both recreational vehicle and manufactured housing industries—a title that still resounds today.

The Miles Medical Company, later renamed Miles Laboratories, enjoyed an upturn in business as well. In 1931, Miles introduced what would be its most popular seller, the effervescent pain reliever called Alka-Seltzer. In the months following the release of Alka-Seltzer, sales accumulated to about half a million dollars, but in just a few years, that figure would skyrocket to more than $7 million dollars. The advertising campaign that would follow resulted in one of the most successful marketing strategies in recent memory, with the arrival of "Speedy" Alka-Seltzer in 1951. "Speedy," the cherubic little boy with the pill-shaped hat and torso, was the creation of the Wade Ad Agency, and it certainly bears mentioning that his original name was "Sparky."

Miles Laboratories was purchased by Bayer AG, of Leverkusen, Germany, in 1978, and it later became simply the Bayer Corporation. It was headquartered in Elkhart for an impressive run of more than a century.

Throughout the middle of the 20th century, the ambience of Elkhart became more reflective of the country's innocence and conservatism. There were good times to be had, and the fine arts arena broadened tremendously during those years. The city boasted a fine Municipal Band, and there would also be an Elkhart Symphony Orchestra, a Civic Theatre, and a handful of ballet schools which would debut on the scene and enchant audiences from around the region. And in 1958, the city rejoiced with a year-long celebration to commemorate its Centennial.

There were more changes upon the burgeoning school system as well. The beloved landmark "cracker-box" gymnasium at the Elkhart High School was no longer adequate to seat all of the patrons wanting to catch a glimpse of their athletes. So in 1953, a new gymnasium was added to the North Side Junior High School. At the time, it was the world's largest high school sporting arena, with a seating capacity of over 8,000.

A dramatic climb in the number of high school students during the 1960s called for drastic measures as well. The Senior Division of Elkhart High School, a new building to house juniors and seniors, was opened in 1966, while sophomores remained at the former Elkhart High School. However, the state-of-the-art facility soon illustrated the fact that the older high school was no longer adaptable to present day needs. So in 1972, another school building was raised along California Road, and this would be called Elkhart Memorial High School. The previous structure for the upper grade high students would then be known as Elkhart Central High School.

Sadly, the 1960s would also bring about one of the most devastating and horrific acts of nature to ever strike the area. On April 11, 1965, the phenomenon of the Palm Sunday tornadoes came upon Elkhart County, and struck with a fierce vengeance. Several twisters dipped down into Elkhart and surrounding cities, and the resulting wrath nearly leveled the tiny town of Dunlap. In Elkhart County alone, 52 lives were lost in the event, many of them young children. Even now, although nearly 40 years have passed since that dark, ominous night, there are still many folks who find it difficult to talk about the images they've seen, the tragedies they've witnessed. It was an evening of unspeakable horror, too painful to recollect, yet too vivid to forget.

Now, Elkhart has entered its third century of existence, and the remarkable journey continues to evolve and present new challenges to discover. The city has taken great measures to tip the proverbial hat to yesteryear, with such fine institutions as the Time Was Museum, the RV/MH Foundation, the S. Ray Miller Auto Museum, the National New York Central Railroad Museum, the Midwest Museum of American Art, the Ruthmere Mansion, and the historic Elco Theater. The tradition of the arts still reigns supreme, with various festivals and spectacles. Yet

there is always room for growth and change, as each new administration strives to balance the heritage of Elkhart with dreams for the future.

"The City with a Heart"—truly, the pulse of Elkhart still echoes with honor, fortitude, and pride.

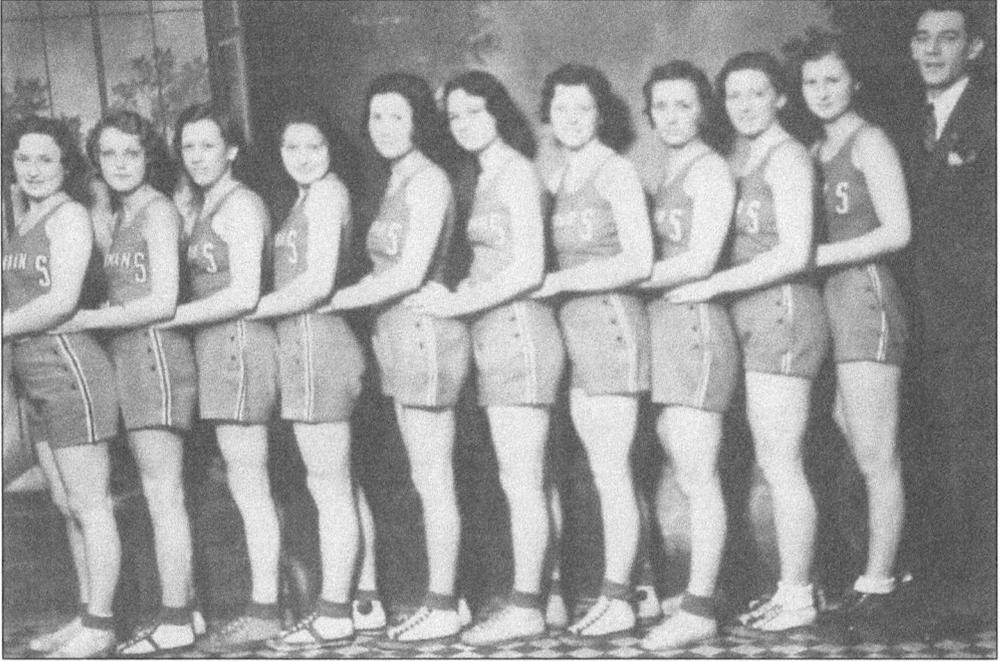

Berman's Sporting Goods, a retail outlet once located at 129 South Main Street, was the sponsor of this women's basketball team from 1933. (Courtesy of Time Was Museum.)

An aerial view of Elkhart, though it's not entirely clear when the photograph was taken. A small notation attached to the picture suggests that it was taken in the 1930s, but little else is known. (Courtesy of Time Was Museum.)

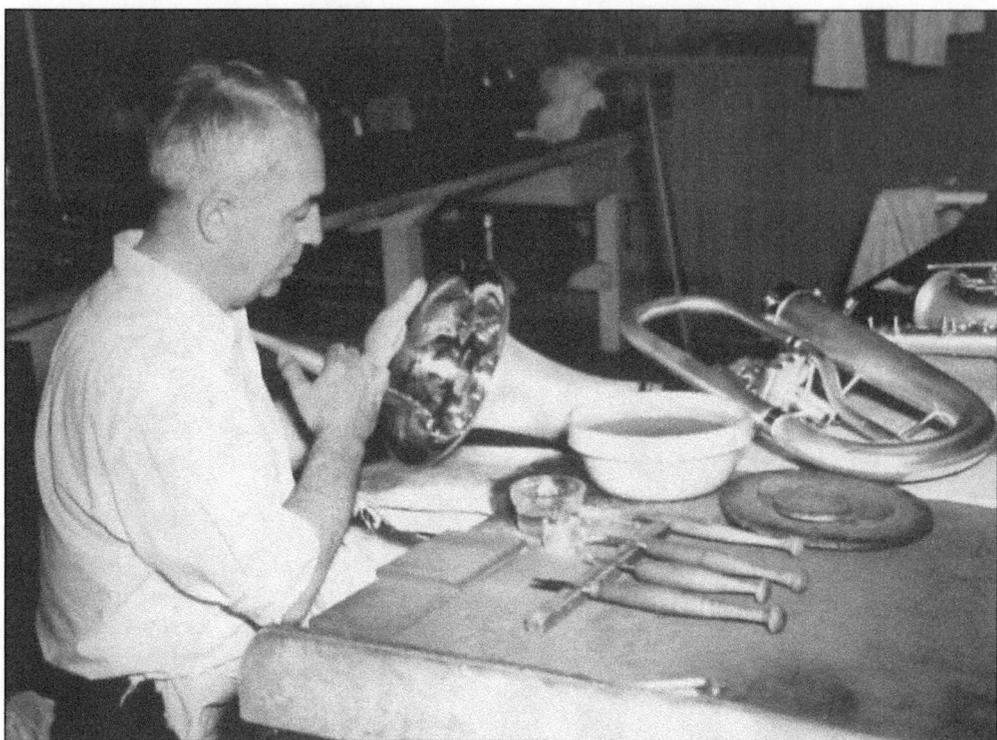

An employee of the Buescher Music Company puts the finishing touches on a brass baritone horn bell in April of 1945. The process involved the craftsman having to hand burnish the gold-plated surface. (Courtesy of Time Was Museum.)

A fairly spartan interior for the office facility of the Elkhart Chamber of Commerce, in a photograph dated 1950. (Courtesy of Time Was Museum.)

The old A & W "root beer barrel" restaurant, at the southeast corner of Main and Sycamore streets. One of six such "barrel" restaurants in the city, these establishments were at the peak of popularity during the 1950s. This particular diner was one of only three in the United States which was fashioned from steel—the other restaurants in the franchise used wood. (Courtesy of the City of Elkhart.)

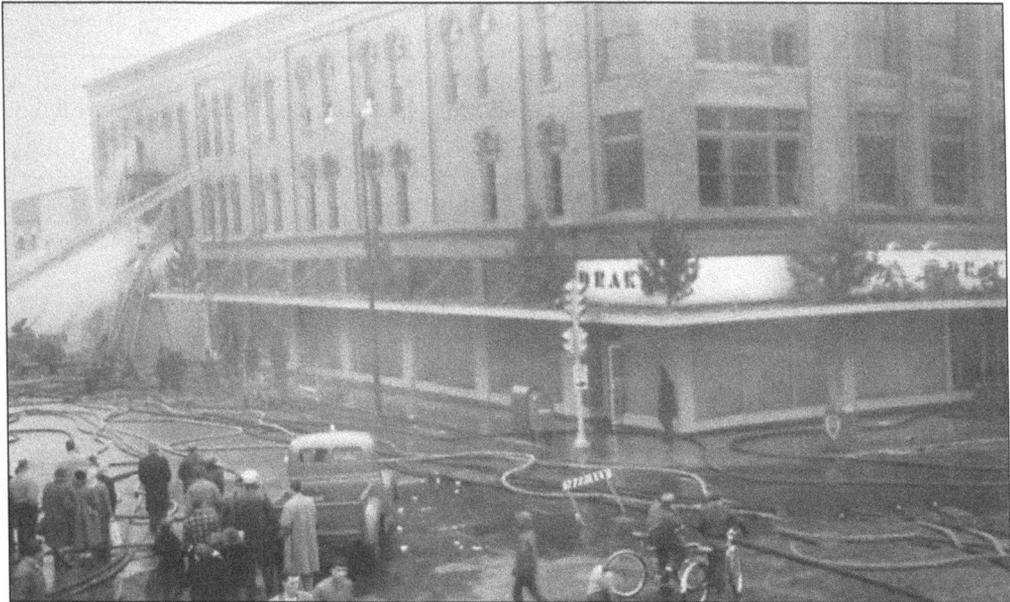

A massive fire at the Charles S. Drake Co. department store, 227–231 South Main Street, struck in the early morning hours of December 23, 1955. The fire was discovered by the night watchman at around 5:30 a.m.; he and his wife rushed to safety and then flagged down a passing motorist to ring for firemen. The fire's origin was determined to be the basement, but all three levels of the building sustained serious damage, to the extent that one floor had collapsed, and all of the store's contents, including hundreds of Christmas gifts set aside on layaway, were completely destroyed. The damage estimate was in excess of $250,000. (Courtesy of Time Was Museum.)

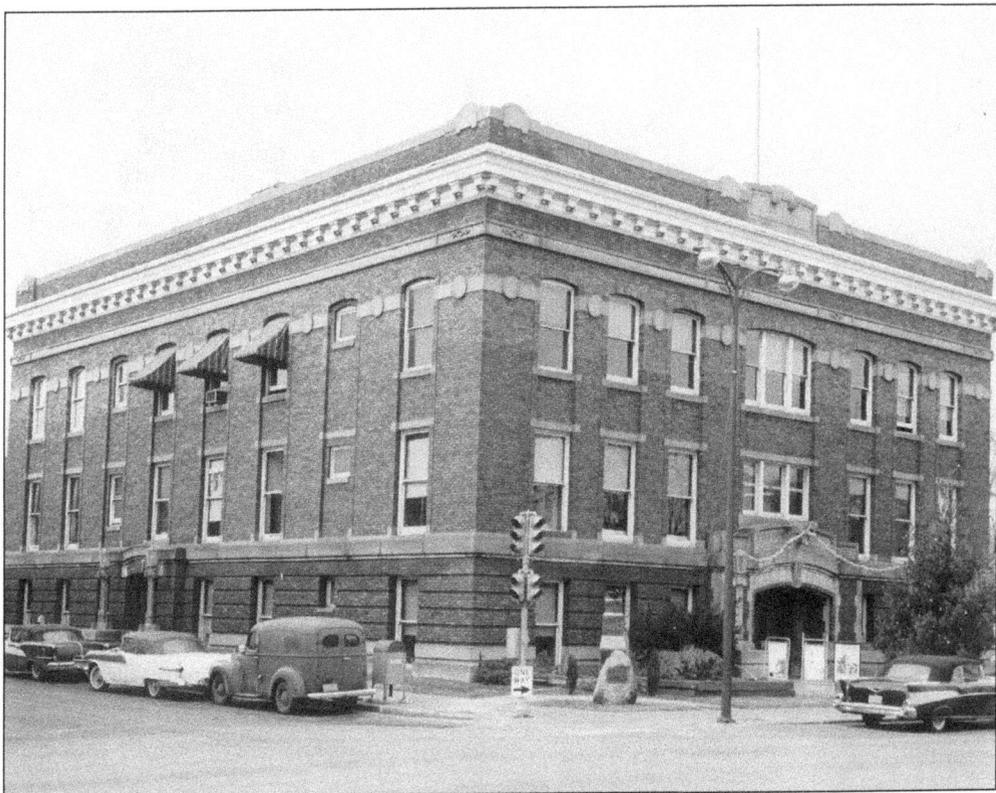

The Elkhart City Hall, or Municipal Building, as it was in December of 1959. Very little of the structure's appearance has changed since this photo was taken. (Courtesy of Elkhart Public Library.)

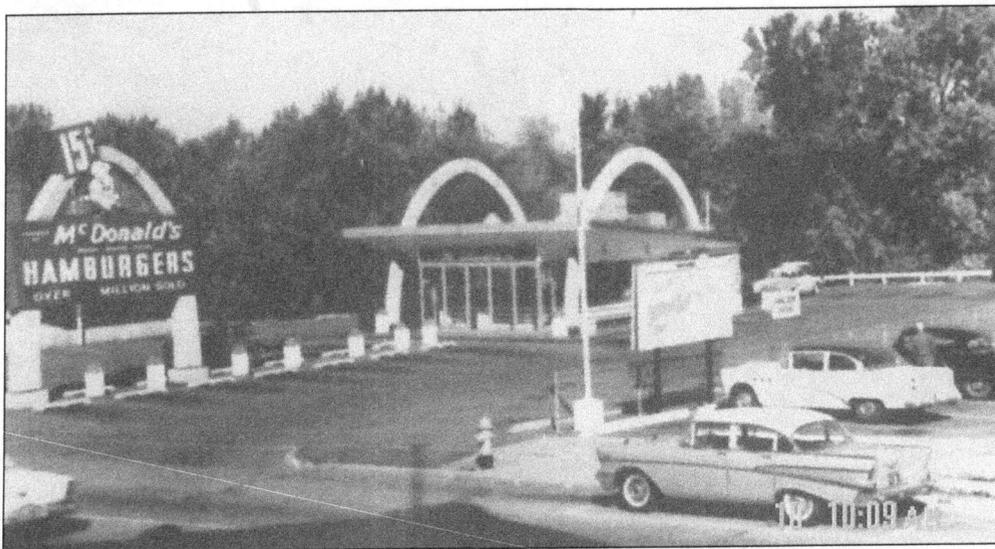

Elkhart's first McDonald's restaurant, which was opened in 1960 at the corner of Main and Jefferson streets. The eatery still exists today, though obviously it has changed drastically in appearance. (Courtesy of the City of Elkhart.)

Traffic in downtown Elkhart slows to a crawl as the municipal Christmas tree is carefully maneuvered through the heart of the city. This tree would then be positioned atop one of Elkhart's most unusual attractions of the 1960s—the Arch. The Arch was a span of iron that stretched across one corner of Main, to the opposite corner of Franklin streets, from 1963 until 1968. For those holiday seasons, motorists were treated to the sight of a gaily decorated tree, seemingly suspended in midair. When the holidays had passed, there were other uses for the Arch, as it supported a flag pole, a United Fund poster, and even a small mobile home. When the Arch was dismantled, a portion of it was used to create an overhead walkway between the Mary Daly School, across Nappanee Street, to the West Side Junior High School. (Courtesy of Time Was Museum.)

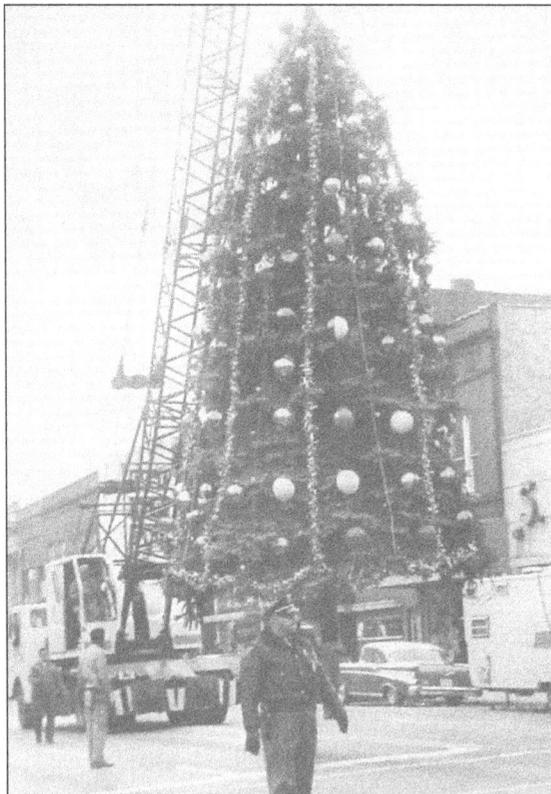

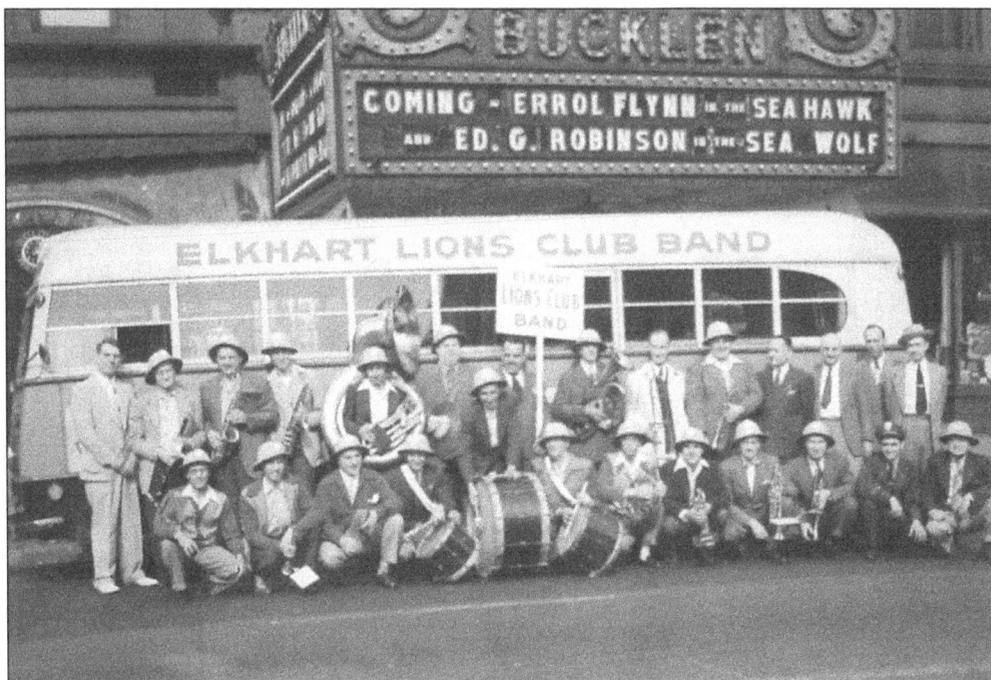

The Elkhart Lions' Club band, as they prepare to depart for a state convention in 1947. (Courtesy of Time Was Museum.)

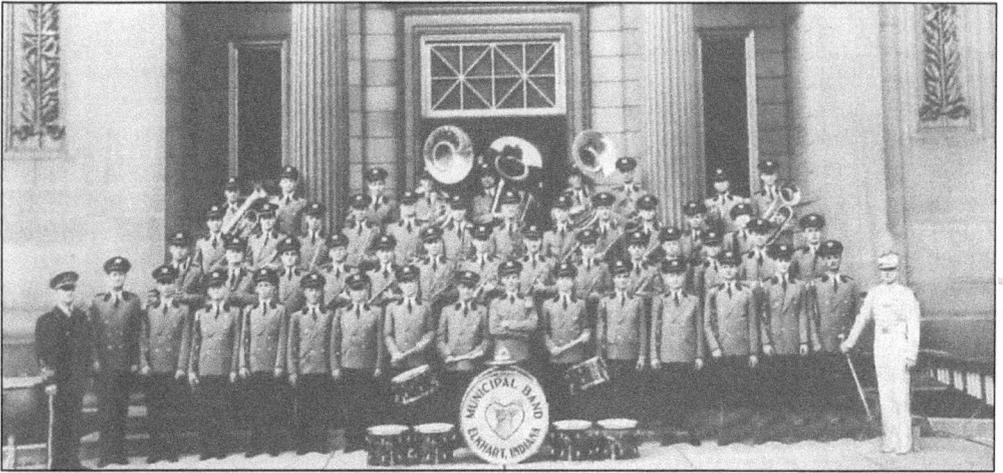

A majestic looking troupe of musicians—the Elkhart Municipal Band of 1940. The members of this group are identified as, front row: M.A. McKay, L.A. Knowles, Joe Artley, Eugene Russell, C. Flurkey, Ed Brady, Ed Bixby, John Endicott, Orland Banning, Dave Boyer, Irving Denton, Glenn Forry, Irv Leatherman, Ray Bowman, H.A. Bicknell, Ralph Miller, and Bob Holtz. Second row: William Diehl, Harry Lewis, R. Driver, Don Hellenga, Ed Naftzger, R. Fiandt, Hubert Hive, Francis Eckstein, Ernest Kenega, George Brown, Forrest Stoll, Allan Eagles, Russ Saunders, and Jack Crowley. Third row: Bob Young, L. Bradley, E. Johnson, Joe Elias, Bailey Caufield, Robert Kenega, Clyde Boyland, Ray Mechling, Crawford Hertel, Reggie Andrews, Charles Sands, and Paul McDowell. Fourth row: George Banning, Lowell Lerner, Paul Pressler, Les Waddington, Joe Gaspelin, Howard Baumgartner, Charles Lambdin, John Boyd, and Charles Towsley. (Courtesy of the City of Elkhart.)

Robert Ralston's Dixieland Jazz Band, during a rehearsal for the Elkhart Pops, in a program entitled "Music of Nations." The musicians are only identified by their last names—Paxton, Hill, VanDoren, Miller, Ralston, North, and Banning. The date was June 17, 1954. (Courtesy of Time Was Museum.)

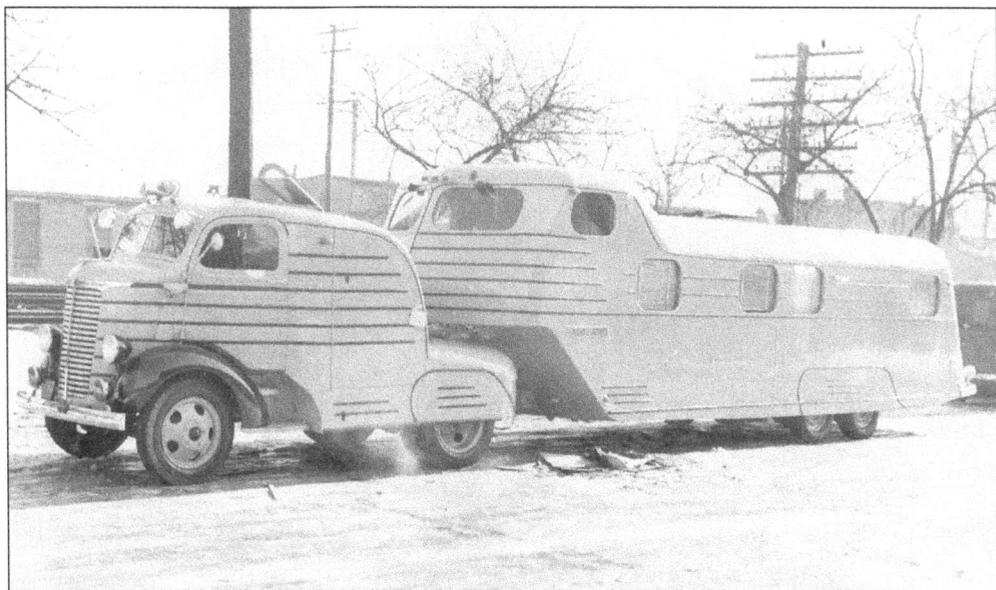

Schult Trailer Company's "Continental Clipper," unveiled in the fall of 1938. This was marketed as one of the very high luxury RVs of the late 1930s—this particular model was eventually owned by King Farouk of Egypt. (Courtesy of RV/MH Foundation.)

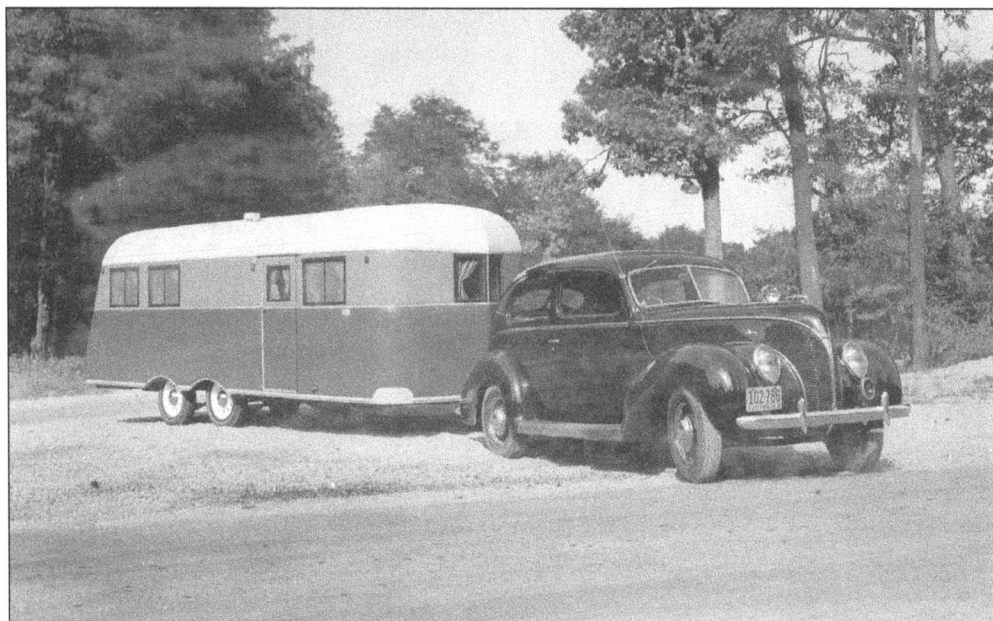

This is Schult Trailer Company's 1939 "Aristocrat" model, one of the very first units to be built in the new South Main Street complex. The Schult plant had originally been operating in a small facility at 515 Harrison Street, in 1935. Back then, each trailer sold for about $200, and the plant could generally turn out one trailer per day. (Courtesy of RV/MH Foundation.)

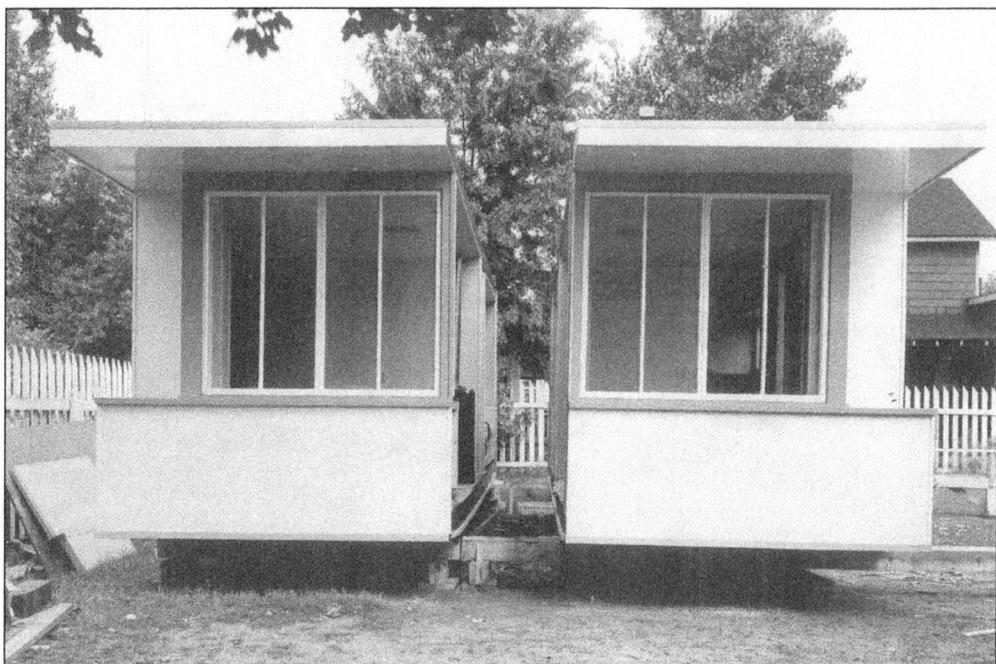

One of the very first modular homes ever constructed—this is a "before" picture of a 1942 model created by Schult. Several of these types of units were built and shipped to Oak Ridge, Tennessee, to create a new town for the Manhattan Project to build the first atom bomb. (Courtesy of RV/MH Foundation.)

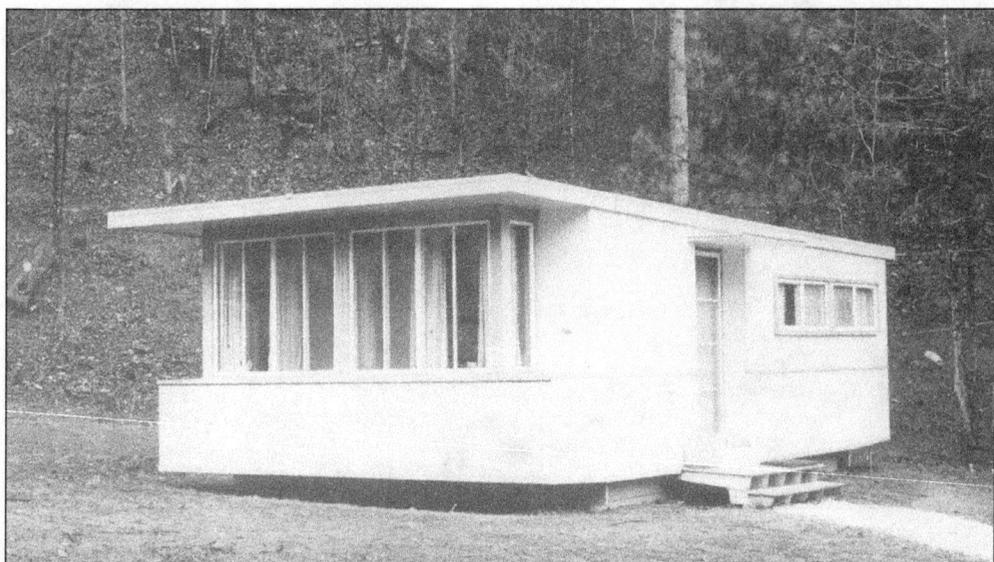

This is how the modular home looked after it was assembled. (Courtesy of RV/MH Foundation.)

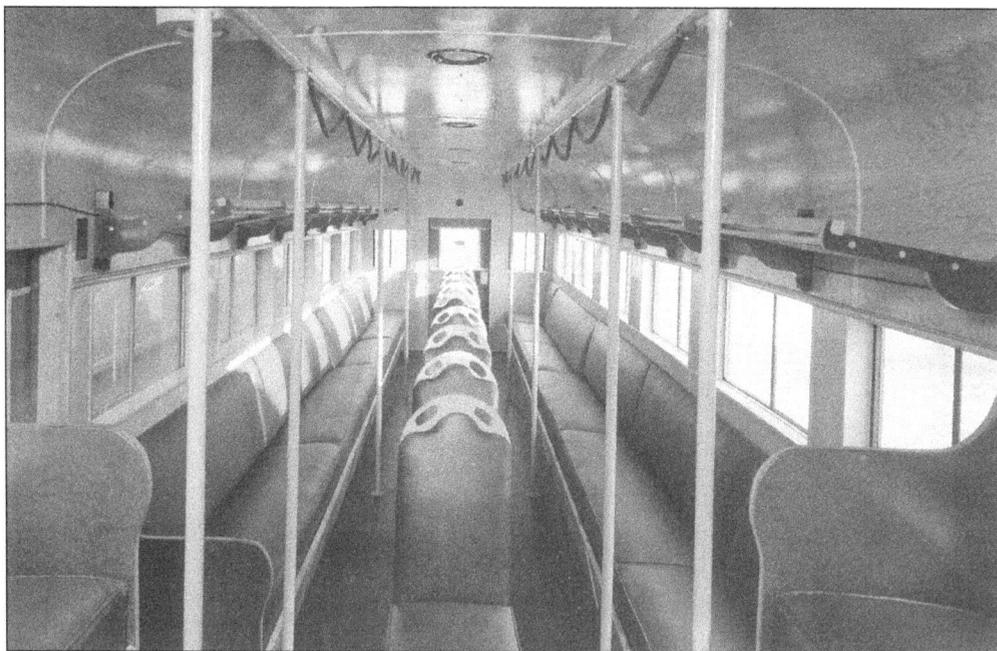

The interior of a POW transport bus, a product of Schult Trailer Company. The open holes along the top of the center columns were there so that the riders could be anchored to their seats by the use of handcuffs, preventing them from moving about the bus. This was just one of Schult's contributions to the World War II effort. (Courtesy of the RV/MH Foundation.)

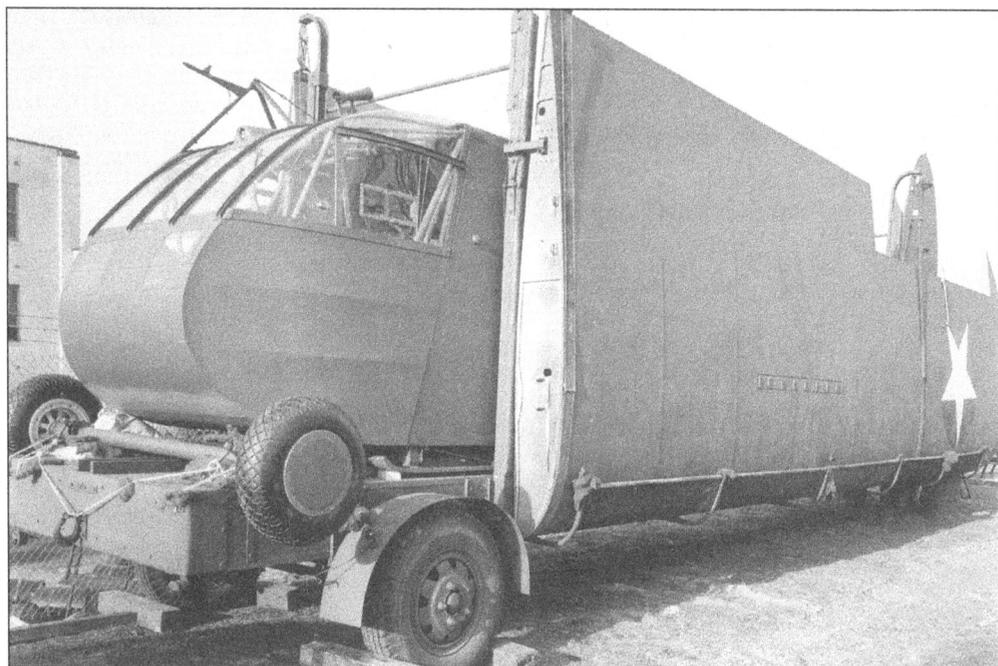

This is a glider trailer, another unique manufacture from the Schult Company. This was created for the task of recovering paratrooper gliders for the Army Air Corps during World War II. (Courtesy of RV/MH Foundation.)

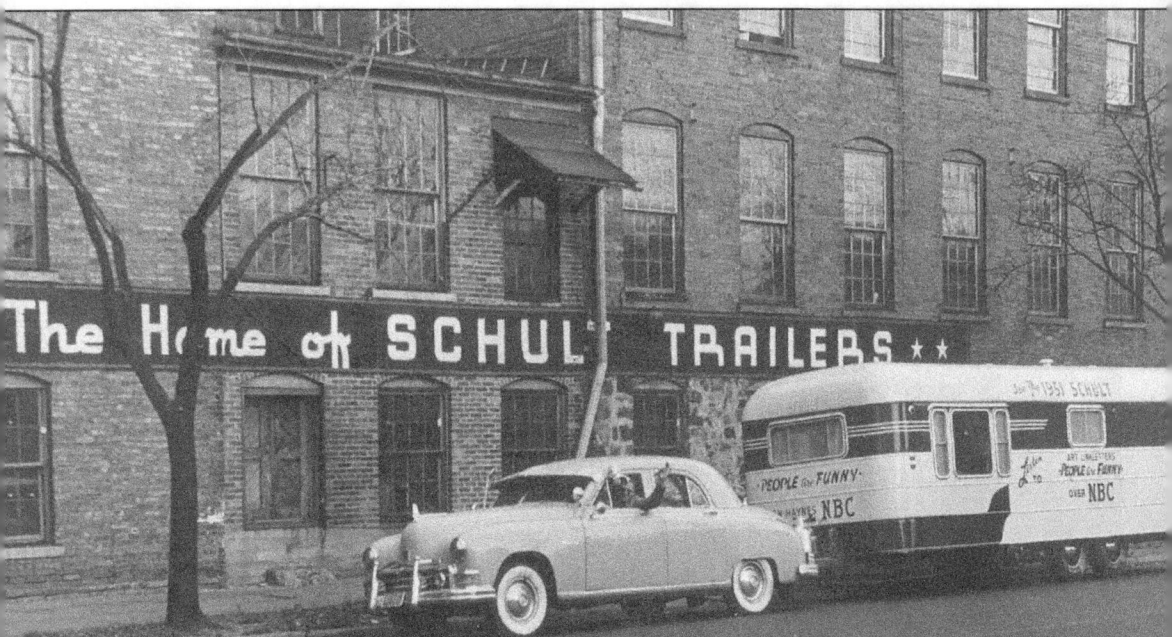

A 1951 Schult trailer, used by NBC as a promotional vehicle for its popular television show, Art Linkletter's "People Are Funny." Many nationally recognized stars came to Elkhart to purchase similar types of trailers. This is one of the few photographs that was taken in front of Wilbur Schult's enterprise, which was housed in the former Noyes Carriage Company on South Main Street. (Courtesy of RV/MH Foundation.)

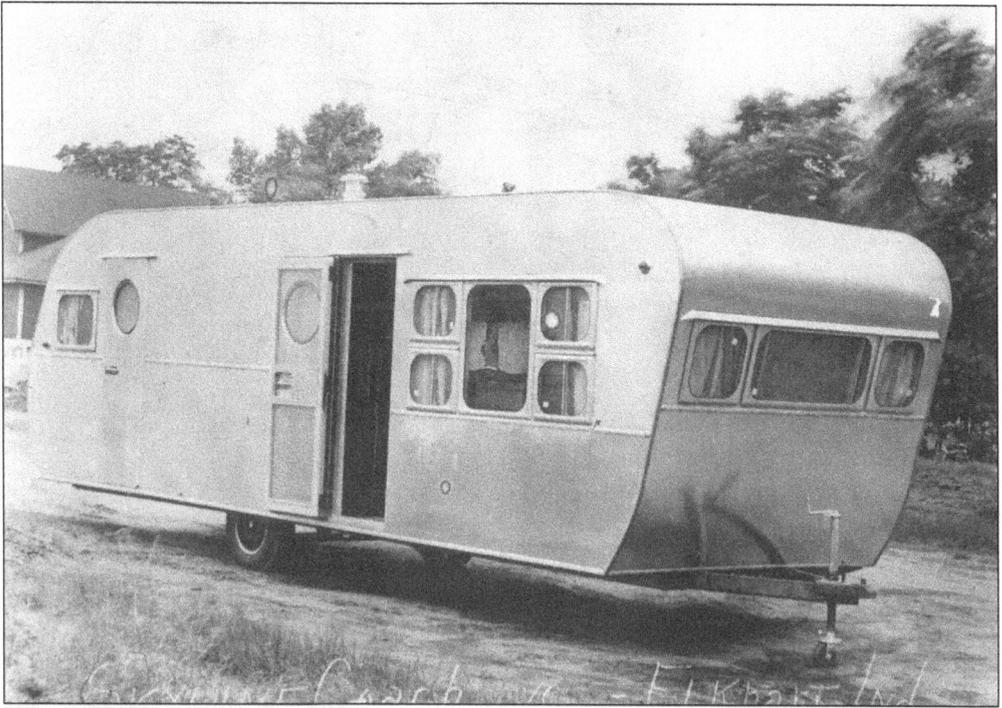

The first model ever produced for Skyline Coach, c. 1950, when the company was founded. In just a decade, Skyline rose to notoriety as the world's largest producer of mobile homes. (Courtesy of RV/MH Foundation.)

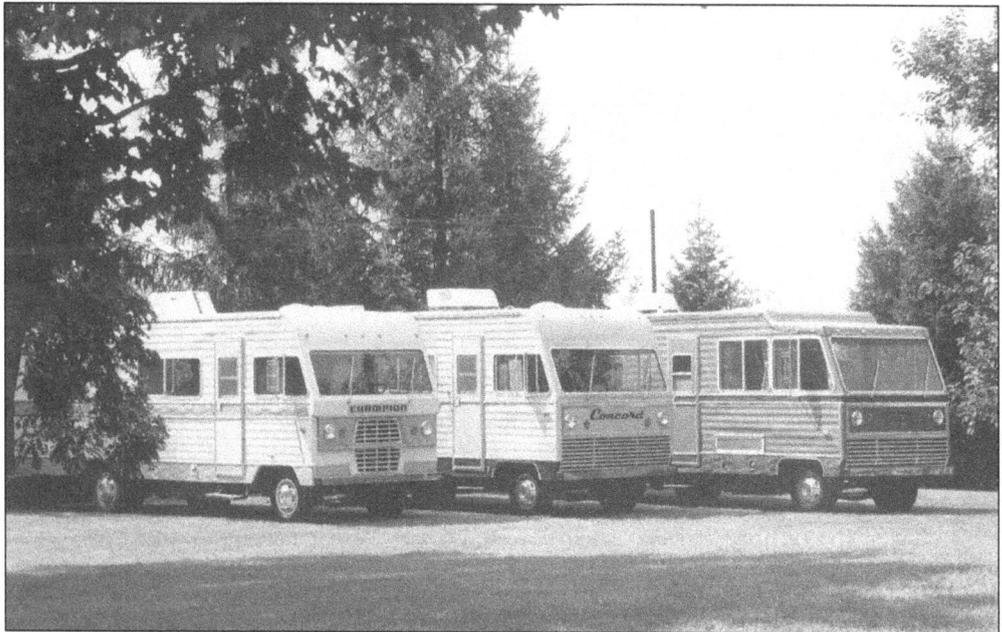

A trio of Champion Motor Homes, pictured in 1973. By the mid-1970s, Champion Motor Homes, headquartered in Elkhart, was the world's leader in the production of motor homes. (Courtesy of RV/MH Foundation.)

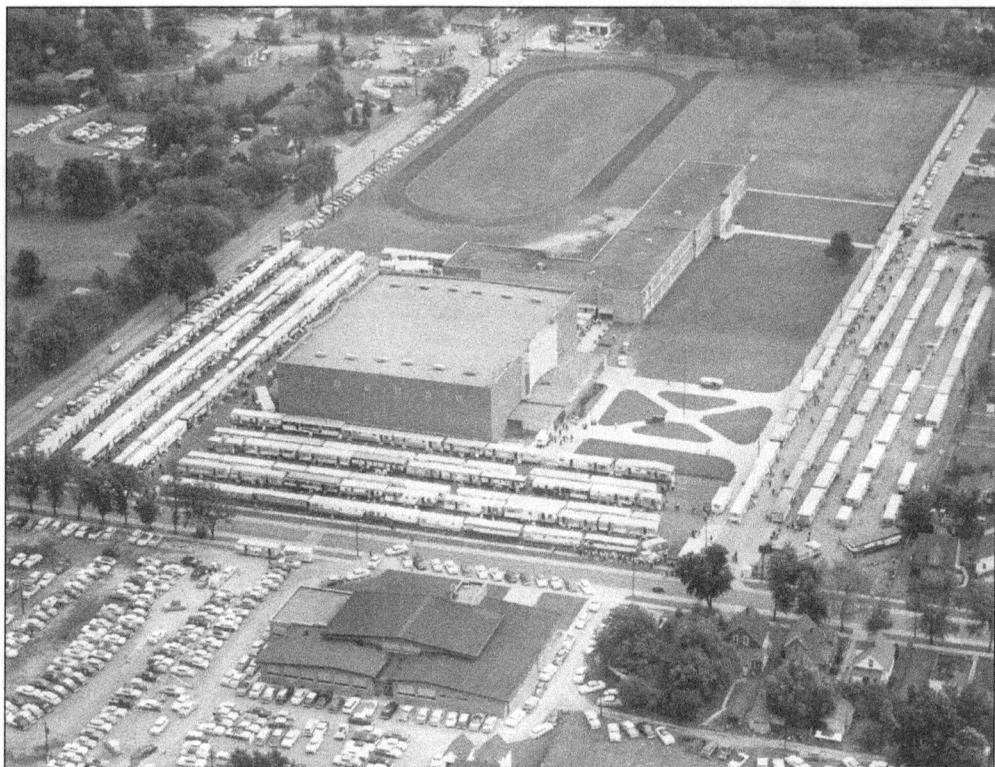

An aerial view of the Elkhart Mobile Home and RV Show, which was held at North Side Junior High School. This photo was taken around 1956—by the end of the 1950s, this was the largest trade show of its kind in the entire recreational vehicle industry. (Courtesy of the RV/MH Foundation.)

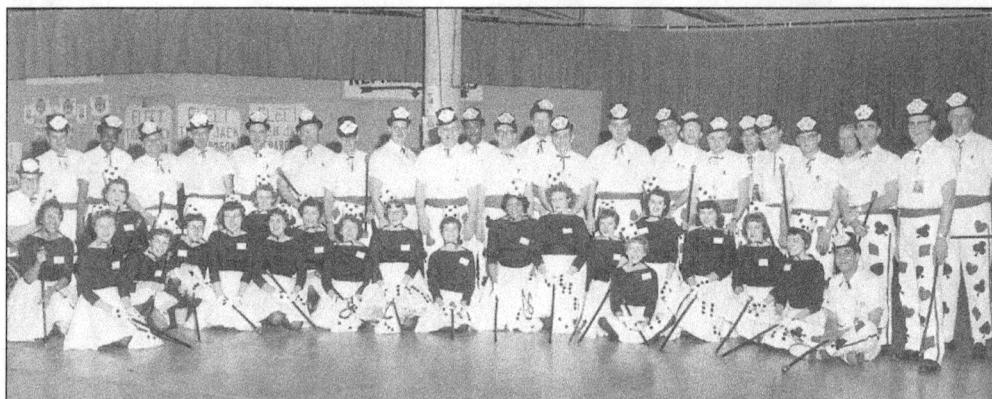

Here, the Elkhart Jaycees are en route to a convention in the mid 1950s. Ronald Coulter was a member of the organization and recalls, "Our Jaycees participated in all city events, and were in charge of many." Among the happenings that the Jaycees helped to coordinate were polio drives, "get out the vote," fish derby, soap box derby, and Easter egg hunts. Coulter also remembers that the group would deliver Thanksgiving baskets and accompany children on Christmas shopping trips, all done in an effort to assist those less fortunate. Although the Jaycees disbanded some years ago, Coulter adds that they are in the process of regrouping. (Courtesy of Ronald Coulter.)

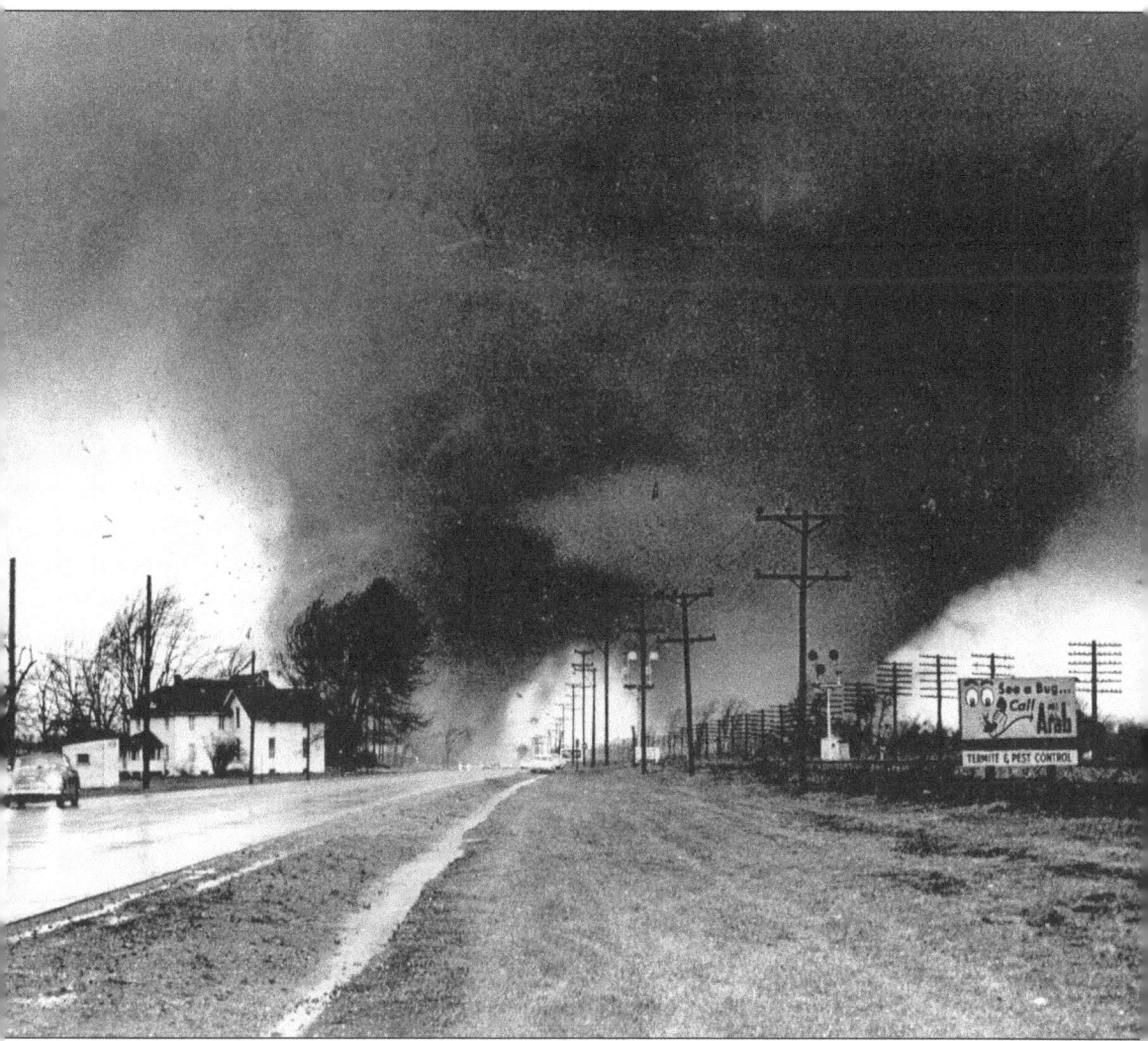

One of the most devastating events in Elkhart County history, this is the frightening and haunting image of the twin tornadoes that ravaged the region on April 11, 1965—an event referred to as the Palm Sunday tornadoes. The day had begun like any other spring day, but by nightfall, the air turned hazy and sultry, and an explosive weather situation of historic proportions was born. There was an epidemic outbreak of twisters across northern Indiana that night, but nothing like the storm which tore through this area. This picture was taken by *Elkhart Truth* reporter Paul Huffman, as he was driving northbound on U.S. 33, approaching Dunlap. He was intrigued by what he thought were merely giant black storm clouds on the horizon—only later did he realize he had just witnessed, and captured on film, two funnel clouds. The storm just missed him and his car, but it nearly obliterated much of the little town of Dunlap. Fifty-two souls were lost that evening across the county, and damage topped $100 million dollars. Days later, President Lyndon Johnson visited the destruction, and was said to be mournfully walking amidst the wreckage, rendered speechless by what he was seeing. When reporters pressured him to make a statement, his simple response spoke more than perhaps words could ever express—he only offered a slow, solemn shake of his head. A memorial honoring the dead has since been dedicated in the Dunlap community. (Paul Huffman photo, courtesy of *Elkhart Truth*.)

These smartly dressed gentlemen were part of one of the city's most unique and captivating social groups. Known as the "Heart City Harmonizers," their specialty was perfecting the a cappella, four part musical style of barbershop quartet. The Harmonizers had a long and successful run in Elkhart, even producing a 1947 international champion quartet known as the "Doctors of Harmony." Ronald Coulter remembers the fanfare and the pride surrounding the celebrated Elkhart musicians, and he himself was a member of the Harmonizers for many years. Along with competing in various contests, the singers offered their talents amidst such venues as nursing homes and service clubs. They had a national endorsement and sponsorship from the Institute of Logopediss, a Kansas-based facility dedicated to the cause of assisting young people with speech handicaps. This photo illustrates the group during the days of its final chapter, in the 1960s. Coulter notes that interest in continuing the Heart City Harmonizers had dwindled by about 1980, but a few "die-hards" relocated to the South Bend chapter. (Courtesy of Ronald Coulter.)

www.ingramcontent.com/pod-product-compliance
Lightning Source LLC
Chambersburg PA
CBHW080627110426
42813CB00006B/1618